EXTREME BRICKS

EXTREME BRICKS

SPECTACULAR, RECORD-BREAKING, AND ASTOUNDING LEGO PROJECTS FROM AROUND THE WORLD

SARAH HERMAN

SKYHORSE PUBLISHING

Skyhorse Publishing books may be purchased in bulk at special discounts for sales promotion, corporate gifts, fund-raising, or educational purposes. Special editions can also be created to specifications. For details, contact the Special Sales Department, Skyhorse Publishing, 307 West 36th Street, 11th Floor, New York, NY 10018 or info@skyhorsepublishing.com.

Skyhorse® and Skyhorse Publishing® are registered trademarks of Skyhorse Publishing, Inc.®, a Delaware corporation.

Visit our website at www.skyhorsepublishing.com.

10 9 8 7 6 5 4 3 2 1

Library of Congress Cataloging-in-Publication Data is available on file.

ISBN: 978-1-62636-212-3

Printed in China

For my wonderful nephews
Aaron, Daniel, Matthew, and Nathan

Contents

CONTENTS

EXTREME BRICKS

Introduction

You may not be able to remember the first time you stuck two LEGO bricks together. And you probably can't recall the first time you dismantled the Space set your dad helped you to build, and started putting the pieces together yourself to create your own ultimate spacecraft—transforming levers into laser guns, windscreens into high-tech communication panels, tiny transparent plates into teleportation devices. And the day you "borrowed" your older sister's Barbie to stand in for a giant humanoid space alien on your bedroom carpet is most likely a distant memory. But what you might be able to recall, more vividly, is the way it felt to reach into your LEGO brick bin to find out that there weren't enough left to make the base modifications your minifigure mining army were counting on. How else were they ever going to find enough Uranium to make it back to Earth? Mortified, your eyes scanned the carpet universe for the next victim—the model you would sacrifice to make sure the work gets done.

An unlimited supply of LEGO bricks isn't hard to imagine. Whatever piece you want, in whatever color, and whatever quantity, is a dream harbored by almost every child who plays with LEGO toys. While such a supply is never really going to be an option for the mini people the brand is aimed at, with the rise of brick-reselling websites such as Bricklink.com and LEGO's own Pick-A-Brick service in LEGO Stores and online, there are some adults amassing collections so large and abundant they are able to build the models of their imagination in shocking detail. Not only that, but they're able to build those models on a scale like never before. These adult fans of LEGO—or AFOLs as they are known among the international plastic brick-building community—are dreaming so big and building on such an impressive scale that their models are enthusiastically shared on the Internet, receive worldwide media coverage, and attract thousands of fans at conventions across the globe.

Of course it's not just amateur fans of LEGO who are getting in on the extreme building action, and this tale is not limited to their endeavors. There are professional builders too, certified by the

LEGO Group (TLG), who create sculptures, mosaics, functional items, and art out of the building blocks. Their work is featured in gallery exhibitions and museums, bought by art collectors, and commissioned for the homes and offices of LEGO lovers. Sticking LEGO bricks together for a living is the fantasy of many a child (and grown-up), and the added privilege of building with LEGO bricks for TLG is reserved for another small group of revered individuals. The Master Model Builders—hired and trained by LEGO HQ to roll out giant models for LEGOLAND Parks and Discovery Centers, TLG-sponsored and -attended events, LEGO Stores, and any other impressive LEGOy

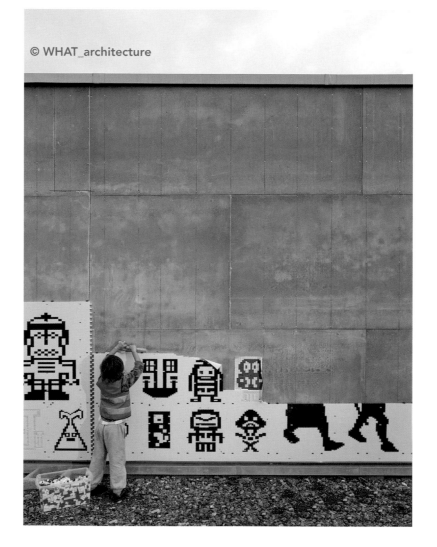

© WHAT_architecture

purpose. From the world's most iconic buildings, to larger-than-life-size *Star Wars* characters, and everything in between, these are the people who make it happen.

Many professional LEGO builders often say they wish they had an extra set of hands when it comes to building big. And some extreme builds are the result of such a wish. If you're looking to build the world's tallest LEGO tower, a life-size house made from LEGO, or a giant LEGO ball that needs a forklift to get it off the ground, you're going to need a lot of free time or a dedicated army of builders (not to mention an entire truckload of perfectly molded bricks) to see your mega build come to life. As architect Anthony Hoete explained—when talking about WHAT_architecture's world record–setting permanent building installation (see page 88)—"LEGO is a democratizing design tool, because everybody can use them, and everyone loves 'em!" Bring people together, throw a bunch of LEGO bricks in the middle of the room, and watch as they create and build—it's a medium that's so ingrained into the cultures of so many countries, no instruction is necessary. Through large-scale group projects, more people have the opportunity to build creations that match, or even surpass, their childhood imaginations.

Beyond the realms of sculptural, decorative model building are those who see the functional potential of the LEGO product range and breathe computer-operated life into LEGO bricks and Technic elements using the robotic circuitry of LEGO MINDSTORMS. Pushing the boundaries of what LEGO can be used to build, enriching the simple plastic pieces with the technological wizardry of programming, and challenging the scientific thinkers of tomorrow to see beyond the limits of motionless objects are a niche group of kids and AFOLs who channel their passion for the brick into action. Much of their work needs to be seen via video or in person to be fully appreciated, but some of those creations are explored here.

And then there are the collectors—those who love the brick beyond all else. They were the kids who saved up their pocket money for months to buy the latest Blacktron set so they would have the complete fleet of spacecraft, even though their parents said they would grow out of it before long. Now adults, and with disposable income to buy what they couldn't get their hands on before, some store their stash in happy isolation, displayed and dusted for the eyes of close friends and family. Others offer up their hoarding habit to the world, a proud display of perseverance and passion. With over fifty years of the brick, this is LEGO collecting on an unprecedented scale. This is extreme.

In trying to compare the different commitments to the LEGO building phenomenon, Master Model Builder Gary McIntire compared the hobby to music:

> There are some people who are just fans of it. They enjoy it but they're not really involved in the music world at all. Those people are the people that go on Brothers Brick [LEGO blog www.brothers-brick.com] and they look at things people are doing with LEGO. And going to

a LEGO convention would be like going to a concert, where you're seeing it live. And then you have the people who are actually doing it. And much like the music world there are way more musicians who are just playing music as a hobby. Those are the builders. People who sit around at home working on stuff, and maybe they throw it up online and share it with some other people. And then you get some bands who get really lucky and get signed, and I guess I'm one of those people who got lucky enough that I get to do LEGO for a living.

What all these people have in common is their high regard for a children's toy. A toy that has successfully transcended generations, revitalized itself from the inside out, moved with the times, and yet remains the same essential product it was at its conception. They also share a trait of tenacity—testing the limits of the bricks' capabilities, pushing the power of plastic to a level that might not succeed just to see if it will. They are patient and persistent, and with time, effort, some out-of-the-LEGO-box thinking, and a little bit of luck, their work pays off in ways that are spectacular, jaw-dropping, and fundamentally inspiring to the children and other adults who witness them. In these pages you will find a celebration of these artists, builders, programmers, and professional LEGO modelers, and some of the most extreme creations they've ever made.

Pioneers
of Play

"You name it and it was probably built out of LEGO!"
Alan Jones, former Marketing Designer for British LEGO Ltd

"It's just a joy to be able to build such big models now that I have more LEGO parts than I ever dreamed of as a kid," said British LEGO fan Gary Davis. "I build small things too, and I don't want to suggest that smaller models are less appealing. . . . Nevertheless, the look of awe on people's faces when they first see extreme models is a great reward for all the time, effort, and cost."

Hitting the LEGO brick firmly on the stud, Davis raises a key factor that remains largely responsible for the brand's continued success. The look of awe he described can be seen on the faces of children as they browse the LEGO aisle at Toys "R" Us, or when they open a big rectangular box on their birthday, and see that it contains the set they really, *really* wanted. It can also be seen as children and adults stroll around LEGOLAND Parks in California, Florida, Germany, the United Kingdom, Malaysia, and the home of the LEGO company in Denmark, taking in the impressive displays created from the same LEGO bricks built by professional model builders. The same look can be as easily prompted by an older sibling building a huge LEGO castle from their imagination, as their younger, less dexterous brother or sister looks on in wonder.

What that look really is, is a realization that LEGO truly is restricted only by the imagination. Whether your collection is small or gargantuan, what you can create with it is inspiringly without constraint. Perhaps nowhere is this more simply expressed than on the back of one version of a

1970s LEGO building guide Idea Book No.2 which shows a photograph of a man building a human-sized replica of the Empire State Building and a child seated next to him building a much smaller version. The slogan reads: "There's no limit to what you can build." There aren't that many eight-year-olds who could easily construct a six-foot-tall Empire State Building from the contents of their LEGO box, however, models like these, created by the Lego Group (TLG), have been inspiring builders both young and old to explore their own potential for generations.

In 1932, when Danish LEGO founder Ole Kirk Christiansen started whittling away making wooden toys, to provide an additional income to his struggling family-run carpentry business, he probably had no idea he would soon start trading under the LEGO name, and what that name would come to mean for millions of people around the world. While the quality of his birch-wood pull-along ducks and six-wheeled school buses was second to none, in line with the consistency and high standard of LEGO toys today, these fully-functioning, ready-to-play creations bore little resemblance to the LEGO bricks the company would go onto develop.

With the introduction of plastic through the acquisition of an injection-molding machine in 1947—at a huge financial risk to the company—the ability to produce large quantities of plastic parts and

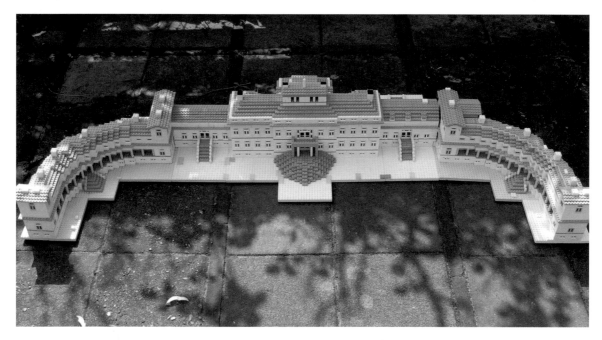

This mid-1960s model of the Dutch Soestdijk Royal Palace was the only one made by TLG and was photographed with one of its residents—Prince Claus—in 1973. The wings are from the original model and the main building was constructed by collector Henk van Zanten.
© Collection Henk van Zanten, the Netherlands

A copy of an original LEGO mascot model used for promotional materials by TLG in the late 1950s and 1960s—it weighs more than six and a half pounds. © Collection Henk van Zanten, the Netherlands

A four-story, thirty-three-inch-high skyscraper seen in LEGO advertisements in the United States in 1962. © Collection Henk van Zanten, the Netherlands

toys became a reality. Bricks known as "Plastic *Kubus*" were some of the first plastic LEGO building blocks to be sold by the company followed by Automatic Binding Bricks (later changed to LEGO *Mursten* and then LEGO Bricks). But it wasn't until the 1950s that Ole Kirk's son, Godtfred, found a way to package and promote LEGO bricks that would be the company's meal ticket.

The Town Plan *System I Leg* (System of Play), unveiled at the Nuremberg Toy Fair in 1955, showed customers how they could be the builders of their own LEGO domain. By building up your own brick collection, you could erect houses and shops connected by roads, and even skyscrapers if you had enough. The incorporation of TLG's own 1:87 scale metal and plastic cars and other vehicles, trees, and signage, brought the Town Plan to life, and literally put LEGO on the map. Godtfred and TLG took this idea and ran with it—increasing the number of manufactured LEGO parts and colors considerably throughout the late 1950s and 1960s. Colorful

packaging and advertising was key in highlighting the possibilities of the product, as well as the popular Idea Book series of pamphlets and books put out by the company.

Sold in countries all over the world in various versions and editions, and often included within gift boxed sets of bricks, the Idea Books proved a successful way of providing children and adult collectors with points of inspiration for their building hobby—never mind the fact that many of the models displayed required more bricks than were included in any particular set—and encouraged children to build up their LEGO collections to be able to build bigger and more impressive models. This was prior to the detailed instructions included with each set, which children are familiar with today, that didn't appear until 1964, and even then weren't available in every set until the late 1970s.

As any LEGO convention attendee will no doubt tell you, it's one thing to see an illustration of a model or a photograph in a book, or these days online, but it's quite another to see that model with your own eyes; to be able to get up close, walk around it, and see how tall you are compared to it. And the LEGO Group wasn't ignorant of that fact, even in the early days. To truly capture children's imaginations, since the beginning, it has produced display models for stores and events to show the extreme capabilities of its somewhat modest product range. These models were available for store owners to order from the company's own model shops where they were constructed, glued, and then sent to the store for display purposes. "Almost all of the early models were buildings," said Gary Istok, author of *The Unofficial LEGO Sets/Parts Collectors Guide*. "Many medieval buildings were among the larger models that were used for displays. Among them were half timbered medieval houses and house facades, Gothic cathedrals, castles, and other town sets. One of the more popular models was the Empire State Building, built six feet tall. After the introduction of LEGO wheels in 1962, many wheeled models were also produced by model shops."

This is a big-wheel version of a London bus, similar to the smaller 1966 toy version by LEGO. It is believed this model was used to promote the sale of set 313 and LEGO wheels.
© Collection Henk van Zanten, the Netherlands

This passenger ship from 1965 is a great example of the LEGO Group's growing use of more complex building techniques such as the 1 x 1 round bricks used here as portholes. © Collection Henk van Zanten, the Netherlands

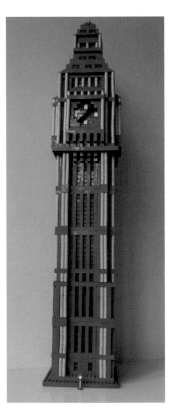

The first model shop was at TLG's headquarters in Billund, Denmark. There was also a model shop in Wrexham, Wales, which supplied models for British LEGO Ltd. as well as a model shop in Detroit, Michigan, set up by licensees Samsonite (when they produced and distributed LEGO toys in the United States and Canada during the 1960s and 1970s). A lot of the output from these shops included large architectural models, often of famous landmarks. Alan Jones worked as a Marketing Designer at the Wrexham location during the 1980s and 1990s, and was involved in everything from the original ink drawings of the toys, to the packaging, promotions, point of sale displays, LEGO events, the LEGOLAND Park themes, as well as The LEGO Builders Club newsletter *Bricks 'n Pieces*. "It was a real privilege to be part of LEGO UK and looking back I was influential in a whole range of aspects of the toys," said Jones. "I spent nearly half my life in LEGO and it was just amazing!" He also worked on the design and production of window displays for the largest toy stores and department stores in the United Kingdom. "The model shop function was a marketing support role, but realistically there to purely create the 'OMG! WOW!' factor when people could see what could be achieved if you had enough bricks—and the know-how of course!" said Jones.

The top half of this three-foot-tall LEGO Big Ben tower was found by collector Henk van Zanten in a German toyshop. It was featured in a 1966 LEGO Idea Book. © Collection Henk van Zanten, the Netherlands

Unlike other brands that relied on store workers to effectively display their toys in shop windows, "The Lego model shop was totally unique, which of course gave the company a significant competitive advantage and the management used it as a very strategic marketing tool," he said. The core team consisted of Jones, four model designers, an events manager, and an in-store manager, although with the increased demand for models, especially at peak times of year, temporary model builders would be taken on to spread the workload. According to Jones, these in-store models had a direct influence on the sales of LEGO toys, and the direction themes were pushed in, "especially when the actual products were replicated at a larger size. Children could see the large display model, get the 'Wow' factor and then of course wanted to get the figure, vehicle, or playset to play with at home."

As is common in the AFOL community, where builders push each other to "up their game," Jones remembers a similar sense of competition between the different model shops. "There was a little bit of friendly rivalry with the UK and Billund in Denmark, but nothing that a 'mine is much better than yours' couldn't cure!" Using elevation and plan-view graph paper, the model designers would use rectangles to represent the height and width of a standard eight-stud LEGO brick to plan their designs. "You name it and it was probably built out of LEGO!" said Jones on the types of models emerging from the Wrexham shop during the 1980s. "Three-meter-high by four-meter-long [ten-foot-high by thirteen-foot-high] animated roaring dinosaurs, a three-meter-high [ten-foot-high] giant Dublin city hall, *Alice in Wonderland* and *Wind in the Willows* tableaus, and loads more," he recalled. "Some of these displays were approx eight meters by six meters [twenty-six by twenty feet] and could take one or two days to install with two or three people. Each display of course came with its own challenges, for instance, how do

A US-designed tower building, built as part of TLG's Town of Tomorrow layouts for Idea Books in the 1960s. This model measures nearly twenty-seven inches high. © Collection Henk van Zanten, the Netherlands

you get a meter-wide [three-foot-wide] 'Mr Badger' into a very famous shop window with a door only sixty centimeters [twenty-four inches] wide?"

A large part of Jones's job was to work on the backgrounds, and display the large LEGO models in each location, often in high-profile shop windows like London's Selfridges department store, taking up three or four large windows for the Christmas shopping period. "All the tableaus and sets were made to be component parts but some of the larger models like the dinosaur were made in sections and did have to have metal frames inside, purely to support the weight of the bricks," he explained. "All the bricks were of course glued using a special secret bonding ingredient that almost welded the plastic together."

Stores weren't the only destination of the model shops' output. The LEGO Group also required the production of large, impressive models for trade fairs and other LEGO events and promotional activities, for example for the launch of a new set or product line. Since 1955 TLG has put

Giant LEGO models built on scales previously unseen were a spectacular sight at LEGOLAND Billund. These images were taken by a LEGO employee during the park's first season.
© Peter Christiansen

on displays to remember at the annual Nuremberg Toy Fair in Germany as well as the New York International Toy Fair in the United States. Istok explains in his book that unfortunately, a lot of the earlier large creations built by the model shops have warped over time—due to the fact they were made from an inferior form of plastic, meaning few of them have survived to the present day.

Opened in 1968, LEGOLAND Parks have grown from a modest Danish attraction showcasing the creations of the model shop, to a multinational leisure institution to rival the likes of Walt Disney. There are currently six LEGOLAND Parks and ten LEGOLAND Discovery Centers around the world where children and adults can marvel at LEGO creations on an unprecedented scale, which was former CEO Godtfred Kirk Christiansen's original intention. By the mid-1960s the LEGO model shop in Billund was attracting an average of twenty thousand visitors a year, who were making the journey to the Jutland moors just to see the extreme creations the model builders were piecing together for store displays and trade shows. Aware of this growing thirst for big LEGO models, but concerned about keeping the LEGO factory and model shop running productively, Godtfred Kirk Christiansen decided that an outdoor exhibition would solve the problem.

Scenes from LEGOLAND's first year in 1968
© Peter Christiansen

The original plans for this land made of LEGO bricks were relatively modest, but similarly to when you're building with them, it's hard to stop creating, and soon a sprawling layout of LEGO

models, gardens, and attractions was imagined by Copenhagen window designer Arnold Boutroup. Now owned largely by Merlin Entertainments Group, LEGOLAND Parks have adapted and grown with the times and technology, appealing to children today as much as they ever did in the 1960s. One element has remained steadfast throughout, however, and that is the wondrous world of Miniland. The centerpiece of all LEGOLAND Parks, Miniland is a carefully landscaped area where real architectural landmarks are depicted in 1:25 scale, with a primary focus on cities and areas of interest to the geographical area of the park.

Miniland was inspired by a trip GKC and Boutroup took to Madurodam in The Hague, Netherlands. Also 1:25 scale, the miniature park has seen millions of visitors pass through its gates since opening in 1952, and depicts famous landmarks and industrial projects from across the region. And it was this Lilliputian experience that would be emulated in LEGO bricks, so children could feel like giants walking through a world made from their favorite toy. There was one woman who was charged with the daunting job of coordinating the design and construction of these models, to bring such an experience to life not with modeling clay or wood, but with a children's toy. She was arguably the first really extreme builder, and her name was Dagny Holm.

In his book *The World of LEGO Toys*, author Henry Wiencek described Dagny Holm as one of the most influential creators of the original LEGOLAND. Prior to her working in the Billund model shop, Holm was a clay sculptor, who initially struggled with the additive sculptural technique of LEGO building. Her process involved likening the construction of LEGO models

© Peter Christiansen

15

to the pattern-creating skill of embroidery. She worked tirelessly on the development of LEGO-LAND Billund and other LEGO models until retiring from the organization in 1986. Holm, together with a small team of skilled modelers, were able to re-imagine hundreds of European buildings for the Billund park from nearly six million LEGO bricks, including a Swedish fishing village, as well as landmarks from across Denmark and the Netherlands; over half the models at the park were built under her direct supervision and many still stand there today.

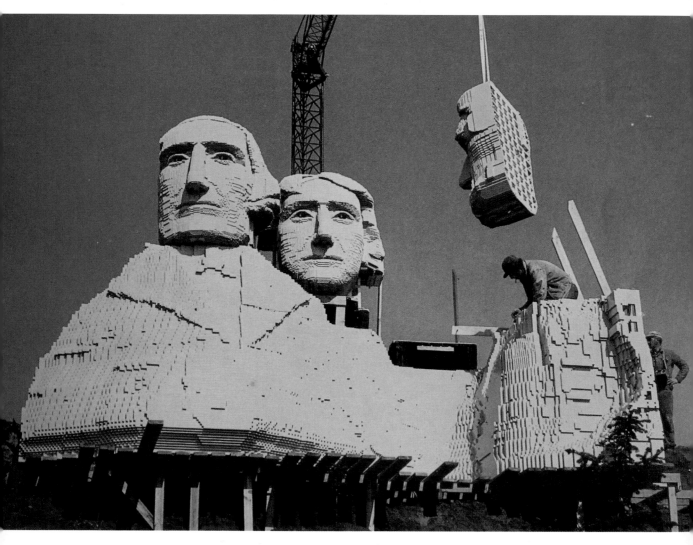

Bjørn Richter's Mount Rushmore model being installed at LEGOLAND Billund. © Bjørn Richter

"Dagny was a close friend at that time," said artist Bjørn Richter, who was commissioned to produce three sculptural LEGO works at LEGOLAND Billund during the 1970s and 1980s. "She worked mostly on buildings and stylized animals while I developed the modeling structures with the bricks. . . . She cared very much about style. She would recognize cheap solutions as well as bad quality. But we, the old guard, probably tend to think like that no matter what."

The old guard also had to contend with slightly different building methods due to the elements available and the lack of sophisticated computer technology—modelers studied photographs of the real landmarks from different angles, as well as taking measurements, to ensure that everything would be to scale relative to each other. Models were then made from wood and plaster before LEGO designs drawn on graph paper were assigned to different builders to start a plastic replica. The introduction of new LEGO elements as the years progressed completely revolutionized the way LEGO model builders worked, "particularly when elements were introduced like tiled smooth bricks, Technic beams, curved discs, and of course different colored bricks," said Alan Jones. "It just opened up a whole new world!"

Those who maintain and add to the parks' inspiring collection of models have certainly made the most of the growing assortment of elements and colors available to them ever since. The introduction of Copenhagen's Nyhavn Harbor to LEGOLAND Billund in the 1980s saw 123 new buildings added to the site using three million LEGO bricks; the park now contains more than sixty million. And that's only accounting for one of the six LEGOLAND sites.

Gary Istok explained that the progression of big building and Miniland scale models at LEGO-LAND has had a direct influence on the wider LEGO-building community. "The introduction to mass production of the SNOT technique [Studs Not On Top—where LEGO elements are connected in an unconventional way so the brick's studs are not uniformly facing upwards] started frequently with the advent of LEGOLAND," he said. "Large-scale building also started the use of different parts in new colors. Although TLG used only parts that were in regular LEGO sets, they introduced new colors many years before they were available in regular LEGO sets. The SNOT technique became more elaborate as the number of new LEGO elements introduced increased in the 1970s."

Gary McIntire, who works as a Master Model Builder at LEGOLAND California, knows more than most the process Dagny Holm would have gone through all those years ago to make something jaw-dropping from the simple material available to her. "What's really unique about sculpting with LEGO is that it's an additive process," he explained. "With almost all the classic forms of sculpture you're removing material to create something, and with LEGO you have nothing and you have to add to it. So that makes it an interesting challenge. I think it's a unique and challenging puzzle to use only what's available to you to create something. You have a set color palette; you can't paint them, and you have set shapes; you can't cut them. I think when you're able to

create something it's even more impressive because you have to overcome those limitations to do it."

Holm's models may have been highly detailed and on a scale not previously imagined, but the seventies and eighties saw the work of one of her contemporaries surpassing the size of any LEGO house, cathedral, or harbor. Bjørn Richter spent years working on three of the most extreme models ever built at LEGOLAND Parks. Unlike Holm, who was more limited to the scale of Miniland, Richter was given free rein to build sculptural models of his choosing with no limits on scale, bricks, or subject matter. "Everything was new; nothing like LEGOLAND existed anywhere," Richter recalled. "There was a pioneering spirit at that time, which promoted the best of creativity." The adventurous encouragement saw Richter build three LEGO creations—Mount Rushmore, the Great Bison Hunt relief, and Sitting Bull—which are still some of the largest and most well-known LEGO sculptures in the world, having been enjoyed by millions of visitors to Billund over the last forty years. The Mount Rushmore model alone required the use of 1.4 million LEGO bricks and forty thousand DUPLO bricks, while the Sitting Bull sculpture eclipsed those figures with a brick count of 1.75 million, looming over the park at thirty-six feet tall. "Nobody had ever seen that kind of work, or thought it possible," Richter said. "I gather I broke some limits and rules."

"There is something about a big model that is just fascinating!" said LEGO Certified Professional builder Robin Sather. "It's fun to see, and it's even more fun to build. There are unique challenges to overcome, like how to support hundreds of kilograms of bricks at odd angles, and how to make square bricks look like smooth curves, but the end result can be very satisfying." These challenges have been testing talented builders since the early days of the model shops. Builders who never build big for the sake of it, but who absorb the ingenuity of regular LEGO sets, raid the larder or LEGO parts, and produce models that deserve to be marveled at. They are not always thirty-six feet tall or populated by thousands of minifigures and millions of bricks, but through their scale, their design, or their complex use of parts or subject matter, they are usually jaw-dropping, and often they're extreme, setting the tone for LEGO fans the world over to explore their own collections in a new way.

Passion, persistence, and precision were three of the underlying factors behind the models created, and it's a philosophy that still underpins the work of professional LEGO builders and fans today. "You can make something huge and it can be utterly boring and all you've managed to do is burn up a lot of empty space," said former LEGO Community Relations Coordinator Steve Witt. "The truly extreme part of LEGO is when you can look at every few inches of a model and see something creative and interesting. That's extreme to me; when someone puts so much time into something that you don't see any gaps, no rushed spots, no unexplainable empty spaces." Beyond

that, however, will always be that illusive wide-mouthed awe that comes, not just from building big, but from pushing the limits of what LEGO bricks can do that appeals to many builders. "The satisfaction of giving a real 'Wow' impact to the people coming to see it," is professional builder Ed Diment's reason for supersizing his creations, as well as the "enormous sense of achievement seeing what is inside your head converted to reality in LEGO bricks . . . After all," he said, "who can resist sticking more and more LEGO bricks together?"

SITTING BULL

By Bjørn Richter

FACTFILE

Build location: Norway
Year completed: 1986
Time taken: Over two years
LEGO elements used: 1.75 million

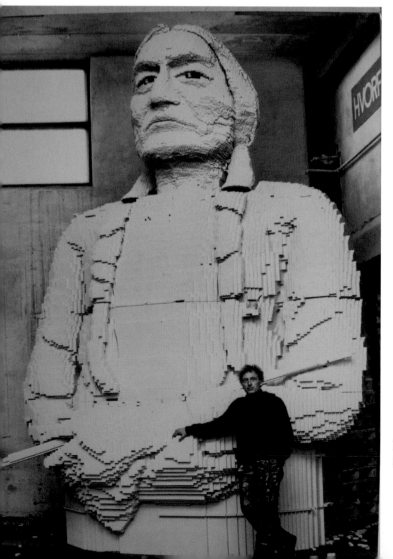

WHAT IS IT?

Of the three monumental sculptures he built for LEGOLAND Billund in the 1970s and 1980s, Norwegian artist Bjørn Richter still holds one more dear to his heart—Chief Sitting Bull. When taking in the sight of this colossal representation of the Hunkpapa Lakota Sioux Native American, whose visions inspired and motivated the Native American victory at the Battle of the Little Bighorn, it's easy to see why. "The 'Presidents' were a mere copy," Richter said recently of his LEGO version of Mount Rushmore. "The buffalo hunting scene was my own creation, but was unfortunately placed in a bad setting—kind of getting lost behind activities."

Bjørn Richter posing proudly with his giant Sitting Bull sculpture. © Bjørn Richter

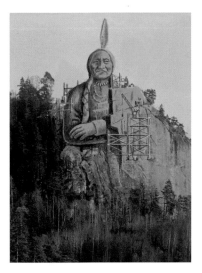

A drawing depicting Richter's model being installed on a rock face in Norway opposite the artist's studio, as part of a practical joke in Norwegian newspapers.
© Bjørn Richter

There's no missing Sitting Bull—measuring thirty-six feet tall, the model towers over a rocky facade in the park. It was originally built in six mobile sections that were transported from Richter's barn in Norway to the park for assembly. But Sitting Bull was far more than just an assembly of LEGO bricks for the sculptor, and was inspired by his extensive travels in the US reservations. "Sitting Bull was my hero," he said, "as one of the last standing up to the whites' suppression (in fact, genocide), he still is. I have not found one single monument anywhere of Sitting Bull, while the presidents, praised as the icons of freedom, were brutally suppressing and killing the native population." Struggling with his moral conscience Richter chose to build Sitting Bull as a counterweight to his Mount Rushmore model. "It finally was a tribute to the spirit of the Indians and respect for their sufferings," he said.

MEET THE MAKER

"I started in LEGOLAND in 1970," said Richter. "I was hired by director Arnold Boutroup who apparently sensed my talents at a social gathering back then. I was promised a studio without interference of any other people at LEGO and LEGOLAND." Richter was one of the first people to create models for LEGOLAND, and he was given a vast amount of creative freedom to build what he wanted. "I felt that it would be exciting to join a unique idea from the very start. There were almost no limits to travel for inspiration or research."

But after spending two years working on Sitting Bull alone, Richter decided to hang up his LEGO-building hat and pursue other mediums. "Had I wanted personal prestige and fame, I could have campaigned for it with my creations as a commercial base," he said. "I could have generated much money too. But something else was on my mind. Fame was not important, so I moved north to the moose, beaver, and lynx." He now lives in northern Norway, in an environment he describes as "fairly isolated, by the river, fjord, and forest," where he is working on archiving 450 of his pieces of artwork, as well as essays and countless articles he has written. His

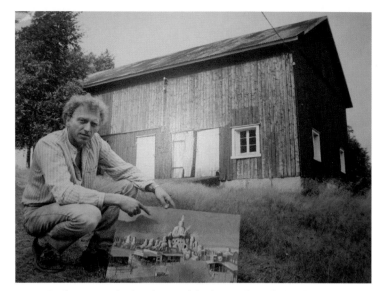

Bjørn Richter crouched in front of the barn where he built the Sitting Bull statue, holding a photograph of the model. © Bjørn Richter

KEEP BUILDING

Fancy finding out what artist Bjørn Richter is up to these days? If you're in Norway, there's a wonderful walk through beautiful countryside that will lead you to his isolated art gallery open from May 15 to September 30. Alternatively, see a collection of his paintings and drawings on www.bjornrichter.no.

home is also his gallery, where he exhibits Gouache paintings, collages, original lithographs, oil and acrylic paintings, watercolors, drawings, sculptures, and masks he has made.

THE PROJECT

Having spent a lot of time in South Dakota, Richter was already very familiar with Native American culture, his subject Sitting Bull, and his significance, before he designed the sculpture and suggested it to LEGO as part of his LEGOLAND portfolio. "I was certain I could make it, otherwise I would not have suggested it," he said. "I was also sure it would create attention for LEGOLAND." Over a two-year period, during which Richter worked intensively on it for one year, he mapped out the giant sculpture and beavered away in his barn in Norway. "The base was a rendering/design on 'knot' paper where every knot is mathematically shown preprinted on huge sheets of paper," he explained, of the pre-computer age process. "We had sheets showing the bricks from above and others from the front. The portrait then is sketched on the paper and the dimensions followed that way."

Because of the permanence and outdoor requirements of the sculpture, and its towering size, every single brick was glued. Richter remembers having to wear a mask while working, which he found to be a "handicap" to his sculpting process. It was impossible for him to build proper ventilation into his barn, making the mask mandatory. Despite this hindrance, Richter enjoyed the more general building limitations that the LEGO bricks presented—especially at the time when

the LEGO catalogue of parts was far more restricted than today. "I introduced the modeling of details in spite of the limitations," he said.

When it came to erecting the model on-site, Richter was in charge, and required a ten-strong team to assist him. The six glued sections were transported from his barn to the site at LEGOLAND where building cranes, tractors, and a lift were used to move and lift it into place. "When set up it took another week of LEGO brick modeling, after that it was all sprayed in a sand color." Richter also designed a product system for casting two square meters (twenty-two square feet) of artificial cliff and rocks around the figure, to make it look more realistically embedded into the natural landscape.

After many years of building with millions of bricks, Richter was happy to see Sitting Bull sitting proudly at the park, where he still sits today. "It was a challenge but I was glad to be finished in order to get more time for my important expressions of Gouache paintings, watercolors, and lithographs."

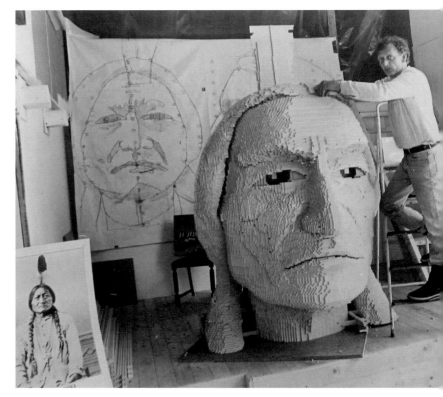

A ladder was required for Richter to reach the top of the model's head—in the background the sketched plans for the face can be seen. © Bjørn Richter

SUPER STUDS

No one is more surprised about the Sitting Bull sculpture's longevity than its creator. "I am surprised the monuments are still there and still popular," Richter said. "It is amazing that they could stand winter, frost, sun, and heat and cold that long." Richter credits the model's long-lasting lustre to the fresh coat of paint it receives each spring.

THE WALKER

By Jørn Rønnau

FACTFILE

Build location: Denmark
Year completed: 1989
Time taken: Four months
LEGO elements used: More than 100,000

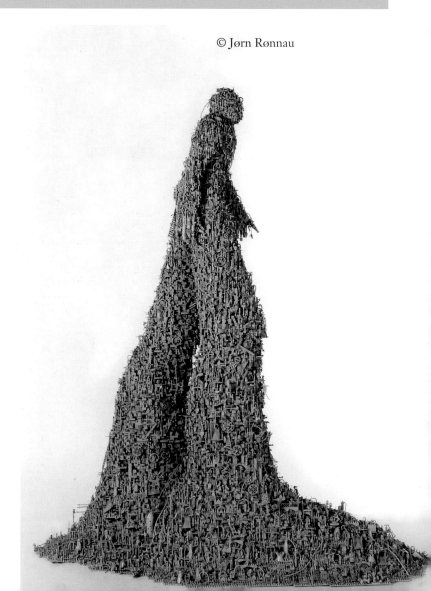

© Jørn Rønnau

WHAT IS IT?

At a distance, you'd be forgiven for thinking Jørn Rønnau's The Walker was made from a futuristic mechanical mud—the humanesque figure appears to be dripping in the stuff down to his feet that merge into a murky muddle of texture and shade. Get a little closer, however, and you'll see that the six-foot-tall sculpture is built in its entirety from LEGO elements. Some 120,000 tiny gray LEGO shovels, LEGO levers, LEGO propellers, LEGO flagpoles, and LEGO tubes (to mention a few of the parts used) obscure the core of LEGO bricks, all in gray. The Danish-born artist described the model as "a person—half boy, half adult, and half human, half robot. As

© Jørn Rønnau

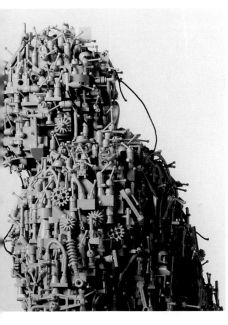

high as a man, with big legs and even bigger feet, stuck more or less to the ground." Built in 1989 as part of a traveling exhibition of LEGO sculptures, the artwork encourages questions about progress and humanity. "The title, The Walker, is ironic," said Rønnau, "because he does not seem to be able to, stuck as he appears in mud, or waste, or mechanical junk. And he is himself contaminated or made from that same junk."

MEET THE MAKER

Jørn Rønnau lives in Aarhus in his native Denmark, where he works as an artist. While The Walker is made from LEGO parts, Rønnau does not specialize in LEGO works like other artists in this book. The majority of his more recent sculptures are made from wood and other natural materials. That doesn't mean he's not a fan though. "To me, LEGO is the ultimate creative toy for children," he said. "Getting the unique opportunity to build a fine art sculpture in my favorite childhood material was a dream come true, but as a sculptor working with nature and organic forms I hesitated for a while." While he may have experienced some trepidation at the start, Rønnau's The Walker has been an inspiration to other model builders since its creation, and even spawned a lesser-known younger brother. "I have made one more sculpture out of LEGO," Rønnau said. "A commission from LEGO for an international traveling art exhibition for children. The sculpture—*The Discoverer*—was smaller (like a twelve-year-old boy) and not as stuck to the ground as The Walker. Very special too, in its own right."

THE PROJECT

"This is not a LEGO model, it is an artwork made of LEGO, and art appeals more than any model, because it is poetic, meaning open to interpretation," said Jørn Rønnau about the appeal of his sculpture, The Walker, which was built as part of a traveling LEGO exhibit called *Homo Futurus*.

Due to the contemporary nature of LEGO products, the artwork's aesthetic seems as relevant today as it did when it was first conceived over two decades ago. To create such a successful and resonating work, Rønnau insisted that the creation needed to look as natural as possible. "I did not want to make a kind of 'digitalized' form, with only horizontal and vertical lines," he said. "I had to try to achieve the impossible: creating an organic form out of LEGO." The traditional LEGO colors provided the initial stumbling block—LEGO red, blue, and yellow are far from the organic tones the artist was familiar with—believing that these bright, unnatural shades could undermine the form of the sculpture, he decide to use only gray elements. "Much to my luck it turned out that the gray bricks were the ones with the highest number of different special bricks," he said. "Exactly what I needed to soften the inherent digital expression."

After successfully testing his idea to incorporate special LEGO elements to give the sculpture a more organic feel, and producing sketches and small modeling clay creations to arrive at the desired form, Rønnau was able to start on the fun part—building the thing from the ground up much in the way he was used to, "as I would a figurative sculpture in a traditional material, like clay or plaster—trusting my acquired sculptural knowledge of this special human figure."

"From being a vision in my head, the sculpture simply came into existence through an intense creative process, interrupted from time to time by considerations and further studies and detailed sketching," Rønnau continued. "That process of creation is the most exhilarating and rewarding thing, and ultimately the very reason why I am a sculptor." While it is an artwork, rather than a LEGO model in the traditional sense, the artist still employed the "proper LEGO building principles" familiar to all LEGO fans. And for added security, he glued the bricks together using the same

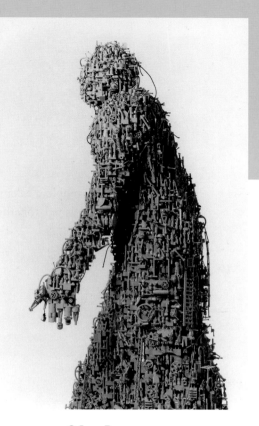

© Jørn Rønnau

KEEP BUILDING

Inspired by Jørn Rønnau's The Walker? Wait until you see the rest of his portfolio! Enjoy more works by the sculptor at www.ronnau.dk.

method employed by LEGO Master Model Builders.

Lots of the work's innovative creative surface—a technique akin to the "greeble" texturing applied to lots of other models, especially of the sci-fi ilk—can be credited to Rønnau's son Anders. Just fifteen at the time, he helped his father develop different ways to incorporate the special LEGO elements. But despite his son's efforts, Rønnau admits a feeling of "complete exhaustion" when the artwork was finished, together with "a deep feeling of fulfillment."

The model joined a host of other sculptures by other artists for the exhibition and toured museums and galleries across Europe. The sculpture received what Rønnau described as a "very positive" reaction. "One of the finest reactions came from the developers and model builders at the LEGO factory. It was their absolute favorite, but they also joked about the impossibility of making a LEGO manual on how to build a copy of the sculpture!" The sculptures were later acquired by the LEGO Group. "As far as I know only my sculpture is still in existence," said Rønnau. He recently restored The Walker and its base for the LEGO company and it is now part of a permanent display of TLG's history at the Idea House in Billund, Denmark. He said, "It stands out at the end as a highlight of creative LEGO achievements."

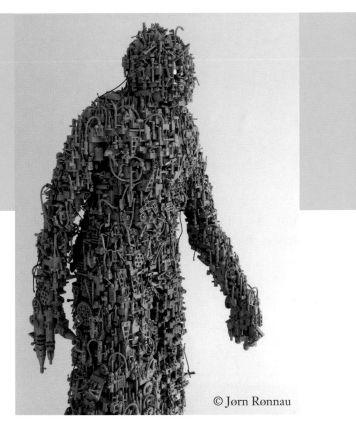

© Jørn Rønnau

SUPER STUDS

"As a sculptor I have a lifelong dream of making a completely new contribution to the ultimate sculpture through history, namely the human figure," said Rønnau. He saw the opportunity to build this sculpture from LEGO as a chance to create a human figure with a contemporary material the likes of which had never been seen before. "I created a man stuck in a universal human situation. Stuck but wanting to move forward against all odds . . . Will he succeed?" The sculpture also holds a certain private relevance to the artist. "Personally at that time, my family and I were going through hard times, because I was getting divorced. So it is also to some extent a self-portrait."

I Build, Therefore I Am

"It's a great feeling to see others enjoy my creations as much as I have admired all those who came before me. My motto is: 'Just keep building!'"

Carlyle Livingston II, Adult Fan of LEGO

"I always get the biggest kick from that simple nod or wink that I get from other builders," said Los Angeles–based AFOL (Adult Fan of LEGO) Bryce McGlone. "That one nod says the world. There's a connection between builders: a mix of respect and competition. It's one LEGO fan acknowledging the work, frustration, and diligence that is LEGO building. It's that mutual respect that I appreciate the most."

The simple pleasure McGlone receives from sharing his LEGO creations with fellow fans, a universal clan of adults bound by their appreciation of the brick, is a sentiment shared by the majority of builders featured in this book, and thousands of the ones who aren't. The LEGO Group's (TLG) adult fans make up five percent of the company's total revenue—a figure which has shown to be steadily increasing annually. And in 2010, executives at LEGO believed there were about forty thousand adult LEGO fans worldwide.

One need spend just a few minutes browsing LEGO-related groups on www.Flickr.com or the slightly archaic www.Brickshelf.com or www.MOCpages.com to appreciate the prolific nature of these adult builders—not for them a passing fad they will grow out of when they reach puberty. That time is long gone, and they are dedicated disciples of the brick with portfolios of MOCs (My

AFOL Bryce McGlone repositioning his H. R. Giger model for a photo shoot to show it off to the fan community.
© Bryce McGlone

Own Creations) that would blow most childish feats out of the water.

The term AFOL first emerged in 1995 on a LEGO Usenet group, at a time when LEGO fans were starting to reach out to each other across the virtual abyss— previously enjoying their hobby in isolation, many fans began to realize that they weren't an anomaly, and that they weren't alone. "In my twenties I was starting to collect other toys, such as Hot Wheels and action figures," said Vancouver-based AFOL Paul Hetherington, whose return-to-LEGO story is reflective of many others. "Through toy shows and garage sales my collection of LEGO parts and sets started to grow quickly. Very few people were collecting LEGO, so all my toy buddies would bring it to me to trade for other types of toys. Then in 1999 things really started to change. LEGO released the *Star Wars* line, and most people started to get computers, and eBay began to get very popular. All of a sudden there were adults in the LEGO aisles. For the first time you couldn't find certain sets in the stores because they would be sold out. LEGO was now a collectible."

Most AFOLs, however, weren't buying sets with the sole intention of collecting them, and displaying them in their homes. They were buying them like cars and stripping them for parts. "I only build three or four sets a year," said Hetherington, who is an avid collector. "I buy most of the current sets, but never build them. I use the parts to create my own MOCs." Websites such as www.Bricklink.com, founded in 2001, where parts, sets, minifigures, instructions, original packaging, and custom items are bought and sold by fans from all over the world, started popping up revealing a LEGO subculture of sorts—the AFOLs had descended.

Similarly to any serious fandom, LEGO fans were a few leaps ahead of the company, and started their own clubs both online and by region, known as LUGs (LEGO User Groups). "Initially, members put on town and train displays at their local model train shows," said Hetherington. "That was my first experience after I joined the new Vancouver LEGO Club in 2001. I built a large European train station as my contribution to the layout, with platform 9¾ for the Hogwarts Express. (This was

before LEGO made Harry Potter sets.) It was so great to see people's reactions to the huge display that we did. I was hooked, and have been doing shows, and going to conventions ever since."

The birth of the LEGO convention (which is explored in more detail in Chapter Four) finally gave builders real-life forums to exhibit their creations. The details and techniques of their building could be scrutinised up close, and explained in person. With very little in the way of restrictions or requirements, such events served to encourage and celebrate LEGO building in its many guises. Naturally, there has been an increase in the number of AFOLs using their collections to the fullest—building big, and building to impress. Wayne Hussey, the director of Seattle's BrickCon—the largest LEGO convention in the Pacific Northwest of the United States—said he had absolutely noticed an increase in more extreme model building. "In the last few years, it seems that 'building big' is becoming the norm," he said. "Last year, [in 2012], my Display Director—Steven Walker—was commenting that he was having a difficult time figuring where to put them all—we only have so many tables."

Popular culture, science, and geek hobby-related blogs and websites regularly feature such creations, particularly those related to popular sci-fi franchises, computers, and breaking records. But building on this scale is not for everyone—especially with the space required and the costs involved as Joe Meno, editor of LEGO fan magazine *Brick Journal*, explained. "There have been a growing number of large-scale builders, mostly in Europe," he said. "In the United States, most of the large models come from groups (train layouts, mostly); the few US large-scale builders create skyscrapers and landmarks. The biggest reason for this is simple logistics. Since the LEGO Group is based in Denmark, it's a lot easier to order and ship parts to other Europeans. Access to the

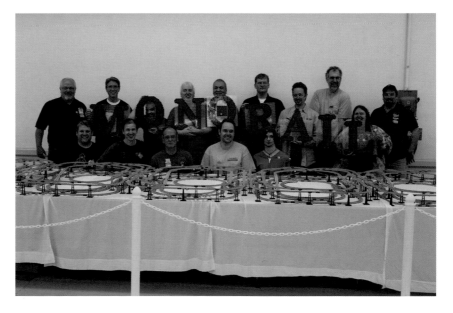

The New England LEGO Users Group (NELUG) at BrickFair NE in 2013 with their record-breaking LEGO monorail.

company is a bit easier too, as the community is a bit closer with the LEGO Group in Europe than in the United States." He also cites the architecture of European cities as being inspirational fodder for LEGO builders, the likes of which is less prevalent in the United States. "Modern architecture is rather simple—glass and concrete. That's not as inspiring as a city block in Hamburg, for example."

The main prerequisite of building big, however, is having a lot of bricks. While for those building on a small-scale parts are contained within a confined workspace or individual shelving unit, extreme builders can dedicate entire rooms in their home or garages to their hobby—storing bricks methodically in ceiling-high units, all the parts they need easily accessible (or a few clicks away online). Of course space is also essential for the building of such a creation. When Ed Diment took on the USS Intrepid (see page 42) his regular-sized family home only just provided the requisite space. "There was the issue of where to put completed sections once the model was built," he said. "These ended up dotted around rooms all over the house. The only room we could test fit the model was my conservatory, which it filled completely."

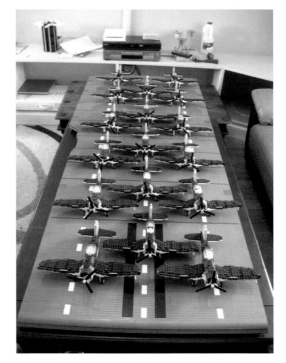

A hobby like this takes time and commitment—here is the fleet of F4U Corsair fighter aircraft—just some of the highly detailed elements that accompany Ed Diment's USS Intrepid model. © Ed Diment

Inspiration can strike LEGO builders from anywhere—from their favorite TV show, as in the case of sci-fi fan Garry King (see page 48) whose love of all things *Battlestar Galactica* has resulted in a number of extreme spacecraft builds, or the way they feel—many of "Brick Artist" Nathan Sawaya's sculptural works are the result of emotional and ideological expression, particularly Gray (featured on page 227). But on the whole, the love of building and using LEGO bricks in a variety of ways is paramount. This was summed up by Master Model Builder Gary McIntire when he said, "With each scale whether it's microscale, minifigure scale, Miniland scale, life-size, or larger-than-life, different elements become different things. A minifigure head is a person's head in one scale and it could be a basketball at another scale, or even a baseball; it could be an entire building at micro-scale, or it could be the iris in an eye at life-size scale, so it's cool to see how the pieces change in their use and what they actually are as you go from one size to another."

The LEGO community has proved itself an essential component of the wider LEGO machine—through LEGO fans' persistence they have seen AFOLs go from being ignored by the company, to being a thriving part of it, contributing thoughts and ideas through the LEGO Ambassador Program and being responsible for the design of sets through LEGO CUUSOO.

In 2012 there were eighty-eight members of the LEGO Ambassador Group, from thirty different countries, including as far-reaching destinations as Thailand, Slovenia, Brazil, and Canada. Of those members, twenty-six were representatives from the United States. The community-based volunteer program is made up of members of LUGs from all over the world, who communicate directly with the LEGO Community Team. According to TLG's website, "The mission of the LEGO Ambassadors is to work together with the LEGO Group in all areas which concern the worldwide LEGO community and be the voice of their respective LEGO User Group towards the LEGO Group." For five years Steve Witt worked as a Community Relations Coordinator for TLG in North America, and managed the LEGO Ambassador Program. "I helped with community events, club building, and online accessibility for fans to a member of the LEGO Group," he said. "I also worked with the internal marketing and design teams to help build strong fan-friendly product lines."

LEGO CUUSOO is a website started by Japanese company CUUSOO. Launched worldwide in April 2011, it offers users the chance to upload their ideas—be they sketches, computer designs, or actual models—that they would like to see become real LEGO products. Other users can view their ideas and show their support for the ideas and creations they love. If an idea receives ten thousand

Dirk Van Haesbroeck having a great time working on his record-breaking Mario model.
© Dirk Van Haesbroeck

fans, then the company agrees to pass it onto the LEGO Group for review, with a chance of becoming a real product. Examples of products that emerged from CUUSOO include an asteroid exploration spacecraft and a set based on the popular Minecraft video game.

Developments such as these, which have occurred fairly recently in the life of the AFOL community, have challenged hobbyist builders to showcase the best of their work and to come up with innovative ideas and new building techniques, the likes of which even professional builders—often working on behalf of clients—find it hard to match. "Generally speaking, but while not always the case, the fan community tends to focus on raising the bar, namely, improving the caliber of what is created," said LEGO Certified Professional Dan Parker, "and there is some amazing work being done as people pursue their interests in LEGO circles."

Innovative and inspirational it may be, but big building is time-consuming even for the most avid LEGO fan, especially when there's a full-time job and a family to consider. "I think about building with LEGO every day," said Paul Hetherington, "but will really only sit down once or twice a year to build some kind of large project, when there is a convention or a local show coming up." And he's not the only one. Projects on this scale require a highly involved, long-term commitment, as Alice Finch discovered when she set about building the entire Hogwarts campus from Harry Potter over an eighteen-month period. "My husband would often stay up with me, not to build, but to read aloud to me," she said. "It was good to have his company but also because I could ask if a technique I was using was working well or not." Finch built the bulk of the school late into the night

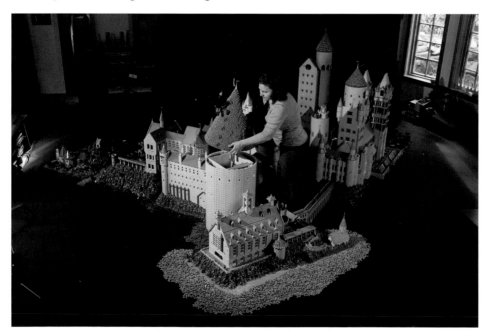

Alice Finch positioning one of the turrets on her giant Harry Potter Hogwarts model in her home. © Alice Finch

34

after her two sons had gone to bed, but the model was truly a family affair. "My boys also helped a bit here and there: my older son has a good feel for how to arrange minifigs in a scene and he populated many of the classrooms with hundreds of students. My younger son added a few bricks to walls and built a few shrubs for me that are charmingly wobbly. He also tested the tunnel down to the Chamber of Secrets almost on a daily basis to make sure it still worked!"

Not all AFOLs have kids of their own, or build with kids, which still raises some eyebrows in certain social circles. "Standing next to a model as tall as yourself, which you built by yourself is incredibly satisfying," said Belgian builder Dirk Van Haesbroeck. "Observe it long enough and it comes alive to drag you into its world. And bragging rights about being the unofficial world record holder [for the world's largest LEGO Super Mario] are a nice bonus. Until you go on a date with a woman—best not to bring this up first." While Kyle Ugone—a US Marine who is the current world record holder of the largest private collection of complete LEGO sets—reckons LEGO toys carry a cool nostalgia that most people appreciate. "LEGOs are kind of weird," he told the *Yuma Sun*'s Chris McDaniel. "It is a childhood toy everyone kind of respects when they get older. If you say you have a bunch of LEGOs, they say, 'Oh that's cool. Can I come see them?'" And according to *Brick Journal*'s Joe Meno, the promotion of AFOL from geek hobby status to noble and revered artistic medium is closer than you might think. "That day is coming," he said, "but it will take the courage of some builders to go beyond the literal modeling that is happening now. It is beginning to happen—a great example of an artistic work is Nathan Sawaya's hanging mosaic of John Lennon's portrait sketch. The model is only the line work, so the sketch is suspended in air, making the sketch magically float in space. It's going to take a person who looks beyond the possibilities of LEGO building to model reality, to the possibilities of LEGO building to *create* reality."

Until that day, most extreme builders are happy to work hard on their models and make the most of sharing them with an appreciative audience. "The best thing is to see the reactions at the shows where we have displayed the model," said Washington AFOL Carlyle Livingston II. "It makes all the time, effort, and cost worthwhile when I see a kid's eyes light up and point to the model while exclaiming excitedly to their parents, 'Look, the Batcave!'"

Through his community relations work, Steve Witt is someone who has more experience than most fraternizing with AFOLs across North America. When asked to describe the culture and nature of those who make up this creative construction phenomenon, he said, "That's hard because it requires me to pigeonhole the group. The LEGO community is made up of such drastically different people from all different walks of life that I couldn't begin to narrow them down. The LEGO hobby is so keyed to the individual and one's own creativity that coming together creates just a massive mishmash of ideas that no one could ever develop alone. The neat thing about the community isn't that we're all so similar, it's that we're all so different, and we just happened to pick building as our way of spending our passion."

HOGWARTS SCHOOL OF WITCHCRAFT AND WIZARDRY

By Alice Finch

FACTFILE

Build location: Seattle, Washington
Year completed: 2012
Time taken: Twelve months of building over an eighteen-month period
LEGO elements used: 400,000, give or take a few!

© Alice Finch

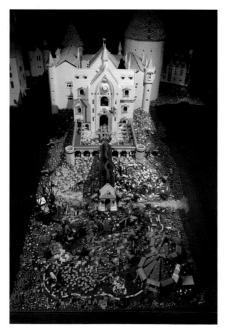

WHAT IS IT?

In Alice Finch's own words, "Hogwarts is unique, not just because of its enormous scale or the sheer number of bricks. What makes it extreme is perhaps the amount of detail that has been included: a complete castle with all the proper towers, turrets, fenestration in correct locations, classrooms full of students telling the story of a particular moment, down to the tiniest of moments, such as the handlebar of the tricycle that Grawp offered to Hermione. I've included as many scenes and locations from the books as I could and I think that is what people have enjoyed the most." Approximately 250 minifigures populate the architecturally accurate model of Hogwarts School of Witchcraft and Wizardry from J. K. Rowling's bestselling series and Warner Bros. film adaptations.

Finch was inspired by her visits to Oxford, England, where her brother attended college, after feeling unsatisfied with the size of the original Great Hall in TLG's first edition set of Hogwarts. "After I built the set, I knew that I needed to build my own Great Hall full of the wood paneling, a high table, a dramatic timber-framed ceiling, and four long tables with benches. Once I started laying out the bricks I quickly realized that this was going to be quite a bit bigger than the set. It was important that it have a

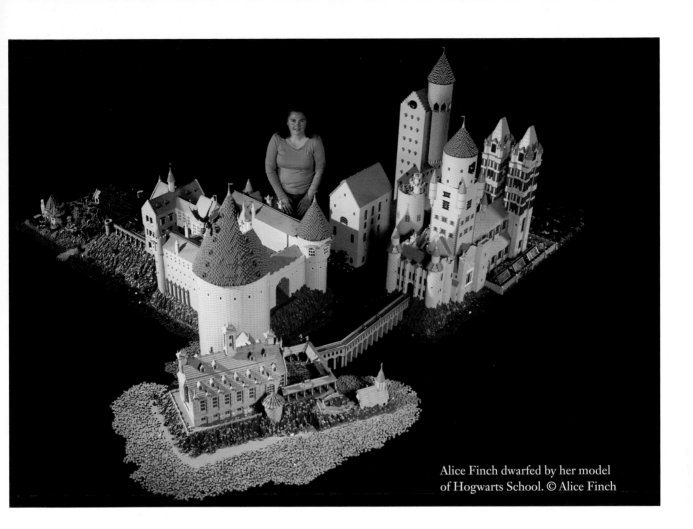

Alice Finch dwarfed by her model of Hogwarts School. © Alice Finch

high level of interior and exterior architectural detail, but the space needed to be accessible so that my son could actually play in the space and have his own Hogwarts adventures."

MEET THE MAKER

Although she had built basic house and farm models as a child, populated by old DUPLO figures and animals, it wasn't until her oldest son started developing an appreciation for more complex LEGO sets in 2009, that Alice Finch returned to building, inspired by his creations. She snapped up some Harry Potter sets, and began using the parts to build her own models—she's now also a fan of *The Lord of the Rings* and *The Hobbit* themes. "I am interested in anything that has striking architectural techniques or details, and sometimes that includes sets that are great for parts even if they don't include any buildings themselves."

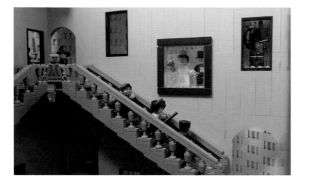
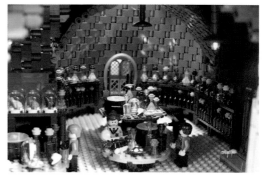

Her love and knowledge of the Harry Potter books and film series enabled Finch to accurately depict moments from the stories using LEGO minifigures. © Alice Finch

She has since joined Seattle's SEALUG community, and has been pleasantly surprised by the warm welcome. "When I was contemplating how I was going to move and set up Hogwarts at Emerald City Comic Con, I had a dozen different people volunteer to help haul it, set it up, and at the end, break it down, and haul it back. It was amazing to have so many people willing to just help out," she said.

A teacher by trade, Finch is a builder at heart, nurtured by her general contractor father. "I grew up around house plans and the philosophy that you can be creative and build from all kinds of materials. It is a tradition in my family to build gingerbread houses for neighbors and friends, and when I was in high school, I took this to the next level by building Chartres Cathedral, complete with flying buttresses, and St. Basil's Cathedral with radiating onion domes. . . . And when I was a teacher, I built curriculum from the ground up. So no matter what the medium is, I tend to build things."

Carefully positioned doors provide accessibility to playable scenes and spaces for Finch's children.
© Alice Finch

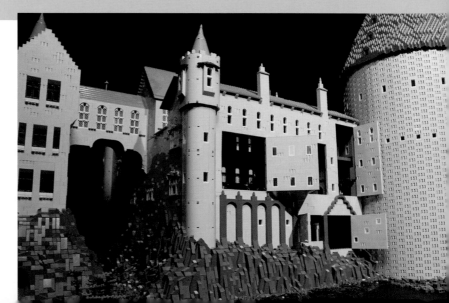

Finch used up boxes of blue, gray, and brown 1 x 2 bricks to help soften the model's edges.
© Alice Finch

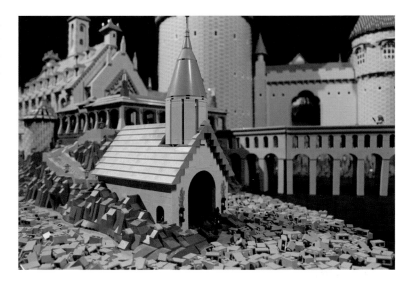

THE PROJECT

Finch's completed L-shaped Hogwarts measures thirteen feet in two directions. It's huge. No wonder then that the planning of such a beast was a mission in itself. Finch did more than her due diligence, referencing the books, the films, behind-the-scenes materials, and even taking in the Harry Potter studio tour in London. "The more research I did, the more I found that the book and movies didn't align, so I had to choose what worked best," she said. "Other than the location of classrooms and architectural features of the building exteriors, I

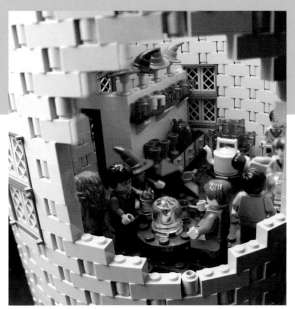

© Alice Finch

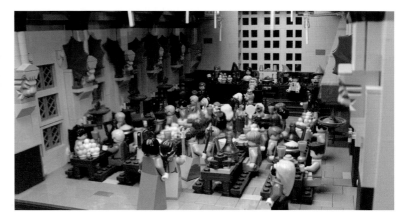

Finch's take on the Great Hall at Hogwarts—a rather more dramatic interpretation than the original LEGO set. © Alice Finch

spent a lot of time researching individual scenes and features that I thought would make it interesting and identifiable. . . . I also collected pieces for other details like the slide projector that Snape used in Lupin's class, or the rows of snake statues in the Chamber of Secrets."

Essential for the mobility of the model was the planning out of how each building would fit onto the base plates. "There are basically three sections of the castle," Finch explained, "the center, the right, and the left. Before I built anything, each side had to be completely planned out with the outlines of the buildings on base plates, which was quite a bit more challenging than it might sound. When you are dealing with twenty or more base plates at a time and multiple buildings that need to separate in convenient but not conspicuous places, it takes lots of shifting and resizing to make it work."

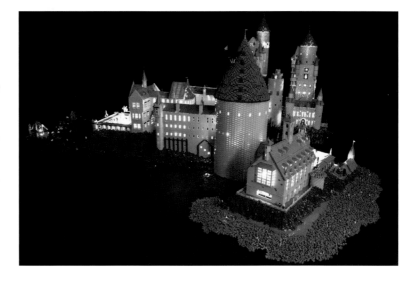

Let there be light! The model is filled with lights to add realism and to improve visibility in smaller spaces. © Alice Finch

The majority of the building work took place late at night over the five-month period leading up to BrickCon 2012, where the model was due to be displayed. In her family's LEGO room, Finch alternated working on different parts of the structure, switching from the right side to the left. She was careful to take into account the accessibility of each part of the build for maximum viewing and playability. "Almost everything was an enclosed space, and as I built I experimented with different types of lights and what worked better in different situations." This included the use of battery-powered Christmas lights and push-button lights, both manual and remote-controlled.

"One of the techniques that I am the most excited about is from the Defense Against the Dark Arts class. The design of that room is very unique—the tall windows alternating with wood paneling and sharply angled beams were key to making it look right. When I started experimenting with brown minifigure legs I knew I had it. I could spread the legs and get the alternating pattern of the beams *and* get just the right angle. I ordered up one hundred legs and got to work. It is so subtle that most people don't even see them, but there are legs used at three different levels to get the timber framing to look just like the movie set."

After intensely involving herself in the build for such a long period, Finch said she had no idea how Hogwarts would be received beyond astonishment at its size. "The reception at BrickCon 2012 was pretty overwhelming. After two days of interacting with my fellow builders and thousands of public viewers, I was practically levitating. I came home with both of the big awards—People's Choice and Best of Show—which I'm pretty sure hasn't been done before."

After a rigorous four-day photo shoot in her front room, she was finally ready to unleash LEGO Hogwarts on the wider world. "I was aware of the potential for it to go viral, but I have been completely overwhelmed by the global response," she said. "Six million views of my Flickr pictures, press requests from a dozen different countries, being recognized by strangers who then want my autograph, and more emails than I can keep up with. It has been extremely exciting and exhausting at the same time."

SUPER STUDS

"If all of the doors and panels are closed, you might not even notice that there are internal spaces that are fully detailed and meant to be played with," said Finch. "For example, a large and a small rock panel hide the Chamber of Secrets. The small panel gives access to the bone bed at the bottom of the tunnel from Moaning Myrtle's bathroom (and yes the tunnel is fully functional from the opening sink panel). The large panel reveals a rounded tunnel bottom with circular openings so that you can play the scene with the blinded basilisk seeking Harry. This tunnel section also lifts out so that you have full access to the Chamber, its stone statues, Tom Riddle, Ginny, the journal, and the ladder from the chamber door."

USS INTREPID

By Ed Diment

With help from Anne Diment and Ralph Savelsberg

FACTFILE

Build location: Built in Diment's house in Waterlooville, United Kingdom, the model now resides aboard the real USS *Intrepid*, which is permanently moored on the Hudson River in New York City.

Year completed: 2010

Time taken: Nine months

LEGO elements used: 250,000

WHAT IS IT?

Not content with visiting the US Navy Aircraft Carrier USS *Intrepid* in the steely flesh at its Hudson River mooring in New York City, UK-based AFOL Ed Diment decided to turn his home into a shipyard and build the entire thing from scratch in minifigure scale. One of over twenty Essex-class carriers built for the US Navy during World War Two, USS *Intrepid* served a storied career, and was involved in a number of engagements in the Pacific theatre. After a number of refits, and stints in the Korean and Vietnam wars, she was retired in 1986 and has lived out her days as a museum and National Historic Landmark.

"I was inspired to build the model as I have always been interested in naval vessels and had previously built models of the Royal Navy Type 42 Destroyer HMS *Edinburgh* and the Royal Navy battlecruiser HMS *Hood*," Diment said. "The only option left was to go bigger, which meant an aircraft carrier."

And bigger he certainly went. At approximately twenty-two feet long and weighing in at nearly six hundred pounds, this LEGO carrier is the largest LEGO warship ever made. Diment decided to depict the carrier with the color scheme she would have had in 1945, with a forty-two-strong fleet of accompanying aircrafts com-

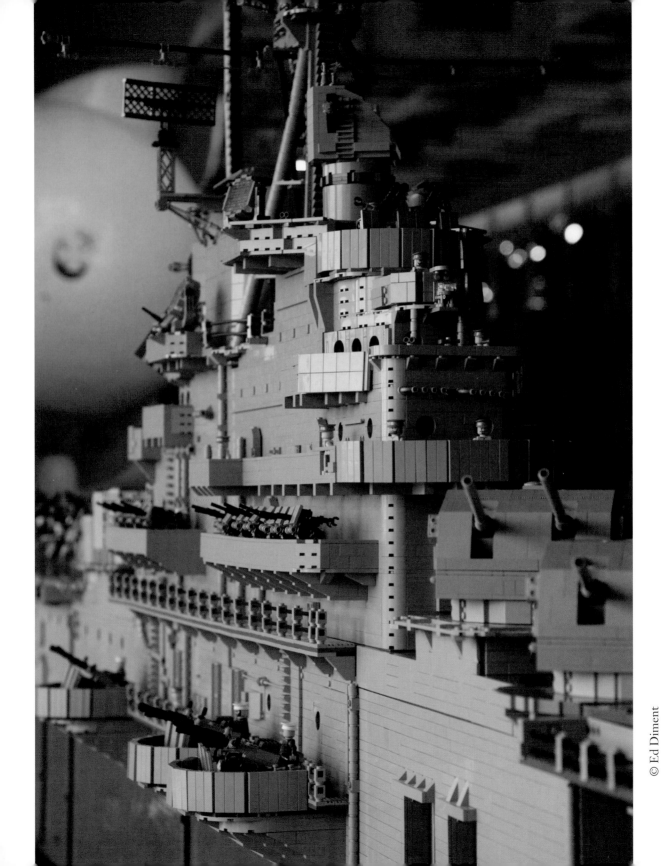

prised of Corsairs, Helldivers, Avengers, and Hellcats. And to keep everything running shipshape? A crew of over two hundred able minifigure seamen of course!

MEET THE MAKER

Unlike many AFOLs who experience an away period from LEGO collecting and building during their teenage years (known as a "dark age"), from the age of two until today, Diment never stopped. He accidentally stumbled across the fan community in 2003, and is now the chairman of the United Kingdom's Brickish Association (the country's AFOL community group).

As well as being hugely active in the LEGO fan community at events and online, Diment is also a professional LEGO artist working with the United Kingdom's only LEGO Certified Professional, Duncan Titmarsh, for their jointly owned company Bright Bricks. The company is responsible for an impressive array of large models (see page 84), a 150,000-piece, half-scale model of a Rolls-Royce Trent 1000 jet engine with a moving fan, compressors, and turbines being one of Diment's favorites. "This was easily the most complex model we've ever built and one of the most complex LEGO models ever made."

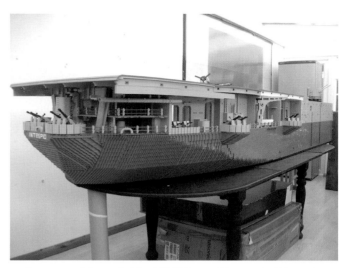

Just part of the unfinished USS Intrepid setup in Diment's home. © Ed Diment

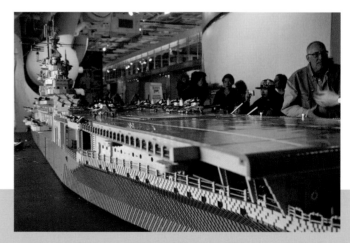

Ed Diment's painstaking attention to detail resulted in a realistic looking vessel of epic proportions. © Ed Diment

THE PROJECT

Approximately two months were spent planning before any building work began on this nautical giant. "I found a great book—*Anatomy of the Ship: USS Intrepid*—which I bought a copy of as it contained large numbers of detailed engineering drawings, photographs, and illustrations," said Diment. "I was able to take a large number of measurements from these and set up a spreadsheet listing all these dimensions in terms of LEGO stud counts (multiples of eight millimeters). This meant each feature of the ship would be in scale and in the correct place." The aircraft, from the brain of fellow builder Ralph Savelsberg, were designed in the same way. Savelsberg then supplied Diment with LEGO CAD file instructions so his wife Annie could assemble the entire fleet with accuracy.

With previous LEGO ship-building experience, the construction itself was a smooth process for Diment, as he explained. "The first trick was to make the hull modular, in six sections, and the deck and all structural elements removable. This enabled it to be transported and handled sensibly. I used a LEGO Technic skeleton to give the model strength. I also built sub elements in a replicable fashion (such as gun turrets, boats, and cranes). Finally, I moved from one thing to another to keep from getting bored, e.g., building an interesting detailed part as a reward after having built a big slab of hull side."

This model may be big, but it's highly detailed too, and that required Diment to use a number of clever construction techniques, least of all retaining as much gray brick as he could for the visible parts of the ship and building the hidden parts out of a myriad of other colors. "There is a huge amount of SNOT building in the model. This is where elements are mounted

One of the center-deck lifts, which Diment built to be remotely operated, enabling the model aircraft to be carried from the hangar deck to the flight deck. © Ed Diment

Just some of the ship's 200-strong crew in their uniforms. © Ed Diment

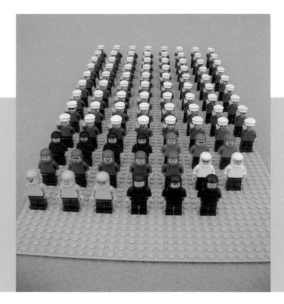

on their side to give more shape options and are held in place by brackets or bricks with studs on the side," he said. "The whole bow shaping is, in fact, made from roof slopes on their side to 'sculpt' the bow shape. The hangar deck is built on large 32 x 32 base plates and effectively 'floats' over the framework not being connected at all."

So smooth was the construction process that Diment's main concern was where to keep it—his conservatory was the only room in the house big enough to display it completed. Looking back on the build, Diment said, "I was and still am extremely proud of the model. It was very hard work, but well worth it in the end. When I first put it up at the show and was finally able to stand a long way back and look at it, I finally appreciated how realistic a model I had been able to achieve."

And the public's reaction has been one of incredulity. "Most people just couldn't believe a private individual could build a model so epic at all, never mind in such a short time-scale," said Diment. His building work also attracted the attention of the Intrepid Sea, Air & Space Museum, which shipped the model to New York to display it in a permanent exhibit. "We spent a week at the museum with the really great staff and even got to meet some veterans who

BRICK BIT

The USS Intrepid is a thing of beauty, but it also has some really cool remote-control capabilities. Diment used LEGO Power Functions infrared remote controlled motors to enable the four five-inch twin gun turrets and the radars aboard the vessel to be remotely rotated, and to make the center-deck lifts capable of carrying a model aircraft to the flight deck.

Tiny LEGO versions of the USS *Intrepid*'s twin five-inch dual-purpose gun mounts.
© Ed Diment

had served on the real ship," Diment said of the experience. "Their compliments and comments on the accuracy of the model meant the most as they had actually lived and breathed the ship in action."

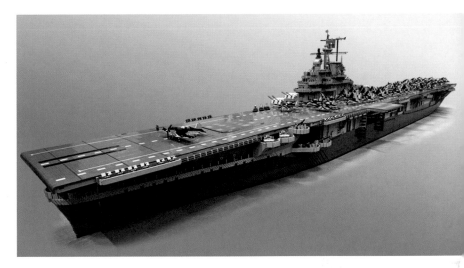

© Ian Greig

SUPER STUDS

"The model has minifigure deck crew in different colors as on real aircraft carriers where each color denotes a different role—purple for fuel, red for weapons, and so on." But Diment's miniature crew weren't the ship's only inhabitants. "During the build one of my cats pretty much took up residence on the hangar deck and used to delight in scaring the pants off me by suddenly sticking its head up through the deck lift opening when I would least expect it!"

EXPERT ADVICE

All aboard mateys! Take a few tips from Captain Diment about how to build beautiful, big ships!

- "Do your homework. Find out as much as you can before you start."
- "Plan properly. Calculate sizes based on your chosen scale—using a spreadsheet is helpful here. Don't only scale the objects such as gun turrets, but scale the spacing between objects. If things get squashed up or spread out it can ruin the whole look of the model."
- "Move from one bit of building to another to maintain momentum. If you have planned properly there should be no need to start at one end and work to the other, you should be able to jump on to any bit you feel like."

KEEP BUILDING

Ed Diment can be found on Flickr (Legomonster) and is chairman of the Brickish Association (www.brickish. org). He is also codirector of Bright Bricks (www. bright-bricks.com).

BATTLESTAR BERZERK

By Garry King

FACTFILE

Build location: Tasmania, Australia
Year completed: 2011
Time taken: 336 hours over two months
LEGO elements used: 20,892

WHAT IS IT?

With its colorful assortment of sci-fi ships, TV's *Battlestar Galactica*—both the original 1978 series and the re-imagined 2000s show and TV movies—provides endless inspiration for Tasmania's Garry King. Known in the AFOL-verse for his collection of large-scale models based on those seen in the franchise's various facets, King originally started building his own sci-fi creations as a teenager when he couldn't afford collectible models available in the shops.

Battlestar *Berzerk* is a Colonial support ship that featured briefly in the television movie *Battlestar Galactica: Razor*. King described it as "one of the hardest builds [I'd made] at that time as it has a rounded bow section, thin neck, bulky midsection, thin

rear with four very large engines, and boosters at the rear." The dimensions for the mammoth model are 6.1 feet (1.86 meters) long, twenty-four inches (sixty-one centimeters) wide, and nearly fourteen inches (thirty-five centimeters) high. And it weighs in at a hefty 52.4 pounds. In the TV series, most of the Battlestar ships were gray with a splash of reds, but King went a different route, choosing to build in white and dark red, adding other color elements for effect and a retro feel. The abundance of white and chrome cannons make for a shiny addition.

© Garry King

MEET THE MAKER

Born and raised in Hawthorn, Victoria, in Australia, Garry King has worked as a builder, designer, and "all things to do with houses" over the years. He sees LEGO building as an instinctive natural extension of his profession; a creative outlet and means of expressing himself. In his home, now in Tasmania, he has a dedicated, purpose-built LEGO room where he spends up to six hours a night working on his models—either building or on his computer editing images to share online.

His childhood love of space and sci-fi was inspired by his first Classic Space LEGO model—set 924—which his mother bought for him. He caught the LEGO-collecting bug again as an adult in 1996, which was fueled by the 1999 release of LEGO *Star Wars* sets. King now has over two million LEGO elements, which he incorporates into his elaborate *Battlestar Galactica* spaceships—although, he admits, "I still seem not to have the elements I need to do a build."

King is dedicated to his art, aiming to build at least six new models each year. His ultimate LEGO goal is to create a thirty-three-foot-long version of the show's titular craft, and to show it off in a museum dedicated to his two passions—LEGO bricks and *Battlestar Galactica*.

BRICK BIT

When King moved from mainland Australia to Tasmania, he took his vast LEGO collection with him. "I was surprised by just how much LEGO I had," he said. "Sixteen fifty-five-liter [14.5-gallon] containers, and even more five-liter [1.3-gallon] containers. And that was only the first trip. I had another six fifty-five-liter containers. I am still purchasing thousands upon thousands of elements as I come up with a new idea." That is a whole lot of LEGO.

THE PROJECT

After purchasing thousands of new LEGO elements specifically for his Berzerk build, watching *Battlestar Galactica: Razor* for inspiration, and studying an eight-inch resin model of the ship, King started out as he always does with, as he calls it, "the head of the beast." Working from the front first, he is then able to estimate the overall size of the model and the best method to use. He redesigned the ship's bow a number of times to create the striking curvature of the finished model.

For the framework of the ship's neck, body, and rear section King relied heavily on the use of Technic elements, finishing off the outer shell with LEGO plates for a smooth finish. During the build he flipped the growing model over a number of times to ensure the undercarriage looked as realistic as possible. The real challenge came when he had to join the complex engine system to the bulk of the model. With the half-completed engines partly attached

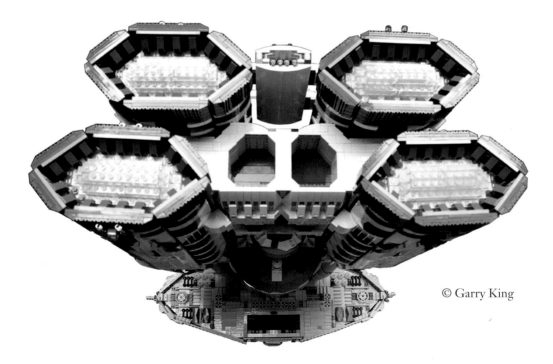

© Garry King

50

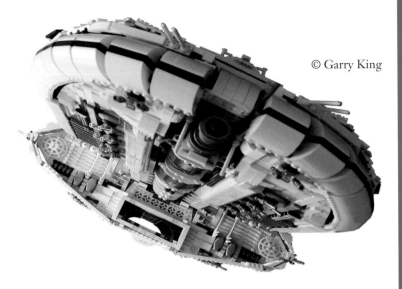

© Garry King

KEEP BUILDING
Find more of Garry King's brick-baffling ships on MOCpages (www. mocpages.com/home.php/ 39677) and Brickshelf (www.brickshelf.com/ cgi-bin/gallery.cgi?m= appollo)

using a fork-shaped LEGO support, he used further supports to hold the ship off the work bench so he could add more details. "It was looking great," he said. "So the next step for me was to see if the ship could support itself. I removed the front supports from the bow . . . no movement . . . then the supports from the rear . . . and there was a slight dip." When King returned in the morning, he found somewhat of a twisted mess where the engines had snapped off, which led him to rethink the design, incorporating a timber and steel support system to take the weight of the model.

After completion, he took over 300 photographs of the model to capture his many hours of hard work. Because of the remote location of his home, and the cost of shipping models, King has yet to exhibit at any conventions, but makes sure the world gets to share in his creations online. The ship survived for several months, before the pieces were salvaged for King's next build—the Battlestar *Valkyrie*.

SUPER STUDS

"It was a very proud moment when it was completed, after all the hassles," King said of his Berzerk-building journey. Looking back, he wishes that the model could have been constructed completely from LEGO, rather than requiring the wood/steel support, but he admits this is one part of the ship he is also most proud of. "I feel that one of the unique sections of this build would have to be the construction of the bow and the join between the hull and the engines," he said. And the work paid off—King received an email from the designer of the film's model congratulating him for creating the ship out of LEGO.

H. R. GIGER'S LI II
By Bryce McGlone, a.k.a. Cajun

FACTFILE

Build location: Los Angeles, California
Year completed: 2008
Time taken: 200+ hours
LEGO elements used: 15,000

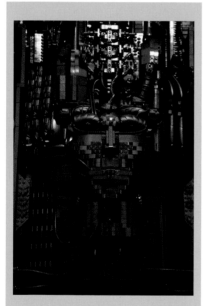

© Bryce McGlone

WHAT IS IT?

Bryce McGlone's LEGO interpretation of H. R. Giger's 1974 painting *Li II*, is a monochrome master class that delivers on scale, detail, and accuracy. "Li" refers to Li Tobler, a Swiss actress who had a relationship with the surrealist artist, who is probably most famous for the design and visual effects work he did on Ridley Scott's *Alien*. The painting that inspired this sculpture is one of Giger's better known, and its haunting face is the element McGlone was most hoping to capture with this model. "I purposely steered away from more easy solutions with LEGO and tried to mesh parts not often used," he said. "More than anything I wanted to get the blank, other worldly expression of *Li II* correct."

"I have always loved Giger's work," he said. "He paints dark, biomechanical landscapes, designs, and various other things. . . . I've always wanted to make something using LEGO with the same organic dark textures that Giger uses. I was looking at some of Giger's art and had decided to create one of his paintings in LEGO." The decision of which to go with was made simple by a 3D model of *Li II* produced by McFarlane Toys in 2004. "Because this was already 3D I decided to go for it."

McGlone's homage to the surrealist Swiss artist measures over three feet tall, two feet wide, and nearly a foot deep in all-black LEGO goodness. "On a purely conceptual level it's interesting that the art piece was 2D, created in 3D, re-created in 3D with LEGO

using 2D pictures, and finally shown on the Internet in 2D again, but maybe I just over-think too much." Talk about surreal!

MEET THE MAKER

"I built LEGO as a child. It was my favorite toy, hands down," Hawaiian-born Bryce McGlone said. "I began building again in 1999. The AFOL thing was just picking up and then exploded. I've just rode the wave. I've met people from all over the world. I get to build for money as well, which is pure bliss. It's been a good ride."

McGlone, who now works as an operations manager in post-production, moved to Los Angeles when he was four and still lives there. The city's LEGO community—LUGOLA—is fairly informal, but is well-subscribed. "It's always been a good support group," he said. "I'm not very active in the community and haven't been for a few years. I own Bumpy Brick Logos and build commissioned projects. For the past

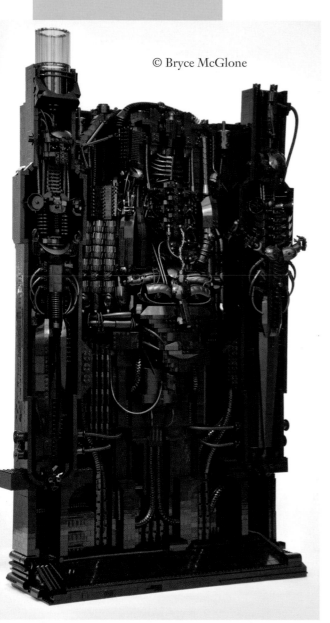

© Bryce McGlone

BRICK BIT

McGlone built two models that featured in different episodes of *The Sarah Connor Chronicles*: a volcano and a tower comprising of 30,000 pieces.

© Bryce McGlone

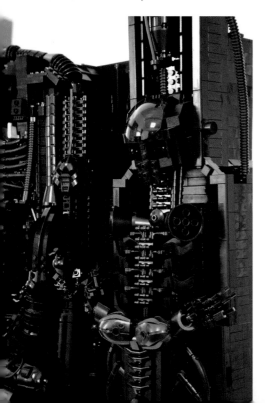

several years I seem to get a new project every time I gear up to 'free build.'"

McGlone is a huge fan of Mecha building ("big Japanese-inspired robots"). "I never get bored of looking at other people's LEGO Mecha creations. I also really like spaceships, though I don't build them often the 'space guys' are some of my favorite builders."

THE PROJECT

Despite being inspired by the McFarlane Toys release of the Giger painting as a 3D model, McGlone was unable to get his hands on one to use for reference. Instead, he received help from a Swedish Flickr member, who had taken photographs of the model and uploaded them. "From these pictures I was able to build the LEGO version," he said. "Sometimes I would ask for a close-up or more light on an area. He was very good about sending more pictures. By the end of the project I had over 100MB of reference pictures."

He then spent a few weeks drawing and thinking of suitable parts to create the model's unusual shapes and details. "I mapped the project somewhat on LEGO graph paper. I also had to draw out areas using the pictures as a reference. The majority of the connections and fitting was done using just bricks. . . . I used the pictures mentioned above and the stock shots on McFarlane's website. I also looked at pictures of the actual painting online."

Despite having ample reference materials, recreating a work of art was as difficult as it looks. "This build was not a smooth process. Many of the techniques were new, though considered normal by today's standards. Many hours were spent rebuilding areas to make them fit together. . . . Some of the biggest challenges came from not having a 3D reference. On more than one occasion I'd miss some details or scale an area incorrectly. By far the biggest problem was simply not having three hands! That would have been fantastic!"

With only a standard set of hands to help him, McGlone built the model alone in his free time. "On this model I would get up early some days and others would be late nights," he said. "To-

ward the end of larger projects I tend to get obsessed and spend much too much time on them." But fellow AFOL and friend Brandon Griffith did come to his rescue after the finished work took a setback in transit to Seattle where it was going to be displayed. "It was so heavily damaged that I didn't think I'd be able to show it, but Brandon helped rebuild it."

On completing the work, McGlone's reaction was one of elation. "I didn't think I would finish. The model building stalled right above the head area, which was by far the most difficult to make work. I'm still happy with the model. I like to think it stands the test of time, but I'm biased. Building larger projects often takes a toll on me though, so I usually need some recharge time afterwards."

He has displayed the model at BrickCon in Seattle, and at Comic-Con International in San Diego where he spoke on a panel about LEGO building. "It was well received by other AFOLs. . . . When I've shown it publicly most people freak out a bit. Many don't believe it's all LEGO. Most don't know Giger's work. There's this thing we call the 'Holy F' factor. Though not kid-friendly it's when someone sees a creation and you can read their lips even from across the room. That's always been funny to me. I'll admit too that there's a dark side of me that would love to see some poor kid knock it over and BAM! Though I would of course want the reaction video-taped."

SUPER STUDS

© Bryce McGlone

With so many delightful details to choose from, it was tough for McGlone to pick a personal favorite, but he did. "I personally like the old-school space jets running up one side. I like the way they feel all bumpy!" Choosing what size to build this model was completely up to McGlone, and ended up coming down to his selection of a single LEGO element. "The whole model's scale is based on the piece used for the eyebrow: a Rahkshi back." The Rahkshi are armored slug-like creatures in the world of LEGO BIONICLE.

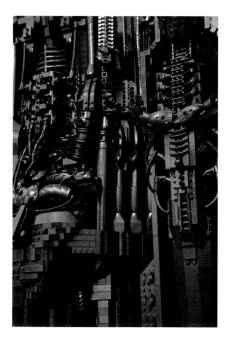

EXPERT ADVICE

Planning on taking on an all-black mind-bending build? Heed McGlone's advice . . .

- "Don't do it unless you are slightly masochistic."
- "Beware, LEGO will consume you."
- "LEGO is *not* a cheap hobby."

HARPSICHORD

By Henry Lim

FACTFILE

Build location: Redondo Beach, California
Year completed: 2002
Time taken: Built over two years
LEGO elements used: Estimated 100,000

Lim's initials appear in LEGO on the harpsichord's casing. © Todd Lehman

WHAT IS IT?

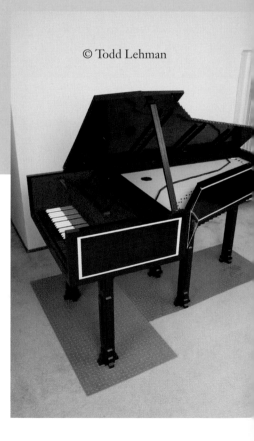

© Todd Lehman

In 2000 Henry Lim set out to fulfill an ambition—to build a musical instrument out of LEGO pieces. "Ideally, I'd have made a piano, but the physics of such would've been impossible in this medium. So I settled for a simpler challenge: a harpsichord." With the exception of the wire strings, this life-size harpsichord is constructed entirely from LEGO parts—everything from the keyboard and jacks to the soundboard, bridge, and legs have been meticulously pieced together from thousands of plastic bricks and pieces. Oh, and not forgetting the fact it's completely playable.

The harpsichord's disposition is 1 x 8' (not to be confused with a 1 x 8 LEGO brick), which means that each note plucks one string in a standard pitch (i.e., middle C on the keyboard corresponds with middle C on other instruments). There are sixty-one playable keys spanning five octaves. The finished instrument still resides in Lim's front room, which is just as well, because moving it would be a challenge—this musical monolith measures approximately six feet by three feet and weighs 150 pounds.

MEET THE MAKER

Henry Lim works at UCLA's Music Library, where he found an array of reference materials for his harpsichord model. "I'm surrounded by music there," he said, "so my building can't escape its inspiration. The university has all sorts of instruments that I can investigate."

Lim is from Los Angeles, and grew up a LEGO fan in the 1970s. "I started playing with LEGO when I was about five years old (back in 1977)," he said. "I came to build as an adult during the *Star Wars* fever of 1999 with a life-size model of Queen Amidala." And if there's anyone who knows how to build big, it's Lim. Not only does his harpsichord occupy a sizeable space in his front room, it's neighbor is a life-size juvenile stegosaurus sculpture (see page 224). Lim explained why building on this scale worked for him. "Besides the idea of many tiny parts making one giant whole, finding solutions to maintain the structural dilemmas that come from building on this scale, within the limitations of LEGO, are what appeal to me."

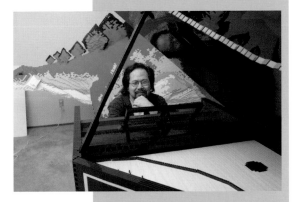

Henry Lim seated at his playable, life-size LEGO harpsichord with his stegosaurus model in the background. © Todd Lehman

© Todd Lehman

THE PROJECT

Lim dedicated around a year to planning this model. Although his construction tactic was "build and hope for the best," he made sure he had a clear understanding of the project. "The important considerations during design were strength, efficiency, and durability," he records on his website. "Anticipating the tension of the strings, the instrument had to be built strong, yet be able to incorporate the functions and mechanisms on a life-size scale. With many moving parts, it also had to withstand the repeated demands of a keyboard instrument."

The keyboard was the first part Lim built, with the continuation of the model dependent on its success, followed by the casing, and then the attachment of the five legs—Lim was helped by fellow builder Eric Harshbarger to lift the half-completed casing onto them. Then the soundboard and wrest plank were constructed later-

ally in relation to the casing, with the bricks' studs facing to the side. Lim writes, "This was done in order to preserve the smoothness of the bricks' sides and to counter the tension of the strings. With this design, as the strings pull they hold the soundboard and wrest plank together rather than ripping them apart if built otherwise."

Lim relied heavily on bulk orders of parts for his build, notably larger-sized bricks (2 x 8 and 1 x 16 bricks), Technic elements, and tile pieces. "Acoustically, the instrument would benefit from being as smooth as possible, so instead of having the standard LEGO studs exposed, I covered them up with tiles," he writes. "Besides the functional studs that align the strings on the bridge and nut, no external stud is untiled. Likewise, the entire unseen floor of the sound chamber is decked with hundreds of 1 x 8 tiles. The end result is as resonant as LEGO will get."

Creating that resonance was a nerve-testing process. "LEGO as a medium holds rather well, not to mention is heavier than hell on a compoundedly large scale. This weight is what holds the parts together and ultimately handles the tension. During stringing, as I cranked the tuning pins, often I'd hear a disturbing creak off in a corner. I'd check the case, soundboard, and wrest plank for faults as there was the fear that the whole thing would implode."

Despite conducting a large amount of research, Lim had some help to make sure the harpsichord would sound as good as it looked. "A friend, who is a musical instrument conservationist, gave me expert advice and mapped out the speaking lengths of the strings (the section that vibrates and produces sound). As well, he selected the wire and taught me how to wind the hitchpin loops."

After putting his extracurricular energy into this creation for two years, Lim's reaction was for him, typical. "Like everything else that I've built, after completion my instinctual reaction is disbelief. . . . Even after a decade, I can only reflect on the model as a momentary meeting with delirium." The model has remained in Lim's living room since its creation, next to his LEGO stegosaurus. "Everyone who visits immediately notices the dinosaur and ignores the harpsichord," he said. "Only after I point out that it's also a model do they give it a second look, saying, 'It doesn't look like it's made out of LEGO.' I can't ask for a better reaction."

BRICK BIT
The only parts of the model that weren't made from LEGO parts were the strings. Instead, these were real harpsichord brass and steel wires, which exert approximately 325 pounds of tension.

Real harpsichord wires were the only non-LEGO element in the model. © Todd Lehman

SUPER STUDS

Just because Lim was building big, it didn't mean he had to miss out on using some of the smallest LEGO pieces. He incorporated rubber tires as buffers to reduce the sound of the keys and jacks, as well as cloth capes—as worn by many LEGO minifigure characters—which played the part of dampers.

EXPERT ADVICE

Seeing as building big is Lim's forte, he offered some general advice to those thinking of dedicating their front room to giant LEGO sculptures.

- Be sure to "sort and organize your pieces," he said, for maximum efficiency.
- Building in a well-lit environment is essential for highly detailed work.
- And of course, "Have music relating to your model playing in the background."

A glimpse at the structural building involved in the underside of the model. © Todd Lehman

KEEP BUILDING

See more of Henry Lim's impressive body of work, including *that* Queen Amidala build and some giant mosaics at: www.henrylim.org.

Lim required huge numbers of small plate parts to make the large casing structurally sound. © Todd Lehman

VENATOR

By Sylvain Ballivet,
a.k.a. Iomedes

FACTFILE

Build location: Colombes, France
Year completed: 2011 (with
continuous improvements
ever since)
Time taken: 700 hours
LEGO elements used:
Approximately 44,400

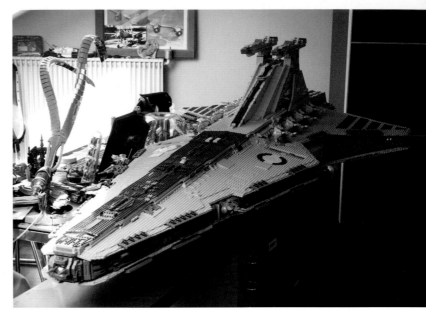

© Sylvain Ballivet

WHAT IS IT?

In 2005, LEGO Master Builder Erik Varszegi took on the challenge of building a Venator-class Star Destroyer spacecraft for the *Star Wars* Celebration III convention. At a staggering eight feet long, it was one of the largest *Star Wars* models ever built, and quickly inspired a whole host of *Star Wars* and Space fans to build bigger and more detailed spaceships. Six years later, one such builder was Sylvain Ballivet, who decided to raise the bar. Rather than glue the model and incorporate a steel frame, as Varszegi had had to do, in order to transport it safely to the convention venue, Ballivet's model would be made entirely from LEGO parts with no glue and no supports. This colossal creation is the result.

The Venator-class Star Destroyer is used in *Star Wars* by the Galactic Republic and the Galactic Empire primarily for ship-to-ship space battles. In the *Star Wars* universe, the ship measures 3,739 feet (1,137 meters) in length, so Ballivet built this ship at a scale of 1:466, making it measure eight feet (2.44 meters) long and four feet (1.22 meters) at its widest point. Unfortunately, at nearly 190 pounds (85 kilograms), this LEGO brick–version isn't going to take off into a galaxy far, far away any time soon.

MEET THE MAKER

Sylvain Ballivet returned to LEGO building as a thirty-seven-year-old, after a quarter of a century away from the brick. He was initially inspired by a number of other builders, and enjoyed trying to recreate and improve on their builds. He credits the likes of Peter L. Morris, Dasnewten, Damien Labrousse (a.k.a. Legodrome), Christophe Corthay (a.k.a. xtofcorthay), and Vincent Grazzioli (a.k.a. John Lamarck) as some of his early inspirations. "Finally, Pierre E. Fieschi showed me it was possible to match creativity, technique, and design with great presentation," he recalled. "Luckily, he is French as well, and also lives in Paris."

Ballivet, who works as a sales rep, is himself from Colombes near to the French capital, and is trying to start his own LUG with other French builders. "Coming back to LEGO, I discovered a fantastic community of artistic and talented enthusiasts, and rediscovered a very sturdy medium, offering endless possibilities," he says. Some of those possibilities for Ballivet have included building spaceships, sci-fi creations, and military crafts, thanks to

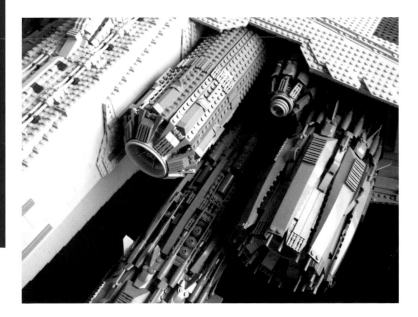

his fascination with futuristic vehicles. "There are many projects I would love to do," he said. "Incredible spaceships, futuristic giant tanks, military concept cars, a [6.5-foot-long] version of Syd Mead's 'Sentinel 400' black limo. . . . I like concept art and designs that seem realistic. I like it when people tell themselves 'The future is going to be like that.'"

THE PROJECT

Unlike many other builders putting together models of this scale and detail, Ballivet didn't so much plan, as just get on with it. After spending hours trawling the Internet, storing hundreds of pictures of the Venator for reference, as well as studying Varszegi's model at great length, Ballivet took to the build like a Stormtrooper. "I didn't use any software. I spent three months building it at night. During this period of time, I was sleeping only four hours every night! There wasn't any planning. My motto was 'build it fast!'"

In order to prepare for any building requirement that the model's creation would throw up, Ballivet ordered a far larger quantity of parts than he would actually need. He made sure he built the sections with extreme care, making them as sturdy as possible to avoid any structural issues or cracks. But despite his attention to detail, "the weight of the model has been and remains a problem. It was also impossible to use only my own strength to 'compress' the structure's bricks together." He also struggled with the building space that was available to him.

And once finished, although he felt satisfied because he had successfully completed the challenge he'd set for himself, he wasn't particularly happy. "It was the end of an adventure during which I was mostly alone, my wife and the children sleeping—lots of coffee, chocolates, and music, but alone. One of the first questions I asked myself was, 'And now what?'" But despite the lonely build experience, he has continued to make improvements to the model, after acquiring new building techniques, and buying new parts, and has even decided to build the model again, only this time it will be twice as big!

KEEP BUILDING

See more of Sylvain Ballivet's impressive models on MOCpages (www. mocpages.com/home. php/55673) or search for Iomedes on www.Flickr. com

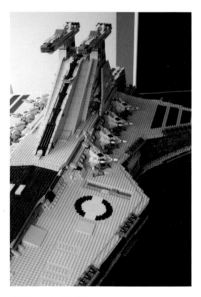

© Sylvain Ballivet

EXPERT ADVICE

For kids and adults who love all things space and sci-fi, building a mammoth model like Ballivet's is the ultimate goal. Here, he offers some advice for building big, *Star Wars* style.

- You'll always need more bricks than you think you're going to, so stock up. "Make sure to have everything necessary for your build, with 15 percent extra."
- Although it might cut costs, "Do not try to save on parts by reducing the structure. You will regret this a lot with the final assembly."
- Build the insides, not just the shell. "Avoid hollow structures. Make sure it is full of bricks!"
- Think ahead, and build for mobility. "Make sure you have enough room for the build plus some free workspace, and, unlike me, build in transportable sections."

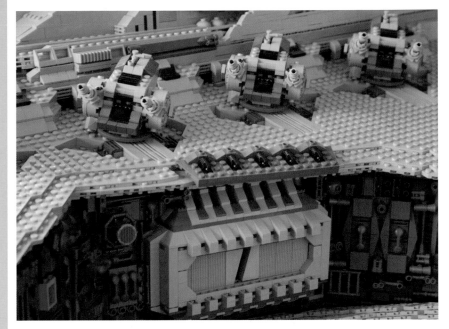

© Sylvain Ballivet

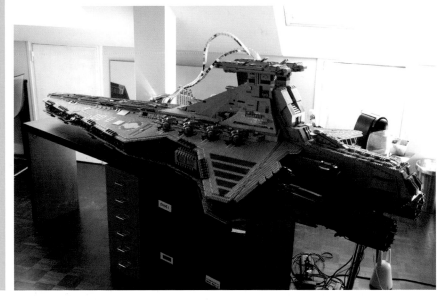

© Sylvain Ballivet

Breaking Records and Extreme Collections

"Standing next to a model as tall as yourself, you built by yourself, is incredibly satisfying. Observe long enough and it comes alive to drag you into its world."

Dirk Van Haesbroeck, Adult Fan of LEGO

On September 9, 2012, teetering above the streets of the Pankrac neighborhood of Prague in the Czech Republic, stood a toy tower of epic proportions. Built entirely from LEGO bricks, the shaft of plastic perfection measured 106 feet and seven inches (32.5 meters) and by a mere eleven inches (thirty centimeters) stole the world record for the tallest LEGO tower away from the British. Both towers had been built to mark the eightieth anniversary of the founding of the LEGO Company in 1932. The British tower—a waif-like homage to LEGO bricks and the London 2012 Olympic Games—was constructed in the LEGOLAND Windsor parking lot in July earlier that year. Their attempt had snatched away the record from the South Koreans by a measly four inches (ten centimeters), who only got to claim themselves as the tallest tower builders for two months. . . .

Building trepidatious towers from LEGO is something all DUPLO and LEGO fans do as children—testing the clutch power of the brick, the builder's ability to stack carefully and evenly,

the laws of physics put to the test in front of our eyes. But it's also been a popular group building activity as far back as the late 1980s, when the first record was set in the United Kingdom for a modest tower measuring around fifty feet (fifteen meters)—at less than half the size of the Czechs' 2012 effort, it makes the record breakers of more recent years look like skyscrapers!

In Prague around 450,000 bricks were used and pieced together by fans over five days and then sections were placed on top of each other to form the structure. The final brick was laid by London 2012 Olympic gold medallist rower Miroslava Knapkova. But, after all that hard work and the help of an Olympian, it's unlikely the Czech capital will hold onto the title for long, or even be the record holder at the time you're reading this—there's always someone looking to build a taller tower. But just how high can a LEGO tower be before the sheer weight of it destroys the load-bearing bricks at the bottom?

In 2012, BBC News carried out an

The record-breaking LEGO tower during construction in Prague, Czech Republic in September 2012.
© Radovan Paska

experiment to determine that point exactly. Using a servo-hydraulic testing machine, the Open University's Dr. Ian Johnston was able to determine the force required on one 2 x 2 LEGO brick to make it break. The LEGO brick was placed on top of a metal plate that was pushed upwards by a hydraulic pump—another plate on top measured the force by which the LEGO brick was being compressed. Surprisingly, each LEGO brick they tested did not explode when the average maximum force of 4,240 newtons was applied, rather the plastic sort of melted, collapsing in on itself. Johnston was then able to calculate that to produce such a force a mass of 950 pounds (432 kilograms) would need to be placed on top of a single brick. With a single brick weighing 4/100 of an ounce (1.152 grams), 375,000 bricks would be needed to achieve the same result. That number of

bricks stacked on top of each other would reach a height of 2.17 miles (3.5 kilometers)—that's the equivalent of stacking nine Empire State Buildings on top of each other!

While a tower of this nature would be structurally unsound long before it could reach such a height, it certainly won't stop LEGO enthusiasts from trying, and tower-builders aren't the only ones with their eyes on a LEGO record. Check out some other super-sized record breakers below.

Mosaics

Large-scale LEGO mosaics are one of the other popular group builds, run by LEGO and licensed partners such as DK. The largest permanent installation of LEGO bricks can be seen in all its glory on page 88, covering a staggering 2,691 square feet (250 square meters). But the Cowley St Laurence Primary School mosaic is not the only time LEGO has been pieced together in such a fashion, and other mosaics boast far more artistic detail and color variation.

According to Guinness World Records, the largest image built with interlocking plastic bricks was made in 2011 at LEGOLAND Deutschland. Thirty-five thousand visitors spent four and a half days putting together 533,000 bricks into a giant mosaic to celebrate the sixtieth anniversary of *Micky Maus-Magazine*. The last brick was put in place by German comedian Ralf Schmitz and the finished image measured nearly 1,500 square feet (137.28 square meters). Not long before, in 2010, Shoreditch Town Hall in London, England became the site of a record attempt by DK Publishing and British LUG the Brickish Association, to promote the launch of a new book—*LEGO Brickmaster:*

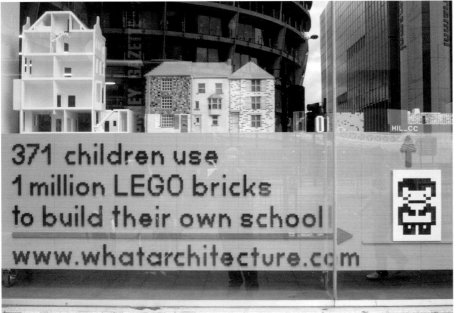

371 children use 1 million LEGO bricks to build their own school www.whatarchitecture.com

What better way to commemorate a giant LEGO build than with a giant LEGO sign like the team from WHAT_ architecture did? © WHAT_architecture

Star Wars. Two thousand participants attended the hall over a weekend to produce a design created by Hungarian artist Zoltan Simon. The finished mosaic was comprised of 384,000 bricks and 1,500 base plates, and featured popular *Star Wars* characters such as Luke Skywalker, Han Solo, and Princess Leia, as well as a number of brightly colored light sabers. The 97.5-square-meter (1,049-square-foot) creation smashed the previous record, which stood at 80.48 square meters (866 square feet). After the event the bricks, worth fifty thousand British pounds (seventy-five thousand dollars)

A large LEGO mosaic of Yoda from *Star Wars*.
© Dan Brown

were donated to children's charity Kids Company as part of their Toys for Christmas appeal.

A few years earlier, in 2007, Dan Brown with the help of 250 children at his Toy and Plastic Brick Museum in Bellaire, Ohio (see page 76), built another giant mosaic of a LEGO truck that measured 80.9 square meters (870 square feet). As can be seen from the photograph, it was a colossal achievement, especially for a private collection, using 1.2 million of Brown's own bricks.

Dan Brown's record-breaking LEGO mosaic made from 1.2 million LEGO bricks. © Dan Brown

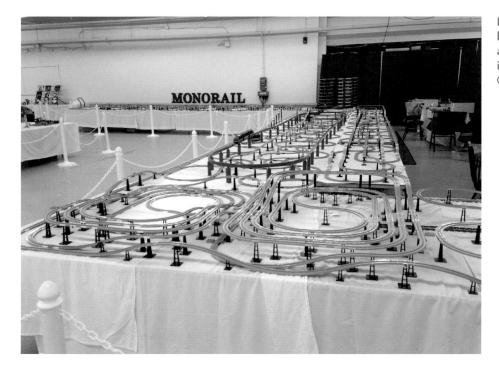

NELUG's record-breaking monorail at the BrickFair in New England.
© Mike Ripley

The NELUG monorail included a bridge that convention attendees could walk under. © Mike Ripley

Boats

When it comes to building big, every brick counts, and none more so when you're trying to break a world record. Although British AFOL (Adult Fan of LEGO) Ed Diment never set out to build the largest LEGO ship, by the time he had completed construction on the USS Intrepid in his home, he'd come pretty close. Unfortunately, his twenty-three-foot-long (seven-meter-long) creation, which you can see in detail on page 42, was a just a bit shy of the current record holder. To be fair, Diment steered his vessel alone, constructing the 250,000 brick boat largely by himself, while the largest seafarer to date was knocked together by 3,500 children. Under the guidance of LEGO Certified Professional Rene Hoffmeister, the German volunteers built a twenty-five-foot-long (7.66-meter-long) container ship in August 2010. They used 513,000 bricks to bring the creation to life at the JadeWeserPort Info Center in Wilhelmshaven, Germany. The center is a visitor attraction for the construction and operation of the deep water container port, where some of the world's largest actual container ships deliver cargo. It wasn't the first time Hoffmeister had been behind a ship's wheel—he'd achieved a twenty-four-foot-long (7.29-meter-long) container ship the previous year at a science museum in Germany, and a twenty-three-foot-long (seven-meter-long) *Queen Mary 2* that weighed over a ton and took six months to construct.

Trains

You know the feeling when you see a model train go round and round the same seven-foot length of track, and you feel kind of sorry for it because it has nowhere else to go? Then this is the record for you! LEGO Train Clubs all over the world meet up to try and create outstanding LEGO displays at conventions and model train events all the time—bringing together their ideas and components to build outstanding scenes and track layouts. Sometimes, however, you just want to be the

biggest—or in this case, the longest. In 2012 a Danish LUG (LEGO User Group) assembled 1,500.64 meters (nearly five thousand feet) of track in Copenhagen. Using a truckload of LEGO blue track components and a huge section of a convention hall at the Bella Center, and under the guidance of Henrik Ludvigsen, the Byggepladen team created a simple but beautiful display of LEGO efficiency. But why stop there? At the time of writing the same group were planning to up the ante quite considerably with another record attempt planned for summer 2013 to try and beat the existing record for the world's longest toy train track, currently held by a non-LEGO construction built in Shanghai for a *Thomas & Friends* train, which measured 2,888 meters (9,475 feet). The LEGO team's aim for 2013 is 4,000 meters (more than 13,000 feet)!

In May 2013, members of NELUG (New England LEGO Users Group) set a new record for the longest ever LEGO monorail, smashing the current record set by Italian group ItLUG, to create a continuous monorail loop of 1,971.41 feet (six hundred meters). The group enlisted the help of registered attendees at BrickFair NE, with a number of members bringing their own track parts to the event to help break the record. The most striking part of the huge design was a tower bridge, designed by Tom Atkinson, that allowed the monorail track to cross over the heads of attendees between different sides of the convention space. The bridge measured a little over 17.5 feet long—the bridge span was unsupported, which NELUG member Mike Ripley described as "an amazing feat using LEGO Technic."

Star Wars Army

If there was one LEGO theme that lends itself particularly well to the amassing of thousands of minifigures it's *Star Wars*. To meet the requirements of a universe where there is a seemingly endless supply of Imperial Stormtroopers, and as the theme marches well into its second decade

The LEGO company set the bar very high with this 2013 full-scale model of an X-wing fighter from *Star Wars*. © Asterio Tecson

The model is forty-two times larger than the X-wing kit sold by LEGO. © Asterio Tecson

with no sign of slowing down, it's no surprise there are more and more of the miniature, white foot-soldiers being produced for sets every year. With sites like Bricklink allowing fans to buy individual minifigures in large quantities from sellers all over the world, *Star Wars* aficionados are now able to assemble their own minifigure army that bears some resemblance to those witnessed in the *Star Wars* films—in a word, immense. A quick online search will lead you to dozens of videos where individuals will guide you through their collections, and while impressive, none comes close to touching the world record holder. With an unlimited supply at their fingertips, perhaps it's no surprise, that in 2008 LEGO UK headquarters assembled a display of 35,310 Clone Troopers over a period of six and a half hours. An army fit for any Sith Lord.

The Long and the Tall of it

Fancy claiming a title for yourself? Start collecting those bricks and maybe you can see your name in the next book of Guinness World Records. Although you might want to avoid attempting to build the world's largest LEGO model. With an unlimited supply of LEGO bricks, and a team of full-time building professionals, the Lego Group (TLG) has cornered the market on building big. Take, for example, one of their most recent giant models (pictured) of a LEGO *Star Wars* X-wing fighter, unveiled in May 2013. Weighing nearly 46,000 pounds, the model, which emerged out of a giant box in New York's Times Square, was built using 5.3 million LEGO bricks. The model was completed by thirty-two dedicated builders, who spent a total of 17,336 hours (or four months)

Each enlarged LEGO "stud" on the big model has the word "LEGO" on it just like with regular LEGO bricks. © Asterio Tecson

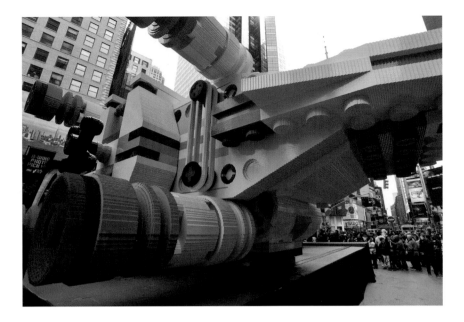

constructing it. It was built to the approximate scale of an actual X-wing fighter from the *Star Wars* universe with a height of eleven feet and a wingspan of forty-three feet. Built around a supportive steel structure, which can be broken down into fourteen separate parts for transportation, the model's engines have lights and speakers playing launch and battle sounds for the crowd. This feat of engineering, art, and LEGO building would certainly be hard (and expensive) for any individual to beat.

But don't be deterred. Here are a couple of records that might be worth striving for (provided you have enough bricks in your collection). The longest span of a bridge made from interlocking plastic bricks record is currently held by visitors of an exhibition in Wolfsburg, Germany. Under the supervision of record-veteran Rene Hoffmeister (see Boats above), a LEGO bridge was created that spanned fourteen meters (forty-six feet)—probably best not to walk on it though. Another extremely lengthy model that's held the record for the longest structure built with interlocking plastic bricks for a while, is a LEGO millipede created by children at an event organized by Le Gru shopping mall in Turin, Italy, in 2005. The brightly colored millipede, made of individually designed sections, used up 2,901,760 LEGO bricks, and measured over 1.5 kilometers (nearly a mile). Of course, it's hard for most normal folks to get their paws on that many pieces of plastic. Why not test your speed-building skills by attempting to beat Chris Challis's record for the tallest structure built with interlocking plastic bricks in one minute, using only one hand. In 2011 he achieved a height of forty-eight bricks tall—think you could do better? Better get building!

EXTREME COLLECTIONS

If you had to find something bad to say about LEGO bricks—you know, if someone was threatening to steal your LEGO *Star Wars* X-Wing Starfighter if you didn't come up with a downside—then it would have to be how darn hard they are to stop buying. Unlike all the other toy brands it's outlasted, one of LEGO bricks' most remarkable factors is their compatibility over time. A collection started in the 1960s can be used and enjoyed alongside a product you just picked up at your local toy store today. For that reason, there is a wealth of "usable" product lying around in attics, waiting to be snapped up at yard sales, floating around in the virtual abyss for much more pocket money than it would have cost back in the day. Of course, LEGO toys' collectability is also one of its biggest charms. And while many adults buy to build, there are other LEGO fans who buy to own, buy to collect, and buy to hoard.

For some, there's a specific niche that they like to focus on—LEGO *Star Wars*, Space sets, pre-minifigure LEGO, or every minifigure ever made—with a back catalogue of over one hundred thousand toys, available in different countries, not to mention special edition items and limited-release products, manufactured across a near eighty-year period, there really is something for everyone. Of course there are some collectors who want to have it all. Wayne Hussey, director of Seattle LEGO convention BrickCon, has made it his mission to own one of every LEGO part ever made, and he's well on his way.

"There have been other hobbies I've explored but I've never left my LEGO addiction," he said. "In the mid-eighties I decided that I would really like to own at least one of *every* element that LEGO has ever produced. I am not very concerned with whether I have that element in blue or red, but I do want that element. I do consider printing (not stickers) as defining a different element. And, of course, minifigures. This includes all of LEGO's themes and series—DUPLO, Fabuland, Space, Castle, Town/City, Technic (first called Expert), ZNAP, Primo, Modulex—everything." And nearly thirty years later, how far has he got? "I have managed to get myself into the ninety-fifth percentile of this goal."

And Hussey's not the only one. The Internet is filled with collectors and traders, swapping and selling their parts and

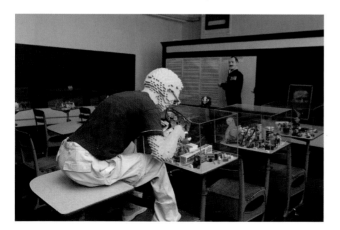

Dan Brown's museum in Bellaire, Ohio, is both an homage to extreme LEGO building and LEGO toys themselves. Here a LEGO model of a student and teacher sit in a classroom filled with old LEGO products.
© Dan Brown

sets to build their ultimate LEGO stash. But there's always one who takes things to the next level, raising the bar ever so slightly. On July 23, 2011, that man was Kyle Ugone, a captain in the US Marine Corps, and Iraq War veteran. Ugone is the current holder of the official record for the world's largest collections of interlocking plastic brick sets. From a collection that began in 1986 with a LEGO windmill set, the Yuma, California, resident managed to amass a total of 1,250 completed LEGO sets.

In an interview with Chris McDaniel from the *Yuma Sun* in 2011, Ugone explained why he decided to build all the sets he'd collected. "I actually keep catalogs of everything, so what I do is take a picture of every set I have for inventory purposes," he said. "The problem was, my hard drive fried so I lost every picture. So I started building them again to take the pictures." What began as a cataloguing exercise soon found itself taking up most of the usable space in the marine's home. With Space and Pirate Ships, *Star Wars* sets, Castles, and just about every other set imaginable, the collection was clearly miles ahead of previously recorded records.

"Nobody really displays their sets is what apparently makes me unique," Ugone said. "There are people out there with a bunch of sets but they are all in boxes and stored away somewhere. I decided I wanted to display." And display he did. After a year's worth of building—sometimes six a day while watching movies on leave from duty—Ugone invited LEGO expert Ash Nickel and a local councilmember to verify the number and authenticity of the sets, and they were greeted by a mini amusement park of LEGO sets squeezed into a home. The team counted 1,091 completed sets—some sets weren't counted if they were duplicates or if they were incomplete or without instructions—making him the largest private collector of completed sets in the world.

Estimating his collection at fifty thousand dollars, Ugone decided to slowly take apart his sets for storage after the record was broken, to regain some of the square footage in his home. According to the American Forces Press Service, "He's taking a break from collecting LEGO sets, planning instead to focus more of his attention on restoring a classic muscle car." Of course, one man's record is another man's bait and it's unlikely to be long before his crown is stolen. Although he told local journalists he didn't mind. "This is a one time, once in a lifetime deal," he said. "If people want to spend six months of their life building sets to break it, they can. I will only do this once."

One of the joys of being in the possession of such a vast and varied collection is being able to share it with

Brown's collection also includes large LEGO minifigures used as promotional tools by the company. © Dan Brown

A 13,000-LEGO part-scale model of the Veteran's Memorial Glass City Skyway from Toledo, Ohio, resides in the Toy and Plastic Brick Museum. © Dan Brown

others, and for Dan Brown from Bellaire, Ohio, that's exactly what he decided to do. With nearly twenty million LEGO elements to his name—eight million of raw bricks, and eight–ten million bricks in built models—he describes himself as a toy hoarder, with a compulsion for purchasing toys. Rather than keep his giant stockpile at home, he opened the Toy and Plastic Brick Museum in an old school building and has been growing his collection in its larger residence ever since. "People thought I was nuts for putting it here," he said of the museum he planned for his retirement, but opened early because the visitors wouldn't stay away. "I like the lack of pressure and our overhead is manageable." His friends and family think he's insane for collecting on the scale he does "but at least they are happy that the majority of my collection is now out of their homes," he said.

But despite his affinity for the bricks his museum is literally built with, and his ongoing promotion and enthusiasm for the toys, Brown describes himself as an AFOB (Adult Fan of the Brick) and

not an AFOL. "The company does not like to 'play well with others,'" he said of his dealings with TLG, who requested he remove the word "LEGO" from the title of his museum. Nevertheless, his passion is tireless and his hoarding habit continues. "I've gained around six to eight pounds of product per week, since around 1985," he said, "and yes I try and 'score' any models I can." That includes hundreds of LEGO sets, collectible LEGO items, promotional models, as well as models built by professional LEGO builders, former LEGOLAND models, and creations by amateur builders and LUGs. Brown's prized possession among the collection? "Signed, Toucan Sam," he said of the Froot Loops mascot model. "I love the fact that I have the model as well as the signature of the builders and designers on the same model." He's also a big fan of the large Scooby-Doo, Darth Vader, and Spider-Man models. "They are all amazing!" he said.

Brown might be an avid collector, but he's also a keen builder, and now he has the collection to match his big building ambitions. "I am very proud of my Castle scene as well as one of the train yard Town scenes. While I built them in the middle of winter (shaking my boots off with no heat), I loved how they turned out." And for his next project? "I just started on it, actually—a large-scale 'alien world.' The final model will be around the size of a small racquetball field." Just what every school filled with LEGO needs!

Two large LEGO models sit down to a game of LEGO chess—just one of the many delights on offer at Brown's museum. © Dan Brown

THE LEGO MILLYARD PROJECT

By New England LEGO Users Group (NELUG) in cooperation with the LEGO Group

With community volunteers from Manchester, New Hampshire

FACTFILE

Build location: SEE Science Center, Manchester, New Hampshire
Year completed: 2006
Time taken: Two years
LEGO elements used: Approximately three million

WHAT IS IT?

On permanent display at the SEE Science Center in Manchester, New Hampshire, the LEGO Millyard project is a minifigure-scale replica of the Amoskeag Millyard complex that stands beside the state's Merrimack River, as it would have appeared around 1900. The entire model measures ninety-five feet by twenty-two feet and sits on an elevated platform that includes a running water system to represent the river and canals that surround the mill. The model incorporates around 100 individual buildings that made up the

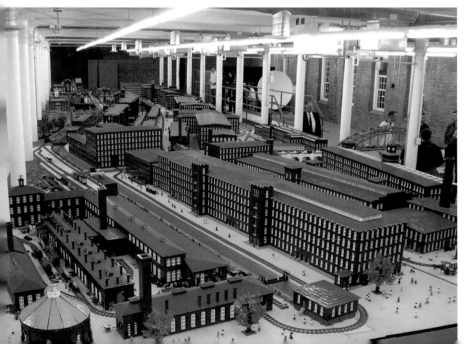

The depiction of the Millyard fills an entire hall at the museum, and is so accurate in its detailing, it's hard to believe it's been built from LEGO bricks.
© Mike Ripley

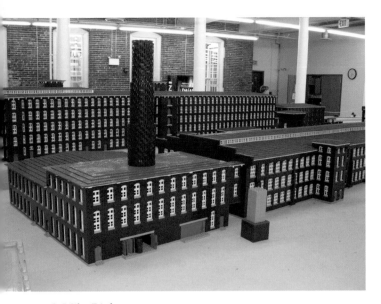

© Mike Ripley

mill complex, downtown Manchester, and other historic buildings from the city. The team also installed a nine-volt LEGO Train system, which sees several trains and trolley cars moving around the display in keeping with the period. With the exception of a custom power supply, which was installed to ensure the system would be able to withstand being in use for nearly fifty hours a week, the entire model is made from LEGO elements, and only a few parts of it were glued for structural stability reasons, notably the foundations of buildings and key support points on the Notre Dame Bridge. This is officially the largest permanent LEGO display built at minifigure scale in the world, and if it wasn't already realistic enough, the team populated the model with around eight thousand minifigures depicting daily life from the era.

BRICK BIT

Due to the scale of the project the museum it resides in had to double in size to accommodate it. "The SEE Science Center staff oversaw the construction of a whole new floor that was added to the museum, that included all of the engineering and construction to build the elevated platform with a working water system," said Ripley.

MEET THE MAKERS

While Master Model Builders Erik Varszegi and Steve Gerling were the professionals behind this project, a lot of the building work was done by members of the New England LEGO Users Group (NELUG). Comprised of those aged over eighteen from the six New England states, NELUG was formed in 1999 and is part of a thriving LEGO community in the area. "Most members built in their childhood and part of their adult building experience has been finding and joining NELUG in order to share our love of the brick," said member Mike Ripley. "The club is heavily into Train/City layouts that include a fair amount of Technic and MIND-STORMS. Members are spread across the LEGO spectrum as far as interests go, to include BrikWars, Moonbase, and Steampunk (building styles)." Many NELUG members come from technical or design professions, and the group displays six to eight times a year

79

at various events in the region—catch them at the Greenberg Train and Toy Show in Wilmington, MA, LEGO Kidsfest in Hartford, CT, and at BrickFair NE.

THE PROJECT

The LEGO Millyard project was conceived by Dean Kamen—the American inventor and entrepenueur, perhaps best known for being the man who gave the world the Segway PT. Kamen is also the man behind *FIRST*, the non-for-profit organization that encourages young people to explore science and engineering through school program and competitions including the *FIRST* LEGO League.

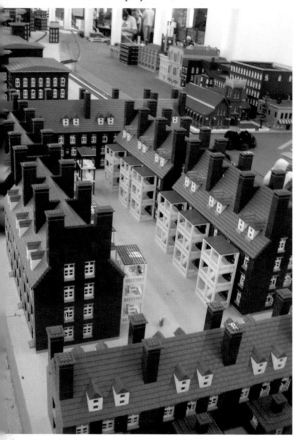

© Mike Ripley

"The story goes that he had dinner with Kjeld Kirk Kristiansen (owner of the LEGO Group) and they agreed to the project, where Dean would donate the museum space and Kjeld would donate the bricks and expertise of two Master Model Builders to create the display," said NELUG's Mike Ripley. But when Master Model Builders Erik Varszegi and Steve Gerling fully realized the scale of the project, they reached out to local LEGO fans to try and recruit some extra building hands. "We in NELUG jumped at the chance of a lifetime—build side-by-side with two Master Builders on a three-million-brick permanent display? Of course we're in!" said Ripley.

Due to the precise scaled-down size of the model (1:55, otherwise known as "minifigure scale"), a vast amount of planning went into the project, to ensure the buildings were the correct size, in relation to each other, and also in the correct position. However, the team wished to include some historic buildings and locations that were a little bit further from the Manchester millyard—downtown Manchester and the Pine Island Park—these were effectively moved closer to the positioning of the millyard to be able to incorporate them into the display space. "Planning involved working with the Millyard Museum to find maps and images from the 1900 time period so we knew what buildings

existed at the time, how big they were, and what their location was in the complex," said Ripley. "For buildings that still exist, we took actual measurements of the buildings as well as photographs from all angles possible, and compiled a three-ring binder for each building as a reference tool for the builders."

The majority of the design of building walls was done by professionals Varszegi and Gerling. It was decided that the wall structures would be somewhat modular. "This allowed for easy participation by the public volunteers who helped build the LEGO Millyard," said Ripley. "The volunteers were given the pieces to make sub-sections of the walls, the window/sill units, the interior

KEEP BUILDING

You can find out more about NELUG's events and other projects at www.nelug.org, and for information about the SEE Science Center visit www.see-sciencecenter.org.

Jamie Berard's LEGO roller coaster installed in the model's own interpretation of Pine Island Park. © Mike Ripley

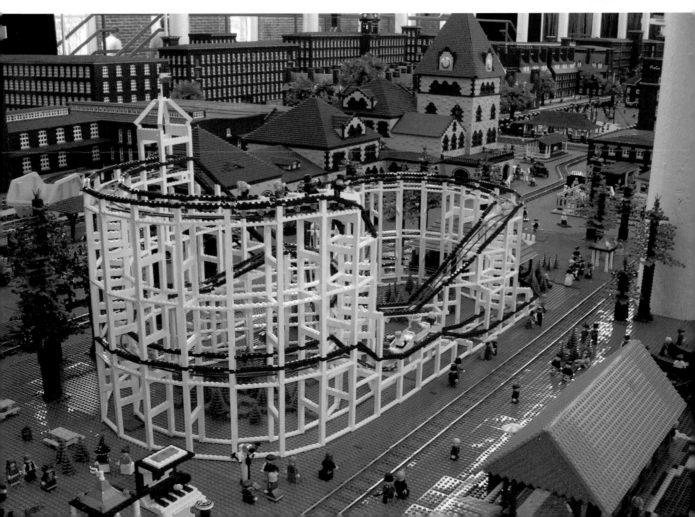

wall supports, etc." Ripley explained that typically the biggest limitation facing those designing LEGO buildings are the windows, especially in 2003 where there were even fewer window elements available. Luckily, the real-life mill buildings have large windows so a standard window part was able to be used.

"We discussed for a while what color to use for the mill buildings," said Ripley. "Real bricks are red, but LEGO red (this was pre–dark red) was just too bright. As *everyone* knows, at this time LEGO decided to change light gray and dark gray, causing a huge uproar in the AFOL community. Less discussed was the change in brown. We actually took advantage of that change by mixing old and new brown to give the mill building walls the 'brick' texture required." Large boxes (known as K8s) of the two tones of bricks were mixed together to ensure a random selection, and used to make the mill buildings. Ripley notes that had the project been conceived two years prior or after this change at LEGO HQ then this technique would not have been possible.

"The mill buildings were completed in nine phases spread across the two years of the project," said Ripley. "For each phase, the SEE Science Center emailed their membership to come to the museum to help build. NELUG, Erik, and Steve provided oversight for their participation, which worked quite effectively to build the buildings. Effectively we came up with a factory-style modular

Over the two-year period of planning and building, a large number of volunteers, both kids and adults, worked on the project. © Mike Ripley

building system to build a bunch of factory buildings." While the volunteers took care of building the bulk of the structures, the non-mill buildings were created by NELUG members, and the two professional builders, largely at TLG's North American headquarters in Enfield, Connecticut, due to the larger array of parts and colors required.

The model was unveiled for the first time in 2006 and the event was attended by Kjeld Kirk Kristiansen himself. "This was a chance of a lifetime for all of the people who participated," said Ripley. "Many friendships were formed and continue today. . . . Having Kjeld show up, in person, for the dedication was immensely rewarding, as was the wonder and admiration we received from the many LEGO VPs and other executives in attendance. This is by far the best LEGO building experience we've had, and we feel personally attached to the museum and the display." Every one to two years Ripley organizes a cleaning weekend where many of its original builders maintain and fix any parts of the model in need of TLC. "Many NELUG members participate and are dedicated to keeping the display alive and relevant. . . . Reaction from the public has been excellent, and AFOLs from around the world visit Manchester to see the LEGO Millyard."

SUPER STUDS

One special element of the build is a roller coaster that sits in the Pine Island Park part of the display. It was built by a NELUG member called Jamie Berard, who was involved in the early stages of the project before moving to Billund to accept a job at the LEGO company as a designer. With a love of amusement rides, Berard volunteered to build the wooden-style roller coaster in Denmark. The team never saw any photographs of the model in progress. "The day before the unveiling ceremony, Kjeld flew in his jet to Manchester with the roller coaster in tow," said Ripley. "A box showed up at the museum that evening and inside was, to perfect scale, the most wonderful model of a wooden roller coaster ever done."

CHRISTMAS TREE

By Bright Bricks: Duncan Titmarsh, Ed Diment, Annie Diment, Abi Bath, Naomi Farr, Martin Long, and Martin Crook

FACTFILE

Build location: The model went on display at St Pancras railway station in London, United Kingdom, during the holiday period of 2011, then again at the Trafford Centre in Manchester, United Kingdom, in 2012. It is currently in storage awaiting its next outing in Bright Bricks' workshop in Farnham, Surrey, United Kingdom.

Year completed: 2011

Time taken: Nine months

LEGO elements used: Approximately 650,000 (including the baubles)

© Claire Choong

WHAT IS IT?

Not content marveling at a regular six-foot fir by your fireplace this holiday season? Then why not decorate your living room with this record-breaking LEGO Christmas tree (only those with extraordinarily high ceilings need apply). It was built by British-based LEGO studio Bright Bricks to promote the LEGO brand. The tree, which still exists, albeit in storage, measures a staggering height of nearly forty feet (twelve meters) when assembled, is comprised of over 120 layers of branches, and features five hundred lights and over 1,200 LEGO baubles.

The idea for the tree came from Bright PR (no relation) on behalf of the LEGO Group, and Duncan Titmarsh's company was asked to make the Christmas wish come true. "[A Christmas tree] was chosen to give maximum impact in a very prominent London location—the busy St Pancras International Train Terminal," explains Bright Bricks' Ed Diment. Building a record-breaking creation was not the initial plan, "but when we informed the client that their proposed tree was roughly the height of the previous record it was decided to add a couple of meters to make it the clear winner," he said.

While the tree is a whopper and comprised of hundreds of thousands of LEGO pieces, only five colors were incorporated and fewer than ten different elements were used to complete the build. There is a steel frame inside the trunk and branches to make the model safe to display in such a busy public space, and for ease of transportation. The model's total weight is over seven thousand pounds (three thousand kilograms).

MEET THE MAKERS

Bright Bricks was founded by Duncan Titmarsh—the United Kingdom's only LEGO Certified Professional. The company is co-directed by partners Titmarsh and Ed Diment, has four key members, and employs up to twelve people during busy periods.

Bright Bricks is responsible for some of the most extreme and eye-catching models seen on display in the United Kingdom, and their builds are regularly featured in national newspapers and on TV. Just some of the mind-bending projects they are known for include their half-scale model of a Rolls-Royce Trent 1000 jet engine, a giant 600,000-piece LEGO advent calendar, a full-sized LEGO greenhouse with real plants and its own irrigation system, and a minifigure-scale model of the London 2012 Olympic Stadium. Nothing is too off-the-wall or extreme for the team. "We were once asked to build a full-sized horse out of LEGO," Diment said, "but were given a two-week time frame to do so! And one of the more unusual things we built was a giant LEGO toothbrush."

THE PROJECT

Rather surprisingly it was the planning phase that consumed most of this build's nine-month project time. Six of those months were spent preparing for the creation and installation of the tree. "Such a huge public model required consultation with LEGO, Bright PR, Network Rail, English Heritage—the station is a listed building—Beamline Steel, the Health and Safety Executive, and a number of other organizations," Diment explained. "A large number of approv-

The tree's LEGO star is raised into position. © Bright Bricks

© Michael Gross
www.proseandpassion.com

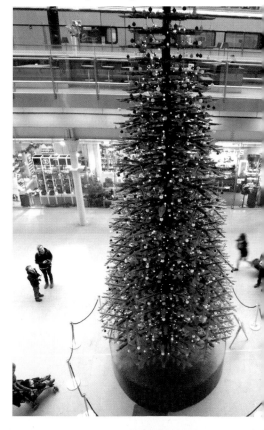

als and submissions are needed to place such a huge LEGO structure in such a prominent location." The build had a "spread restriction" due to the busyness of the train terminal, meaning the branch span had to be carefully calculated in relation to the model's height.

While approvals were being sought, the Bright Bricks team also went about mapping out the tree's branch design using LEGO CAD software. This was done so that the steel support could be built to the correct proportions and so that multiple builders would be able to follow an identical design to build the branches. "The branches follow a repeating diagonal pattern that relies on the simple idea of clamping a brick by a single stud at the end, which allows it to rotate around to forty-five degrees. This gave the traditional angled look of the branches and pine needles." The tree's trunk and star, meanwhile, were built freehand on-site.

When it was time to install the build, the team was restricted to working in the early hours. "Because the station is a very busy working transport hub during the day, there was no option for bringing large amounts of equipment and an industrial cherry-picker on site during the day," Diment said. "We had to wait until the station was not busy—after 11 p.m. and until 4 a.m." The team operated on a shift system over ten nights in the semi-open station enduring chilly November temperatures.

Special matting was laid out on the station's lower concourse, so the building's marble floor wouldn't be damaged by the immense weight of the tree. "We were not allowed to attach anything to the original part of the building as it is a listed heritage site and cannot risk being damaged," Diment said of the project's challenges. "We also had issues transporting tree parts, but thankfully Beamline Steel hit upon an idea for a design that allowed the branches to be held upright for transport, which meant we could pack far more in the lorry."

Unable to assemble the giant tree off-site first, seeing the finished model in situ was as much a pleasure for the team as for the public. "The model went down very well with LEGO as it got massive media coverage globally and it is also our most successful build to date in terms of publicity," Diment said. "We enjoyed a glass of champagne on the day of the official unveiling, which was

a celebrity event with a live band and all the trimmings." The tree reappeared the following Christmas in Manchester and the team hope they'll get the chance to put it up again in the future.

SUPER STUDS

"The tree is so tall that it was a struggle to put the star on top as the cherry-picker used was at its maximum extension," Diment said. "In order to look sensibly to scale the star is also nearly ninety centimeters [three feet] tall. It's covered with thousands of tiny LEGO transparent slopes that catch the light and make the star sparkle."

EXPERT ADVICE

Feel like doing Christmas the Bright Bricks way? Ed Diment shares some words of wisdom . . .

- "When you get into commercial builds such as this you need a huge amount of patience and the ability to deal with a wide range of people."
- "Planning is completely essential otherwise you will fail. Consider how the model will come apart into sections and how it can be transported."
- "If you have a really knock-out model in mind, think about what would be the best location to display it and work this into the planning process."

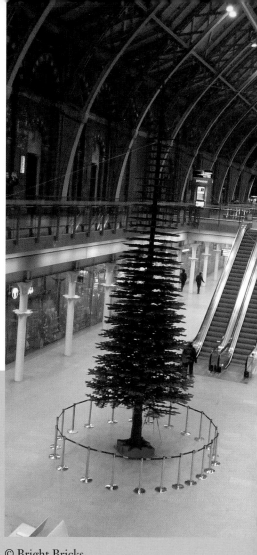

© Bright Bricks

© Bright Bricks

COWLEY ST LAURENCE PRI-MARY SCHOOL MOSAIC

By WHAT_architecture

FACTFILE

Build location: Hillingdon, London, United Kingdom
Year completed: 2010
Time taken: Twelve months
LEGO elements used: 1,395,702

© WHAT_architecture

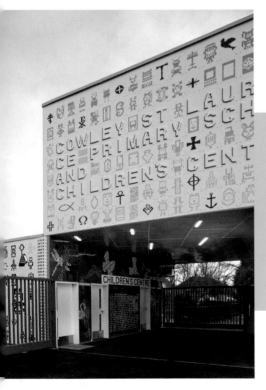

The symbolic gate structure that bridges the two preexisting school buildings. © WHAT_architecture

WHAT IS IT?

Have you ever daydreamed about how cool it would be if your school (or even your office) was made out of LEGO? For some very lucky British school pupils, that dream became a reality in 2010, after a collaborative effort from WHAT_architecture and the London school's pupils and teachers saw them finish covering this new school building's 250-square-meter (2,690-square-foot) facade in nearly 1.4 million LEGO bricks.

"The ambition of the project had to motivate children," WHAT_architecture said in a press release. "It was decided to attempt something never previously achieved anywhere in the world—to build a permanent building using one million LEGO bricks—and in doing so the project would inspire children to believe that anything is possible through ideas, belief, scholarship, and teamwork."

The finished design includes black and white images created by the children, and reproduced in LEGO bricks on the bridge-like structure that also serves as a gate for the students to walk through every day. The building stands as the first use of LEGO elements in a permanent building installation, and received a Guinness World Record for being the largest mosaic of interlocking plastic bricks.

MEET THE MAKERS

WHAT_architecture is a London-based firm, which specializes in education, recreation, and residential projects, which require stakeholder input and have a focus on community engagement. The company's slogan is, "Sometimes it's not the building which needs designing, but the process!" And this can definitely be said of their use of LEGO to inject community spirit and creativity into the design and construction of this project.

The firm won a RIBA National Award (Royal Institute of British Architects) in 2007 for its ingenious design of a rooftop nursery, and received a "Better Public Building" accolade from former Prime Minister Tony Blair. Despite the worldwide praise and intrigue for the LEGO-covered building, Anthony Hoete, the firm's director, said they would only repeat the project if it was initiated by a community group, or another school or local authority, preferably outside of the United Kingdom. "It would be good to be a part of something but a little more remotely," he said. "After all, you don't need to be an architect to build with LEGO; just some imagination." But with an unlimited number of LEGO bricks at their disposal, the team might be tempted to try another LEGO-related structure. "A tall building," he said. "It wouldn't have to be the world's tallest; ten stories in central London (next to our office) would be enough."

THE PROJECT

The London Borough of Hillingdon was looking to make a statement when it approached WHAT_architecture to undertake an important and symbolic project. The Cowley St Laurence Primary School is a union of two former schools—Cowley Infant (a state school) and St Laurence Junior (a Church of England school)—and the local council wanted to create a new building to bridge the gap. Paramount to the firm they hired was the involvement of the facilities' users, namely the schoolchildren, teachers, and parents. "We

BRICK BIT

It's hard to believe that such a striking monochromatic facade was ever intended to be anything other than black and white. In fact, originally the children created their designs in color, and then in a single color, depending on which grade they were in. But it was eventually deemed more effective and striking to build the wall solely from black and white bricks.

So simple, even a child can do it! This student is working on some of the structure's 3D words.
© WHAT_architecture

89

© WHAT_architecture

decided not to use the architect's principle design tool—drawing—as an architect's undoubted abilities to draw has a negative effect on public engagement, who invariably think they cannot draw," said WHAT_architecture's director Anthony Hoete.

Instead, the firm built models of the school's two existing building from LEGO bricks, and asked everyone else to model ideas for the new building using the same medium. "The first conversation was quite simple: do we design a standalone/independent building or a connecting bridge building?" said Hoete. "Through modeling we arrived at the latter. Then somebody said, 'It would be nice if rather than it being a barrier it becomes a gate.' We then thought, 'Instead of just designing the building in LEGO, why don't we actually build the school with LEGO?'

"It was a bold and at times testing move to try to make a permanent occupiable building out of LEGO because as far as we were aware it had not been done," said Hoete. "This required getting the necessary compliance (planning, building controls) certification and the commercial and logistical problems involved in actually building a million-plus piece facade with LEGO." As shown in the diagram the LEGO bricks are just part of a multilayered sandwich of materials that make the wall possible, including fiber cement board, a waterproof membrane, insulation, vapor control, and plasterboard.

LEGO bricks are not a regular industrial building material, and as a result needed a number of adaptations to be suitable for the job. They required anti-graffiti, flame-retardant, UV protection coatings and tamper-proof fixings. The fact that they were not designed to be used permanently in this way, actually works in the school's favor. "The intumescent fire coating needs to be redone every seven years, so the facade had to be demountable," Hoete said. "It's built as a continuous interconnecting wall on site, without the use of glue as per normal LEGO (sculptures). When they take the wall down to recoat it, the idea is that the school could rebuild it differently, change the design and imagery, so it's open to reworking for different generations."

While it's hard to imagine any child not loving a school that looks as fun as this one, the adult response to the project has varied, explained Hoete, "from the Department for Education loving the project through to the architects' professional body (the Royal

KEEP BUILDING
To find out more about WHAT_architecture's other unusual and inspiring building projects, head to www.whatarchitecture.com.

© WHAT_architecture

This diagram shows the various layers that make up these very special LEGO walls. © WHAT_architecture

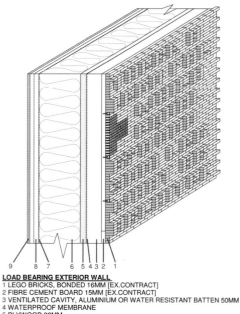

9 8 7 6 5 4 3 2 1

LOAD BEARING EXTERIOR WALL
1 LEGO BRICKS, BONDED 16MM [EX.CONTRACT]
2 FIBRE CEMENT BOARD 15MM [EX.CONTRACT]
3 VENTILATED CAVITY, ALUMINIUM OR WATER RESISTANT BATTEN 50MM
4 WATERPROOF MEMBRANE
5 PLYWOOD 22MM
6 ROCKWOOL FLEXI 140MM OR SIMILAR INSULATION, BETWEEN TIMBER STUDDING
50/150MM @ 600MM C/C
7 VAPOUR CONTROL LAYER
8 2 LAYERS OF ACOUSTIC PLASTERBOARD 25MM
9 2 COATS OF PAINT

Institute of British Architects) being unsure how to understand it. . . . We were very pleased with the outcome as it meant taking a fantastical idea and through good workability and construction skepticism, the force of goodwill forged with the community showed that with education, anything is possible."

SUPER STUDS

The eclectic array of images that make up this mammoth mosaic were produced by the school's students. Each child was given a piece of paper that represented a part of the wall, and as part of a series of twenty workshops they were encouraged to express themselves. The result was an unusual array of cultural and religious images from robots and anchors to bunny rabbits and symbols of faith. Some of the religious iconography, and interpretations of Christ caused contention among parents and the school's governors and raised broader questions about contemporary representations of God on earth.

LEGO HOUSE

By James May

With the help of many others

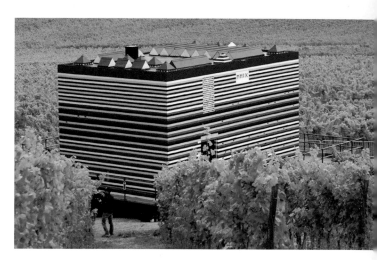

FACTFILE

Build location: Denbies Estate, Dorking,
Surrey, United Kingdom
Year completed: 2009
Time taken: Five months
LEGO elements used: 3,500,000

All images in this profile courtesy of Plum Pictures Ltd

WHAT IS IT?

In 2009, as part of British TV series *James May's Toy Stories*,
the eponymous presenter set out to explore the history of the
country's favorite childhood toys, while reinvigorating them in
a fun and modern way. For one episode, LEGO bricks were in
the spotlight, and May did the fans proud by trying to prove that
the impossible could be done—he set out to build a house made
entirely from them. "I wondered if it was possible when I was a
small boy," James May said. "Adulthood gave me a chance to find
out." The result is a stripey, contemporary cube nestled in an
English vineyard, or as May described it, "A modernist, (theoret-
ically) reconfigurable house, making use of bright colors and a
double-height sitting area. It was really a one-bedroom country
escape. All the fittings, furniture, and accessories, plus the cat
and the newspaper, were also LEGO." The 3.5 million bricks
that made up the twenty-foot-tall house were standard LEGO
bricks, not special pieces. And while a large number of the bricks
were provided to the program by the LEGO Group, May said a
number of boxes of bricks were donated by the public, who were
so excited to get involved and contribute to the creation.

A wooden internal structure was
required for health and safety
reasons, but did not support the
LEGO bricks.

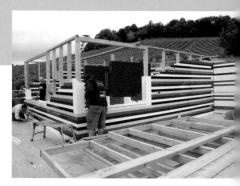

BRICK BIT

When asked if he felt his efforts had inspired others to reconnect with their LEGO collections, May responded. "I think it helped adults to see that it was OK to enjoy playing with so-called 'toys.' I think LEGO is more than a toy. It's a philosophy of sorts."

Just some of the LEGO versions of everyday objects the team produced to make James May feel a little more at home.

MEET THE MAKER

"My elder sister had a box of LEGO," James May said, "so it's one of my earliest memories. I still have some on my desk. I find it theraputic." The popular TV presenter, recognizable for his messy graying locks, old-man wit, and colorful shirts, is perhaps best known for being one-third of the BBC's car-mad *Top Gear* program's presenting trio, and he has also been the face of a number of other popular documentary programs, but at heart he's a big kid who loves driving fast cars, adventuring, and building with LEGO bricks. "As a kid I mainly built aeroplanes and ships. I still do," he said. "I would like to try something massive with LEGO Technic—a machine of some sort. . . . We're working on that," he said, "I'd like to try a full-size motor yacht." Watch this space, readers, May might be about to make another of your dreams become reality.

THE PROJECT

The episode chronicled James May's research and build at great length, showing him investigating the best way a liveable LEGO house might be constructed in a realistic way. "A lot of the planning stage involved experiments with LEGO structures, to see what would be possible on a grand scale," he explained. "A proper architect, Barnaby Gunning, was employed to realize the ideas." The program showed May testing the strength and stability of various building techniques, and meeting with designers who would be responsible for the aesthetic feel of his new pad, although May explained the style of the build was largely influenced by modern houses he likes, as well as contemporary furniture. The team also managed a quick trip to Denmark—the toy's country

KEEP BUILDING

To find out more about *James May's Toy Stories* and his amazing LEGO house, visit the website www.jamesmaystoystories.com where you can buy the book and DVD related to the series.

The house's blue and black LEGO toilet.

of origin—to watch some large structures being built as part of their research.

"By the time we started building, the design was pretty much nailed down," May said. But despite their diligent plans, the build was anything but seamless. "It wasn't that smooth, because no one had built anything like it before," he said. "We had a site foreman to oversee progress and manage the manpower, and because we were making a TV program about it everything had to be quite tightly scheduled."

Around two thousand volunteers were involved in the build—so many fans were keen to help the program had to turn people away from the site because they could not accommodate all the volunteers. The structural walls of the house were built from a series of large LEGO bricks comprising of a number of regular bricks, built by the volunteers. Much to May's dismay on the program, it was decided that building with LEGO alone did not meet health and safety regulations. "Because the house was a public building, it had to meet certain safety standards," May explained. "This meant we had to use a passive internal wooden frame to support the house if it collapsed." And while May doesn't think any particularly clever construction tricks were involved, he did say, "The scale allowed for some clever decorative work. By building bigger, the 'definition,' if you like, of LEGO becomes finer."

Inside the house, a complete array of LEGO furniture, windows made from transparent bricks, kitchen utensils, a toilet, a pair of slippers, and even a cat—named Fusker, after his own pet cat—were constructed from LEGO bricks to make May feel at home. "I was utterly amazed by the finished building," May recalled. "I thought it was the best building in the world." The presenter even spent a full night living in the house, of which he remembered, "It was a bit hallucinogenic, but surprisingly functional. The bed was not comfortable."

And there's not a lot he would change if the same opportunity presented itself. "If we did it again we probably wouldn't do much different, apart from allow more time. It takes ages to push that many bricks together!" The public reaction was equally

inspired. "Thousands came to see it," May said. "It became a tourist attraction for a while. I think it was generally very enthusiastically received. A few people complained that it was 'too garish' and one or two said it was un-environmental. This is nonsense, of course, because every bit of the house could be re-used, which isn't true of any other house."

Unfortunately, and despite plenty of media coverage, the program was unable to find anyone to take the house off their hands when the vineyard needed the land back. Despite original plans for it to be dismantled and rebuilt at LEGOLAND Windsor, the cost of the relocation were too high, and the house was left without a home. Eventually, the house was taken apart and the bricks were donated to charity.

The elusive LEGO cat, Fusker, named after May's own pet cat.

SUPER STUDS

"There was one random 8 x 4 pink brick in the middle of one large brick in the middle of one wall," May said, something he showed his displeasure for on the program. "This was put in by a member of our volunteer team being 'funny.' But we left it, not least because by the time I spotted it the walls had gone up another five feet. Also, somebody nicked our LEGO cat. He was never seen again."

The latest in comfortable living— LEGO slippers!

EXPERT ADVICE

Moving house is a costly business, but the thought of waking up surrounded on all four walls by LEGO bricks is too amazing a thought to pass over lightly. Here are James May's top tips for anyone thinking of building their own home, one brick at a time.

- "You will need a great deal of LEGO. A garden shed might be easier."
- "Find manpower. Pushing thousands of bricks together hurts your fingers."
- "Do not imagine that a LEGO shower or lavatory will actually work that well."

MARIO

By Dirk Van Haesbroeck

FACTFILE

Build location: Antwerp, Belgium
Year completed: 2009
Time taken: 210 hours
(fifty hours of design;
160 hours of building)
LEGO elements used: 42,000

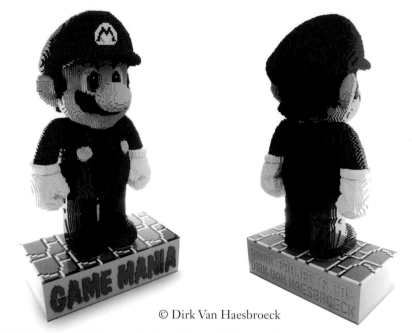

© Dirk Van Haesbroeck

WHAT IS IT?

What's not to love about Dirk Van Haesbroeck's giant symmetrical LEGO sculpture of everyone's favorite plumber? The Belgian builder modeled Mario, from Ninetendo's video game franchise starring the dungaree-wearing Italian, at a staggering fifty-nine inches (one hundred and fifty centimeters) tall, thirty-five inches (ninety centimeters) wide, and thirty inches (seventy-five centimeters) deep. He's stood on top of an orange video game–style pedestal, which alone comprises of two thousand bricks. The model was built for a video-game client called Game Mania, whose logo appears on the front of the pedestal; on the back is Van Haesbroeck's name and his website URL. The model was a natural progression for the builder who preceded it with a smaller version of Mario's brother Luigi. "It turned out nicely so the next logical step was a supersized Mario," he said.

MEET THE MAKER

Not surprisingly for the builder who has created other characters from the Nintendo-verse as well as *South Park*'s Kenny and other colorful creatures, his first memory of LEGO toys is of the colorful, critter-inhabited world of LEGO Fabuland. "My very first memories of LEGO were of the Fabuland Hospital (set 347), in the early eighties. I also remember getting a Classic Space set each month when I visited my grandparents, which definitely got me into building." His career as a young builder peaked when he created a 200-stud-long aircraft carrier at just eight years old.

His dark age or "abstinence" as he refers to it, subsided in 2008 when he saw models created by fellow Belgian (and Dirk), Dirk Denoyelle (see page 180) and Nathan Sawaya (page 202) on the Internet. "I wanted to build sculptures myself and so I bought dozens of basic LEGO brick tubs to get me started," he said. And before long he was hooked. "My contemporary favorites include the Tolkien and TMNT sets. I think it's fantastic to experience the marriage between eighties cartoons and LEGO."

Van Haesbroeck who works as an IT specialist in the construction industry, is an active member of Belgium's BeLUG, and has seen the hobby grow in his homeland over the last few years, as well as enjoying keeping abreast of the international scene on Flickr. He shares his creations online and is known for posting time-lapse videos of his builds. In response to his fans' enthusiasm, he has recently created detailed instructions for how to build a Mario mushroom the size of a basketball, which he is hoping to share with other builders who enjoy his models.

THE PROJECT

Without professional 3D-modeling software to plan out for various layers of such a sculpture, Dirk Van Haesbroeck uses a homegrown method. "I started from a 3D model, which I slightly adapted and captured screenshots from the slabs. After that I used good old MS Paint on each slab and after some conversions I had my layers in MS Excel. The hardest part was getting accurate colors. Undoubt-

A glimpse at the clever internal support structure that enables Dirk Van Haesbroeck to build such large, sturdy models. © Dirk Van Haesbroeck

BRICK BIT

Dirk Van Haesbroeck used some DUPLO elements to complete his LEGO Mario pedestal. "The floor slab of the base is made of dark tan 4 x 8 DUPLO plates. I have used hundreds of these inside the pedestal (floor and roof support under video game tiles), along with a myriad of garage sale DUPLO and LEGO filler bricks as pillars and beams." This is a great way to build really big, really fast, and from the outside, the novice is none the wiser!

For the inside of Mario's head Van Haesbroeck has used yellow bricks, as they will not show once the model is completed. © Dirk Van Haesbroeck

edly there is a much easier way, having seen the custom software that the professionals at LEGO HQ use."

"I opted for a symmetric build to save time as I only needed to conceptualize one half. In my opinion, cartoon characters lend themselves well for this approach." He made an educated guess of what he would need in each color, using his smaller Luigi model for comparison.

After approximately fifty hours of designing and planning, he was ready to begin building under the watchful eye of a video camera, which captured the building process. To keep each stage of the build as organized as possible, he set up his work station with transparent containers each storing a brick of a different color and size, and only placing colors on the table that were required at any given time. "Making use of adjustable table height is important to maintain a good building posture, and to avoid back and shoulder complaints," he said, "simultaneously the distance each brick has to travel by hand from container to model is decreased, I saved several

air miles doing so." As this model was being built to be kept for a client, Van Haesbroeck glued it together—his tool of choice? An old toothbrush!

As he stacked bricks upon bricks, building up the inner and support structure and frame of the model, he found it was "hard to make the bricks connect properly, especially around the shoulders, and the cap on top of his head." He also made some temporary LEGO scaffolding to support the arms before they were connected to the body.

In order to get the model completed in time for the LEGO World event in Zwolle, the Netherlands, at which the client would unveil the model, Van Haesbroeck made an arrangement with his work that he would work half-days for a couple of weeks, enabling him to "burn the midnight oil time and again." When he was done he said he felt "similar to finishing a marathon: exhausted but very satisfied." He has no regrets about dedicating his time to this model, which he describes as "a thing of beauty," and it's not hard to see why. But his time with Mario was short-lived because not long after the event, the model was auctioned off for charity and sold to an anonymous buyer.

SUPER STUDS

"I have a nice anecdote which illustrates the perpetuity of LEGO," said Van Haesbroeck. "The Mario model rises from the ashes of our childhoods, as he stands tall on a pedestal consisting of a lot of heavily recycled bricks originating from my own and some of my friends' childhoods. Coming full circle, the charitable proceeds of the online auction went to a children's hospital. I sometimes envision the sculpture being stored away like the Ark of the Covenant in the epilogue of the first Indiana Jones movie, as no new photos have surfaced ever since. Mario gave his life for the children!"

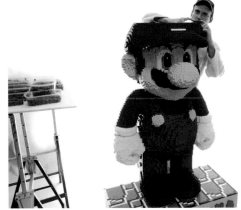

Van Haesbroeck works next to a table covered in plastic tubs of different sized bricks in one color only while he focuses on a specific section. This minimizes movement and decreases his build time.
© Dirk Van Haesbroeck

Van Haesbroeck with his Mario mushroom creation. © Dirk Van Haesbroeck

Here the builder is dwarfed by the finished model when he unveiled it at the Game Mania event. © Dirk Van Haesbroeck

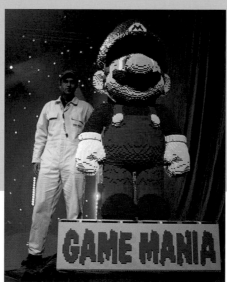

KEEP BUILDING

Want to find out how to build your own LEGO Mario mushroom? Dirk Van Haesbroeck might just tell you how—head to www.brick-projects.com for more Mario fun!

Unconventional Bricks

"Extreme is working so hard on something you're scared to show it off because you put so much of yourself into it any criticism might break you."

Steve Witt, former LEGO Community Relations Coordinator

If you've yet to offer yourself up to the plastic menagerie of a LEGO convention, where your mind and body are engulfed by previously bland exhibition center spaces, now organized zones of kaleidoscopic construction, then there are two bits of news you need to hear: one good, one bad. The bad is that you've missed out on years of blindingly brilliant building—models of such scale, such detail, such ingenuity demanding the attention of your eyes from all corners of a seemingly unending abyss (in reality, the space is determinate, but it sure never feels like that). You have denied yourself the pleasure of getting up close and personal with models you've previously only seen online, witnessing the tiniest of details, and talking to the builders behind them. You've yet to experience the thrill of a competitive build challenge, where two teams take each other on to construct a *Star Wars* Death Star in the shortest time possible. And you certainly haven't stood behind a long trestle table, while you piece together the modules of your own masterpiece, transported from halfway across the country, and heard the whispered hush of awe from your fellow builders as it takes shape before their eyes. But then there's the good news, because your first time, your first onslaught into the carnivalesque showcase of the AFOL (Adult Fan of LEGO) world, is still to come. And there's nothing like the first time.

The crowds gather around Alice Finch's Hogwarts castle at BrickCon 2012. © J. J. Williams (DmChylde on Flickr)

Expansive layouts and group displays are a distinctive feature of all LEGO conventions. © J. J. Williams (DmChylde on Flickr)

Former Community Relations Coordinator Steve Witt relished the opportunities to regularly attend conventions as part of his job. "My first one was very exciting and I got to see a lot of neat things and meet a lot of interesting people," he said. "I made friends that I still have now and hope to have for years. Oddly enough, that convention was probably the least impressive in terms of creations, and not because it was bad but because people just kept getting better after that. I always loved going to the fan conventions. I thought there was more fun and community stuff to happen there than at any corporate run event—lots of great creativity and nice people."

"Brickworld is a place where you can go to see the imagination, creativity, and engineering skills of hundreds of people on display, embodied in the world's most flexible art and engineering medium—the LEGO brick," was how Bryan Bonahoom, executive director and cofounder of Chicago's Brickworld, would describe the event, which has been running annually since 2007. Started by fifteen AFOLs who wanted to bring a convention to the Midwest to complement the times they attended the East and West Coast conventions—"Quite simply, we all wanted to be able to put more stuff on

display without having to travel across the country," said Bonahoom—in just seven years, Brickworld has grown to become one of North America's largest and most exciting LEGO fan events.

"We are honored to be considered one of the best conventions," said Bonahoon. "Our goal has always been to ensure the adult fans spending their vacation with us get as much out of their time at the event as they possibly can. Every year this has meant we have to adapt to the community. This adaptation has happily been continuously made more complicated because of the growing attendance of the event."

This blossoming convention "scene," if one can call it that without making it sound exclusive or stuffy (because it's far from both those things) exists across the world, but is perhaps most prevalent in the United States—from BrickCon, Bricks Cascade, and Bricks by the Bay on the West Coast, to Chicago's Brickworld, Texas's Brick Fiesta, New England and Virginia's BrickFairs—it's hard to find yourself far from a LEGO event, be it a big fan convention, or a small LUG-organized showcase. In a land so vast, it could come as a surprise that attendees are greeted by familiar faces with high-fives and man-hugs on arrival—that they know the other builders (if not by face then definitely by name), and that they greet newbies with warmth and admiration rather than suspicion and derision.

"I have so many friends all across the world who I share these awesome common interests with who I wouldn't have met any other way," said Gary McIntire, Master Model Builder at LEGOLAND California, who has regularly attended these events as a fan. Despite now working professionally for the LEGO machine, doing his dream job, McIntire stressed that for him the fan community is where his heart will always lie, and where he found his motivation and inspiration to be the accomplished LEGO builder he is today. "For me it's about the friendships, the connections, the people involved in the fan community," he said. "That is really what I attribute where I am now to. If I hadn't discovered the fan community I probably would have just done LEGO as a hobby on the side. I would've been this guy sitting at home in his living room, building LEGO sets and putting them up on the shelf. But people in that community inspired me to build more and be more creative."

Even the professionals get in on the action—these towers were built by LEGO Certified Professional Robin Sather and were displayed at BrickCon 2012. © J. J. Williams (DmChylde on Flickr)

The main convention hall at BrickCon 2011.
© J. J. Williams (DmChylde on Flickr)

Giant sculptures can be hard to transport, but the impact at a convention is well worth the effort— as is clear with this model at Bricks Cascade 2012 in Portland, Oregon. © J. J. Williams (DmChylde on Flickr)

That educational and inspirational feel is developed in large part by the events' organizers, who strive to offer much more than a simple space to display LEGO works. "Every event has its own personality," Bryan Bonahoom said, when explaining what sets Brickworld apart. "It is hard to put a fine point on anything specific that is significantly different. We are blessed every year with phenomenal creations. Our display space is always bursting at the seams to fit everything in. One thing that sets us apart is that we have an educational focus for the group year round. A lot of our coordinators and attendees spend their free time volunteering to help

PILE OF BRICKS:
HOW TO AVOID A TRANSPORTATION DISASTER

It's all very well building a model the size of your living room, in your living room, and admiring it from the small corner of your living room that you can still stand in. Taking that model apart and transporting it miles away from your home in a vehicle, or on a plane, or even shipping it to another country, without having to completely start from scratch the other end, is another matter. LEGO sculptures are built from a logistical medium that requires planning, precision, and perfect packing. As BrickCon Director, Wayne Hussey has seen his fair share of transportation troubles, and as a builder who likes to make 'em big himself, he knows all too well what goes into showing up at a con disaster-free.

He recommends building the model in solid, sturdy pieces, not skimping on the bricks. "I tend to over-build my big things," he said. "I build solidly and I have been fortunate to not have any major breakages during transport. Because it is a given that large models must be sectioned to be moved at all, I focus early on where to make the divides and how the individual sections can be lifted or moved and how they will rest on flat surfaces as well as on the finished model."

Chicago's Brickworld has hosted models that have travelled thousands of miles, from as far away as Australia, to show at the event. Executive Director Bryan Bonahoom reckons the secret to preserving your plastic prowess is, well, more plastic. "The one thing I would tell someone

packing a MOC (My Own Creation) to ship is to use cardboard boxes, not plastic containers," he said. "Also, wrap the creation in plastic wrap. If damage does occur, the plastic wrap will help hold the breaking pieces near where they belong instead of creating a pile of pieces at the bottom of the box."

Of course not all models are this stable and not all builders are this lucky. Hussey says over the years there have been a number of examples of models being "Lost in Transportation" for other builders, although it is not a frequent occurrence. However, getting the model to the convention hall catastrophe-free does not mean you're out of the woods. "I am aware of several disasters occurring after the model has reached its destination," Hussey said. "A good example happened at the Emerald City Comic Con in Seattle. Shawn Steele brought his six-foot-tall version of the Space Needle, placed it neatly onto a table only to have someone bump the table and the whole thing crash into a pile of pieces. The amazing part of this story is that he was able to rebuild it in just a few hours and it showed all weekend without the viewers being any the wiser. Another bad experience happened at BrickCon 2012. One of our builders was rear-ended by an inattentive driver on his way to the con. Not only was his car totaled, so were his models. He spent the weekend rebuilding."

kids with LEGO-related activities. Our motto is Share—Learn—Explore—Discover. And we work to apply these principles in everything we do."

While many of Brickworld's attendees are keen hobbyists eager to show off their work for pleasure, there are other builders who use the event as a platform to publicize their creations in the hope of making something more from the pastime. "At Brickworld, your skills can be noticed and that can earn you teaching opportunities, commissioned builds, and even opportunities to work directly with LEGO on projects," said Bonahoom. "It is important to us that people continue making these connections. It fuels the excitement of being a part of the event."

But it's not just American builders who have the opportunity to come together as construction comrades—most LEGO-buying countries have their own convention equivalents—Brickvention in Melbourne, Australia, the Great Western LEGO Show in Swindon, United Kingdom, MADBrick in Madrid, Spain, and 1000steine Land in Berlin, Germany, are just a few of them. Some builders travel from other countries to display their creations, especially at Brickworld in Chicago, which in 2011 attracted the likes of LEGO Certified Professional Ryan McNaught all the way from Melbourne, Australia. McNaught "shipped" his 250,000-piece cruise liner model of Princess Cruises *Pacific Princess* from eighties TV series *The Love Boat* all the way from his homeland to display proudly at the event. Measuring 10.5 feet long and nearly five feet high, it was the toast of the event, picking

up the award for Best MEGA Creation. It also received a surprise visit from actor Gavin MacLeod who played the real ship's captain in the TV show.

Developing quite a few years after the rise of comic-book and sci-fi convention culture, LEGO fan events were born in the early 2000s, after the birth of LEGO *Star Wars* products and online photo sharing. What began as small, hobbyist meet-ups soon escalated into public expos, where ticket-buying adults (many with children in tow) can wander around these super-eclectic convention-hall versions of LEGOLAND that embrace tongue-in-cheek humor, inventiveness, and daring. One person who's been heavily involved in the growth of such an event is BrickCon director Wayne Hussey who runs the Seattle-based convention, which takes place every year in October. Formerly known as NorthWest BrickCon the event has been running since 2002, and sees an increase in attendees and visitors each year—as well as a rise in more ambitious models. Hussey named Last March of the Ents by OneLUG (page 126), Hogwarts Castle by Alice Finch (page 36) and Ball-

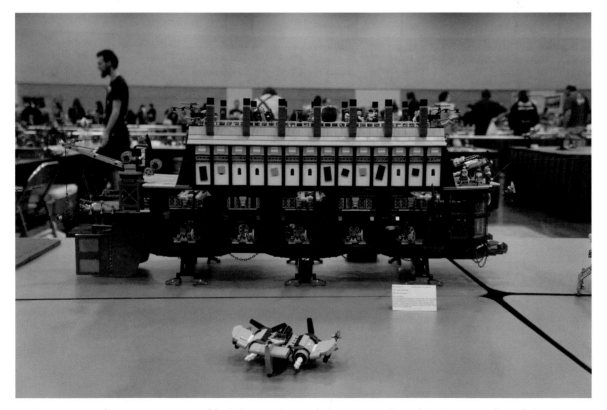

Conventions feature a variety of building styles and themes, such as this Steampunk craft by Cory Janssen, shown here at Bricks Cascade 2012. © J. J. Williams (DmChylde on Flickr)

LEGO conventions celebrate old and new—here at Bricks Cascade 2013, you can see a display of early LEGO sets sharing the convention space with modern MOCs. © J. J. Williams (DmChylde on Flickr)

Mageddon by David Schilling and the Seattle MINDSTORMS and Robotics Techies (SMART) club (page160) as some of his favorites from recent years, but conceded, "There have been so many, I can't name them all. BrickCon has always prided itself on the 'Collaborative Build' where many builders contribute to a single display. Often those displays qualify as giant models."

Building by yourself is fun, and for some it's the only way to get the job done to their satisfaction, but most of the builders profiled in this book receive help in some form from another AFOL, or they built their model as a team. "There are many advantages to group builds," said *Brick Journal* editor Joe Meno. "People can build to their strengths, so one person can place the minifigures and vehicles in place, while another lays down the roads. LEGO is very well suited to a team effort because it is flexible enough as a medium to adapt to different styles of building. A layout can be divided out on a grid for people to build, or divided out by buildings and roads, or however the group wants. The only things that needs to be defined are some initial dimensions and maybe standard joint points, and everyone can contribute."

LEGO conventions like Brickworld fiercely encourage this kind of collaborative creativity, believing it encourages a fresh approach to building and results in spectacular large layouts. "Most of the building that occurs at Brickworld is collaborative in nature," said Bryan Bonahoom. "People are working on planned collaborations where some building occurs before the event and they are integrating the creations into stellar layouts that are seamless worlds of their own once they are completed. At Brickworld we encourage collaboration with the collaborative castle, the M-Tron mining planet, the Micropolis layout, and more recently the collaborations that are created by the Eurobricks and VirtuaLUG contingents that try to set the bar higher and higher each year with brand new themes for their collaborations, each involving ten to twenty people from around the world."

With a growing number of builders digging deep into their LEGO boxes to pull out a build of spectacular detail and proportions, one of the benefits of encouraging builders to buddy-up is it enables a convention space to incorporate the work of more individuals. "We want each person to bring a little less, make sure it is something new, and spend the time on quality," said Bonahoom. "Detailed modules for collaborative displays are a wonderful opportunity for people to show off their talent and still see their stuff in a big display." He explained that another pro of bringing less means there's more time for builders to have fun at the convention and talk to other builders, rather than spending a large chunk of the weekend constructing and dismantling their work. "Of course, we will never say no to large, cool displays and every year we see some different ones," he said. "So, the event isn't so much developing alongside the changes as helping drive the changes to get people to work together and learn more from each other."

Carlyle Livingston II and Wayne Hussey worked together to give life to their Batcave model (on page 132) and found the joint effort rewarding and motivating. "Collaborating with Wayne went very smoothly," said Livingston. "We each brought different skills to the project and we respected each other's ideas and concerns. Of course there were moments where we each wanted to go a certain way but it was very easy to compromise once we had listened to the other's position. We gathered images from the Internet to use as inspiration and as a way to convey to the other what we were picturing; after all, an image is worth a thousand words." Some parts of their model

Various accolades are awarded to convention attendees, and the trophies themselves are usually as creative as the MOCs they're celebrating. © J. J. Williams (DmChylde on Flickr)

were built exclusively by Hussey and some by Livingston, their planning and ability to compromise resulting in a flawless creation that appears to come from one cohesive point of view.

The one definite pro of flying solo is when you take your model to a convention, stand behind it, and watch people's faces as they take it in, questioning whether you really made it from LEGO bricks, because it looks so good, you're the only one who gets to take the credit. "I had mothers thanking me for setting an example for their daughters," said LEGO Hogwarts creator Alice Finch of the first time she showed her model to a public crowd. "Grown men wanting a picture to prove to their wives and girlfriends that women could and did in fact play with LEGOs, and plenty in between who were so completely in awe that they were speechless." And while the reaction of other LEGO fans is certainly not the sole motivation for building for most AFOLs, it's certainly a nice perk, as Carlyle Livingston II explained. "I don't create my MOCs to get attention. I create them because I have an idea that I want to see become a reality. But . . . " he paused, "it sure is great when you are recognized by your peers and LEGO fans far and wide for creating something special. When our Batcave went viral it far exceeded any expectations of what kind of a reaction we thought we might get. It's a great feeling to see others enjoy my creations as much as I have admired all those who came before me and are creating more even now. My motto is: 'Just keep building!'"

By showcasing a model at an event where it will be photographed and blogged about, such as Brickworld or BrickCon, there is a good chance it will reach beyond the AFOL community, appearing on non-LEGO sites, and even in newspapers or on TV. This is particularly true of large-scale models and hyper-detailed creations, which appeal to non-LEGO fans for their novel approach or take on a subject. Joe Meno said the subject matter of a model is usually key to its ability to go viral, more so than its scale or building methods employed. "Any model that is 'great' will be noticed. That said, some things will be noticed faster than others, depending on what the model is." He explained that a model that features a popular character or locale from a sci-fi show or film franchise, such as Adrian Drake's model of *Serenity* from *Firefly*, is likely to go viral very quickly due to the sci-fi fans blogging about it, irrelevant of the LEGO content. "The paradox that I see is that the web allows a lot of really 'well-presented' models to get exposure," he said. "The web doesn't really allow a viewer to truly experience a model in all dimensions like a sculpture, so there is a bit lost in the translation to a webpage. What that also means is that the builder can control what is seen online (a model may not be all that stable), which is why I like to go and see things at events."

Fan conventions and events are more than an opportunity for adult builders to hang out, display their models, and chew the fat on the latest LEGO building theme. They also provide younger builders with the chance to come and see what the toy that they play with is truly capable of. Most AFOLs don't 'play' with LEGO bricks, they build and sculpt with them, and they use them to express themselves. This can be eye-opening for young builders, and those in their early teens. Jordan Schwartz, who spent a one-year internship working as a product designer at LEGO when he was

just nineteen years old, attributes his building skills and professional success to the AFOL community he witnessed, both online and in person at conventions. "There's no question that if it wasn't for the LEGO fan community and the work other AFOLs have produced over the years, there's no way I would have continued to build and had the opportunity to work for TLG."

Schwartz joined the online fan community in 2006 and attended his first convention in 2009 as a teenager. "Naturally, this age is a very defining time in a person's life, and there could've been countless other pursuits I might've kindled a fondness for," he said "But the act of pouring over other fans' models kept sucking me into the community, deeper and deeper, until I finally began posting my own models. I really looked up to the elite builders of those years and strived to make models that looked as good as theirs. Throughout this process of emulation, I began to develop my own building style. But ultimately, there was always another AFOL's model that was serving as the inspiration for my own."

When children and teens attend events like BrickCon in Seattle and see some of the country's most dedicated AFOLs' huge, highly detailed creations, director Wayne Hussey hopes they'll come away with more than a bag stuffed with customized minifigures and LEGO T-shirts. "I hope that children are inspired to do what they dream more than 'go get lots of LEGO,'" he said. "People who build extreme models don't do it to sell LEGO, they do it to feed their passion; to find out if they can surmount the challenges of doing something so big or that no one else has done before. Feeling free to imagine and explore—that is what I want children to take away from our exhibitions."

SEATTLE SPACE NEEDLE

By Wayne Hussey

FACTFILE

Build location: Seattle, Washington
Year completed: 2012
Time taken: Designed, redesigned, and built over a period of fifteen years. Final redesign and build took six months.
LEGO elements used: 55,000

© Chris Blakeley

WHAT IS IT?

Wayne Hussey's Space Needle model is a reproduction of the world-famous Seattle landmark, as it appeared when first unveiled in 1962. "I don't really remember when I first decided I wanted to build a model of the Space Needle," said Hussey, "but I almost can't remember not wanting to. I do know that I began researching it about fifteen years ago. I remember vividly having my twelfth birthday up in the revolving restaurant (in 1966). The Space Needle is one of the most iconic landmarks in the world. Anyone who sees it knows that they are looking at a part of the Seattle skyline." It was the structure's fiftieth anniversary in 2012 that spurred Hussey on to redesign and finish the model.

Over the fifteen-year period he worked on the design, the scale evolved from a twenty-five-foot-tall version (Miniland scale) to ten feet tall, and then to its final height of fourteen feet, close to minifigure scale, weighing in at around 150 pounds. It is comprised almost entirely from LEGO System parts, and incorporates around two thousand hinge parts, all

in the colors that resemble the original Space Needle as closely as possible—white, orange, gold, black, and grey. And of course no observation deck would be complete without smiling tourists enjoying the view—this model features around one hundred minifigure versions of Seattle's sightseers.

MEET THE MAKER

Wayne Hussey lives in his hometown of Seattle, Washington, with his wife Teri who is also an AFOL, and said he has been strongly influenced by the

© Chris Blakeley

KEEP BUILDING

Wayne Hussey is the director of BrickCon. Find out how you and your models can be part of the action at www.brickcon.org.

region in his LEGO building. While he built with LEGO toys as a kid, his collecting hobby didn't really get going until the 1980s when he decided he wanted to try and own at least one of *every* element LEGO has ever produced, from all of the LEGO themes and building streams. He said he is ninety-five percent of the way towards achieving his goal.

By the nineties he had come to realize his passion for building big and the fruits of his labor included six-foot-tall models of a 1950s rocket and the Empire State Building. He previously worked as a printed circuit designer, but after being laid off in 2001 finally found the time to tackle a seven-foot-long model of the Washington State ferry *Issaquah*, which debuted at the first BrickCon, and he has been debuting a large-scale model there almost every year ever since.

Hussey has been a member of PNLTC (Pacific Northwest LEGO Train Club) and SEALUG (Seattle Area LEGO Users Group) since 1999, seeing the latter grow from a handful of members to one of the largest AFOL communities in the United States. He has been the director of BrickCon for the last few years,

and continues to build big. His dream MOC would be a minifigure-scale Starship *Enterprise* (from the *Star Trek* original series) which would measure about thirty feet long, fifteen feet wide, and twelve feet tall.

THE PROJECT

Research was the word of the day when it came to producing this highly detailed scale model. Hussey referred to whatever books, magazine articles, and photos he could get his hands on, and visited the Space Needle several times to fully understand the details that he wanting to replicate with LEGO elements. "I now have a half dozen books that show aspects of the Needle I didn't know about

These images show the construction of the tophouse, the model in Hussey's garden, and a close up of the model's elevators.
© Wayne Hussey

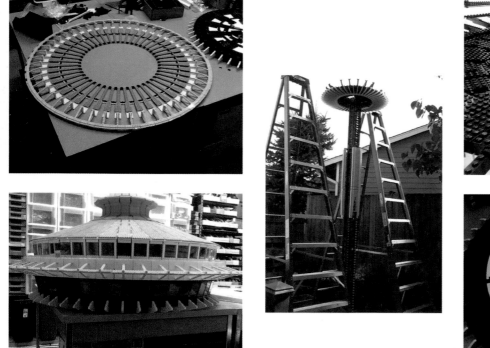

By altering the width of the leg supports by a minimal amount using plates as well as bricks, Hussey was able to capture the narrowing gap between the Space Needle's legs. © Wayne Hussey

before," said Hussey. "I also purchased two *LIFE* magazines on eBay that highlighted the Needle right around the opening of the 1962 Seattle World's Fair."

"The Space Needle is a disk, actually several disks, placed on top of three sweeping legs with a triangular profile. None of that is 'square' like LEGO bricks. So a lot of my planning was experimenting with various arrangements of bricks that would give me the shapes and the structure I needed to build something this large." The majority of Hussey's experimentations involved the tophouse part of the model, with many hours devoted to deciding how many studs in each direction the circular top of the model would be—the final scale of this part of the model determining the overall size of the Needle.

Despite appearances, Hussey said this is not a true scale model. "With the tophouse the size it is," he said, "I would have had to make the legs at least two feet taller to keep 'true' scale." Hussey was reluctant to build the extra two feet knowing it would require expensive lift equipment to be assembled, and was persuaded by fellow builder and friend Carlyle Livingston II that eleven-foot, rather than thirteen-foot, legs would be satisfactory.

"I designed a steel plate that would rest on top of three steel poles that were hidden in the core and attached at the base and held firm with a heavy bottom plate," said Hussey. "The entire structure is encapsulated by the LEGO and the armature would act similarly to the real Needle's "bridgework" to keep it up if sway was imparted to the structure. It may be difficult to believe, but this armature does not actually hold up the tophouse. . . . The whole of the Needle—including the thirty-pound top plate and fifty-pound tophouse is resting on the LEGO bricks. LEGO is a pretty cool material."

© J. J. Williams
(DmChylde on Flickr)

"I designed the core in sections that stack on top of each other (around the armature tubes). . . . The legs attach to the core after the core is put up. After the legs are in place, I add the interlocking triangular levels, which brace the legs and make them much more stable. Finally, the tophouse is made of six sections: the 'bowl' which starts at the ribs that can be seen when looking up and continues up to the top of the restaurant; four quarters make up the halo and observation deck, and the very top piece."

"The build was relatively smooth because I had spent so many years with it that there were few things I hadn't spent some time thinking about," said Hussey. "Those areas I did change were of minor details." And while he did have a number of conceptual problems during the build, and had to make some concessions—notably not having motorized elevators or a rotating restaurant—he was supported by Livingston, who designed the elevator cars and Tom Rafert, especially during installation.

Assembling the model for the first time at BrickCon 2012 was an emotional and risky experience for the builder. "I am, like most people, afraid of heights. Yet there I was, up and down a twelve-foot ladder putting sections on this huge monster. I hadn't expected the final assembly would be dangerous, but it was." When the build was complete, there was one word that sprang to Hussey's mind, "Relieved! I was never sure until I finally started it that it would ever be completed. . . . When I was done putting it together and I looked at it whole, I felt quite a bit of pride that I had finished."

"The reaction by the public and other AFOLs was extremely favorable. It seemed as if everyone just *had* to have their picture taken next to it," he recalled. "When I actually had time to stand next to it myself during the Public Exhibition, there were many people who wanted to know how I "did it." I gave my best description. Most asked, 'How long did it take?' I answered, 'Six months and fifteen years.'"

SUPER STUDS

To give this model an added sense of realism, Hussey carefully studied and tried to replicate the narrowing gap between the real Space Needle's legs as they rise from the ground. "The legs are separated by ten studs near the ground and eight studs where they connect to the core," he said. "I achieved this by using a SNOT technique that turned the bricks. This is based on some of the numbers of LEGO: five plates stacked together and turned sideways have the same dimension as a two studs (bricks). My build needed to evenly narrow by five plates. I built five sections that varied by one plate in height (length). I needed these sideways plates/ bricks to be attached the same way at each end. That meant either both ends had studs out or studs in. It was by far easier to make them studs in. I used a pin-to-pin connector hidden inside my beam to change the orientation of the bricks to studs in."

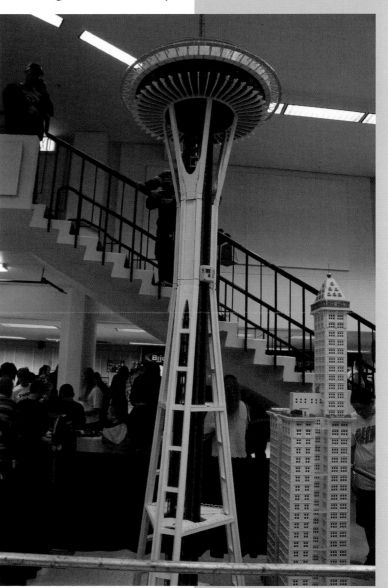

The model towering above the crowd at BrickCon 2012. © J. J. Williams (DmChylde on Flickr)

THUNDERBIRD 3

By Gary Davis

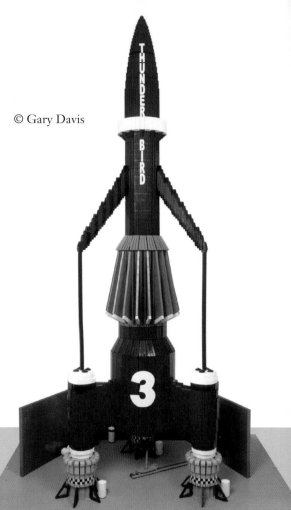

© Gary Davis

FACTFILE

Build location: Hertfordshire, United Kingdom
Year completed: 2012
Time taken: Built over a ten-month period in conjunction with many other projects.
LEGO elements used: 15,000

WHAT IS IT?

"I have been a big fan of *Thunderbirds* since I was boy," said Gary Davis, the British builder behind this six-foot-high red rocket, built in minifigure scale. For those unfamiliar with the cult 1960s puppet-centric television show created by Gerry Anderson, "it was about a secret rescue organization called International Rescue, run by Jeff Tracy, a millionaire former astronaut. Each of Jeff's five sons piloted a different Thunderbird craft."

Davis's model is Thunderbird 3, a spacecraft piloted by character Alan Tracy on the show. The craft was involved in rescue missions, and served as a shuttle between the Thunderbirds' secret island base and their orbiting space station Thunderbird 5. "I had previously built a 1.2-meter-long [four-foot-long] Thunderbird 2 LEGO model, and I decided a Thunderbird 3 would be my next big project."

MEET THE MAKER

Hailing from Hertfordshire in the United Kingdom, Gary Davis, whose day job is as a consultant in the field of ergonomics and human factors, is a member of the Brickish Association, and as of

KEEP BUILDING

Want to check out Thunderbird 2 and Gary's London 2012 Olympic Aquatic Center? Head over to www.Flickr.com where he goes by "Bricks for Brains."

2013 is the organization's LEGO Ambassador. But his love of the brick began many years before. "I was given LEGO sets as a kid and loved creating new things from the limited elements then available," he said. "I always had some LEGO parts around at home, but when my wife bought me the X-wing UCS model (7191) one Christmas, I became seriously hooked and started building again and I began to expand my stock of parts beyond my wildest dreams as a kid."

Davis maintains a strong presence at United Kingdom and European LEGO events—"I attend six to eight LEGO events each year, mostly in the UK but also in Denmark. In 2012 I exhibited at several events including: the LEGO Fan Weekend in Skaerbaek, LEGO weekend at the National Space Centre in the UK (an event

Gary Davis standing next to his Thunderbird 3 model.

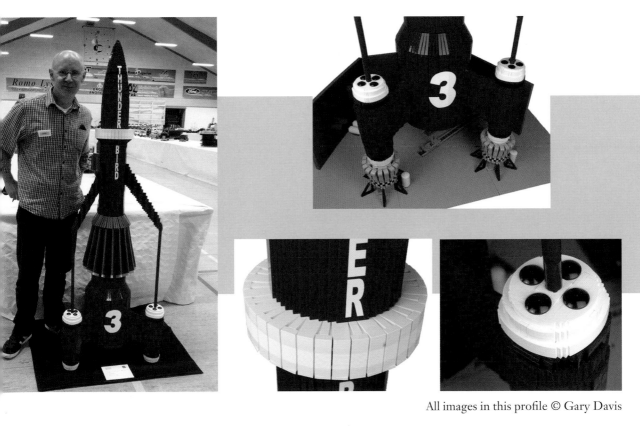

All images in this profile © Gary Davis

119

© Gary Davis

that I organized), and at the LEGO Show in the Swindon Steam Museum, UK."

Other than his Thunderbird 2 and Thunderbird 3 models, Davis is known in the community for his life-size bust of Yuri Gagarin, and a 2.4-meter (nearly eight-foot) replica of World War II submarine the USS *Pampanito*. And while Davis's collection has certainly grown since childhood, like all big kids he still has building dreams beyond his means: "I would love to build a full-size super car—preferably one with lots of curves!"

THE PROJECT

"My design training certainly informs my LEGO building, particularly the conception and planning stages," said Davis. This is clearly evident by the methodical way he plotted out the scaling and construction of the Thunderbird 3 rocket. Delving into his own extensive collection of *Thunderbirds* memorabilia, Davis stumbled across his main reference material—"I found some drawings of TB3 in a Japanese publication that I considered to be reasonably accurate to the original large studio model."

Once he had the most accurate visual inspiration, and had decided he wanted a model of approximate minifigure scale, Davis turned his thoughts to how to construct the craft.

"For these larger MOCs, I prefer to work from full-size paper plans," he said. "I enlarged some key parts of the TB3 plans to three slightly different sizes and started to explore which size would be best in LEGO to create the required external profile and internal structure. The key was the central finned section that has 18 vertical fins plus a conical section. Once that came together, it defined the scale for the rest of the model." Davis took this test-building approach for each successive part of the model as the build progressed, saying, "It was a deliberately slow build. I wanted

to take my time resolving the various challenges as best I could without time pressure."

Due to the streamlined nature of the Thunderbird 3 rocket, David decided to build "studs out" and clad the outer layer of bricks with lots of tiles. This also served a functional purpose, providing space for the internal structure created using cross-braced Technic beams. "Sculpting the nose section proved quite challenging and took some thinking about," Davis said of the build's challenge. "I was very happy with the way the three red and black fins worked out in the end. With studs-out in opposite directions, I used old-style clip hinges to keep the fins as thin as possible."

After fitting in building around the rest of his life, and in between other LEGO projects, TB3 was finally realized in LEGO bricks, although the model's completion was bittersweet, because of how much Davis had enjoyed the build. "I'm quite pleased with it. It's a pretty good representation of the studio model used for filming," he said, before admitting, "There is room for improvement, particularly regarding stability. I should have made larger mating surfaces between the four sections of the rocket. When the sections are fully stacked, there is a certain amount of sideways wobble which is a little disconcerting when it's standing on a table and looming over small children!"

But disaster has so far been avoided, and the public's reaction has been great for Davis to see after displaying the model in Denmark and back home in the United Kingdom. "The reaction was really positive in both venues. However, in Denmark far fewer people have heard of *Thunderbirds*, whereas in the UK, it's more of a national institution and people were far more excited to see TB3 as part of our Gerry Anderson display."

SUPER STUDS

Being such a huge fan of the TV series, Davis knew it was important to accurately represent the rocket's colors, but was also familiar with the limits of the LEGO color palette. "TB3 was a

slightly orangey red in the series, but the closest LEGO color is definitely red," he said. "The various white and black trim details and graphics have all been represented as closely as possible. The central fin section is accurately represented in dark gray with yellow tips and blue trim strips."

EXPERT ADVICE

Are you a huge fan of a cult TV show, comic-book series, or movie, and want to build your favorite space ship, base, or character from LEGO bricks? Read on for Davis's top tips . . .

- "When building a representation of an existing design, get hold of plenty of reliable reference material, including scale drawings if available."
- "Think about the structural design of the model, so that it is strong enough both for display and for transportation."
- "Don't rush, take your time and enjoy it."

SUPERHEROES

By Evan Bacon

FACTFILE

Build location: Austin, Texas
Year completed: 2011–2012
Time taken: 320 hours
LEGO elements used: 52,000

© Evan Bacon

WHAT IS IT?

Most superhero fans are happy to settle for seeing their favorite caped crusaders in the latest singles or in big-screen adaptations, but one Texan teenager has taken his love for Marvel and DC to a whole other LEGOy level. Evan Bacon's life-size models of Batman, Iron Man, and Superman incorporate over 50,000 bricks and seven super-bright LED lights between them, and have been delighting superhero fans at LEGO conventions and local events in Texas. There's no doubt that Bacon's favorite of the trio is Batman—"Since I was very young, I have always loved Batman," Bacon said. "It was no surprise to anyone who knows me that I built my own life-sized Batman model. It was thrilling that I was able to take my model to an event with the original Batman—Adam West—and he loved it."

MEET THE MAKER

Unlike many of the AFOLs featured in this book, high-schooler Evan Bacon is still enjoying his original wonder years with the

Evan Bacon standing with two of the three large superhero models.
© Evan Bacon

plastic bricks, and he's been working hard to improve his building skills. "I first began playing with LEGO kits when I was eight years old. I moved up to the LEGO MINDSTORMS kits, and I began building robots that would alert me to my siblings coming into my room! I then started creating my own masterpieces. I had built a few life-sized heads of Batman and then bravely decided to try a full-size Batman. It took me many attempts to go from the foot to the top of his leg." When he's not building with LEGO bricks or attending school, Bacon works as a chef at a cupcake bakery and does computer programming.

THE PROJECT

For all three models, Bacon spent time researching using comic books, movies, and the Internet, to accurately depict the characters' muscle toning, their outerwear, and any potential lighting features he might be able to incorporate. "I actually conceptualize my plans by sketching them on brick pads that I created," he said. Bacon also thought carefully about how each superhero was going to be posed: "I think about my next project while I'm studying or working. I try to plan poses that elicit the viewer to feel like they are seeing the character in action."

Good planning and accuracy are key for when Bacon starts a build. "I always pre-build any unusual curves before the final build. I take time to make sure the foot is properly positioned, the muscle tone is accurate, the height is true to life, the costume design is accurate, and that it all looks natural." While Bacon's models may be considerably larger than what most teenagers are working on in their bedrooms, his main challenge will be familiar to any LEGO fan—finding enough bricks to build what he wanted, the way he wanted to build it. Fortunately his family understands and appreciates his hobby. "I home study and my family has always been supportive of my creative side. I am able to do my studies, do my computer programming, work and build as needed." He even built the Superman model for his brother, who is a huge fan of the Man of Steel.

And is all that hard work worth the effort? Of course it is! His models have been voted for People's Choice, Youth Creation, and Best Artistic awards at Brick Fiesta in Texas. "I love the feeling when each model has been completed," he said. "They are a reflection of me and what I have created. Each of them represent an improvement in my building skill set. And Bacon's best tip for other teen builders—"Be good to your parents, as they are the transport for all things LEGO."

To see what this extreme teen is building now, head over to his website www.baconbrix.com.

LAST MARCH OF THE ENTS

By OneLUG: Brandon Griffith, Bruce Lowell, Remi and Alyse Gagne

FACTFILE

Build location: Los Angeles, California
Year completed: 2011
Time taken: Designed and built over eight months
LEGO elements used: 100,000+

WHAT IS IT?

What began as Remi Gagne and Brandon Griffith's plan to build a single Ent model—the tree-like creatures from J. R. R. Tolkien's fantasy novel series *The Lord of the Rings*—resulted in this highly detailed depiction of one of the most epic scenes from *The Two Towers*—the second film in Peter Jackson's trilogy—known as the Last March of the Ents. "Having lunch after a local LUG meeting, we were talking about *The Lord of the Rings* and speculating on what elements from the films would be interesting to build," said Brandon Griffith. "We first decided on an Ent, but as the conversation progressed, building one Ent turned into building several Ents, and building several Ents turned into building a small layout for them to stand on."

The two builders soon found themselves wanting to incorporate minifigure Orcs (the henchmen villains of the Ents), and because they would

© OneLUG

© OneLUG

be going to all that effort, they decided they might as well complete the scene with the looming tower of Orthanc. "A couple of Italian beef sandwiches and a milkshake later, OneLUG was born." Alyse came on board because of her strong knowledge of Middle Earth, and Bruce Lowell was recruited for some minor additional help, although he ended up building the top half of the tower.

The result of OneLUG's hard work is this incredible scenic creation. The Last March of the Ents has a diameter that measures 305 LEGO studs (or eight feet), and a tower that stands at 228 LEGO bricks (seven feet, two inches) tall. In the end the team ending up using over one hundred minifigure Orcs, thousands of translucent 'water' pieces, and building not one, but twenty-three Ents.

MEET THE MAKERS

Building this inspirational *Lord of the Rings* model is not the only thing OneLUG's members have in common. They all grew up as LEGO fans, and came back to the hobby as adults in large part because of another hugely successful fantasy franchise—LEGO *Star Wars*. "Like a lot of thirtysomethings, I got sucked into LEGO when LEGO *Star Wars* hit the scene," said Remi Gagnes. "But the Ultimate Collector X-wing is what showed me that LEGO could be used as a serious medium for self-ex-

The OneLUG model from above highlights the effectiveness of the circular layout. © OneLUG

© OneLUG

pression. Ever since, I've been trying to build stuff no one else has tried."

And he wasn't the only one. Bruce Lowell said, "I don't remember a time that I didn't have a stash of LEGO at home.... I would go through seasons of building with my LEGO but once the *Star Wars* theme was introduced in 1999 I was hooked!" The four builders, united by their love of film and fantasy, have a sound designer, a software engineer, and a web development manager between them, and all live in Los Angeles where they are "active members of LUGOLA and long-time regular BrickCon attendees. We have also displayed our creations at Bricks by the Bay and with STUDS at Designer Con (an art and toy convention) as well as the Unexpected Art Show by TheOneRing.net."

THE PROJECT

"What appealed to me most about this particular project was working with such a talented group of builders (who are also great friends) who had such a clear vision of what we were building and how to achieve it," said Lowell. In order for the build to be a truly

collaborative effort, organization and planning were key. Approximately three weeks were dedicated to planning the build, using the battle scene from the film itself, fan-created art, sculptures, and concept drawings by one of the films' lead artists Alan Lee to create blueprint sketches vital to calculating the scale of the finished model.

"The tower of Orthanc was designed first with its height determined by key arches on the side of the tower," said Griffith. "Close examination of the reference material combined with some experimentation helped decide which standard LEGO arch would work best to replicate these key features. Once that was complete, simple math was done to determine the scale and the final height of seven feet, two inches."

"We drew up plans and split the tower into five sections, which Bruce, Remi, and I then built. It took several months to begin to see results, but in late April 2011 we were able to stack the tower sections for the first time and get a real idea of how large this layout would be. We finished the tower in June and began working on the base."

"For the layout, we knew we wanted to do a circle and considered making it either six or eight feet in diameter. We decided on eight feet because we felt it complemented the tower and provided enough space for all of the Ents. The Ent frame that we ended up

KEEP BUILDING
To see more from the OneLUG team head over to www.Flickr.com/onelug.

By building the model as a group. OneLUG were able to come up with twenty-three different Ent designs that populate the model. © OneLUG

using was designed by Bruce Lowell. We each built upon that design and ended up with twenty-three completely unique Ents to populate the layout."

The long and challenging build required the team to confront issues together as they arose. "We often underestimated the amount of bricks we would need, particularly black elements for the tower itself and dark tan plate for the layout, not to mention the various brown pieces needed for the Ents," said Griffith. "Working on a group build has the built-in advantage of having other dedicated builders to bounce ideas off of and help work out solutions to the building challenges that inevitably arise."

The Last March of the Ents model has been displayed at BrickCon, Bricks by the Bay, and Designer Con. "The public often seems awe-struck at the size and surprised that it is actually made out of LEGO!" said Griffith. And what of the model's future? Who got to keep it when the building was over? "As far as the bricks used in the model, the layout has been dismantled," he said, "but the tower is intact and we maintain joint custody of it."

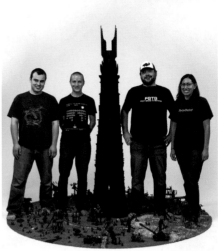

The OneLUG team stand beside their impressive creation. © OneLUG

SUPER STUDS

Teambuilding was the name of the game when it came to One-LUG's the Last March of the Ents, and the four builders have some useful techniques for putting a build of this scale together as a group. "Although we live relatively near each other, we were not able to build together every day, so keeping in contact with each other regarding the progress of our builds was essential," said Griffith. "Email and Flickr proved invaluable in coordinating our efforts between group build sessions. . . . We were able to divide up most of the model so that we could individually work on different sections. Many weekends were spent assembling, re-assembling, and improving our sections until everything fit together to create the whole model."

© OneLUG

EXPERT ADVICE

Think you and your friends could take on the OneLUG quartet in a battle to rival Middle Earth's most deadly onslaught? Maybe heed a little of their advice first . . .

- "When creating something from a film or TV show, do your research! Gather as much reference material as possible."
- "Be respectful to the original. Remember, there is a reason reference material is so popular and if you want your model to have that same spark, try to be as accurate as possible."
- "Plan to build modular. Think about how your creation is going to travel and pack. Sometimes builders don't take that into consideration and when it arrives at a convention, you spend a lot of time with fixes."

© OneLUG

BATCAVE

By Carlyle Livingston II and Wayne Hussey

FACTFILE

Build location: Seattle, Washington
Year completed: 2012
Time taken: 800 hours over forty-five days between two builders
LEGO elements used: Approximately 20,000, but probably more.

WHAT IS IT?

Yes, of course it would be amazing to be as rich as Bruce Wayne and build your own Batcave under your giant mansion. Failing that, why not recreate the whole thing in LEGO bricks and show it off to your friends without the hefty electricity bill, just like LEGO fans Carlyle Livingston II and Wayne Hussey? Weighing in at over one hundred pounds, this shadow box–style model of Batman's lair incorporates four Power Functions motors and features the Bat-mobile on a motorized turntable, the Batwing on a motorized lift that can be raised into launch position with a jet-blast deflector, the

Carlyle Livingston II and
Wayne Hussey with their
Batcave model.
© Carlyle Livingston II

Batboat docked and ready for the open waters, and Batcycles (including Bat-bicycle). There is also a Batsuit/weapons wall, which is motorized too, so it can rotate to reveal Batman's selection of suits on one side and his armory on the other. Measuring at fifty-one inches long, thirty-two inches deep, and twenty-two inches tall, the exceptionally well-lit cave (using non-LEGO lighting to create the most atmospheric model they could) also includes four minifigures—Batman, being served a refreshing drink by butler Alfred, Robin refueling the Batboat, and a skeleton who has perished in the pit. "The Batcave is our unique interpretation of Batman's lair," said Livingston. "We based it on many influences from our love of the Batman universe.

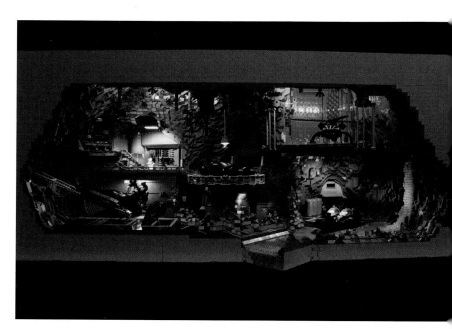

© Carlyle Livingston II

Some of the influences include the original comics, the 1960s television show with Adam West and Burt Ward, the 1989 Michael Keaton Batman film and the recent Dark Knight films."

MEET THE MAKERS

"Building with LEGO has led me to a fantastic community of

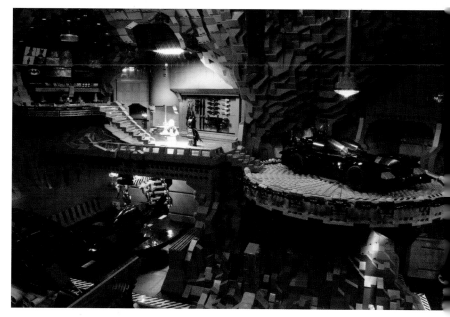

© Carlyle Livingston II

builders, who are inspirational to me and just darn fun to be with," said Livingston, who returned to LEGO building as an adult after a long career making models, sets, and props for the film industry. "I've also found that the limitations of LEGO create a need to problem solve and I find it to be part of the fun."

Livingston now works creating apps for mobile devices, so he finds LEGO fulfills his need to make something tangible. He lives on an island near Seattle, Washington, and together with Wayne Hussey is an active member of SEALUG, one of the biggest LEGO communities in the United States. The LUG also has a number of opportunities to exhibit their work, most notably at BrickCon, of which Hussey is the director. "Seattle is a hotbed of LEGO activity," said Livingston.

If he had access to an unlimited number of LEGO bricks, unlike Hussey (who would like to build the Starship *Enterprise* from Star Trek's original series, he would build the Starship *Enterprise* from *Star Trek The Motion Picture* "as a huge model with interiors! Or maybe Tracy Island from *Thunderbirds* with all the vehicles. That would be cool."

To find out more about Wayne Hussey, read the profile of his Seattle Space Needle on page 112.

To find out more about Wayne Hussey, read the profile of his Seattle Space Needle on page 112.

BRICK BIT

The roof of the Batcave uses a method that Wayne Hussey calls "Brick Plywood." By alternating the direction of the studs on the LEGO bricks, and integrating the layers with Technic pins, Livingston said, "Wayne was able to make a structure that spans almost four feet across the front of the model with virtually no sag. That's quite a trick!"

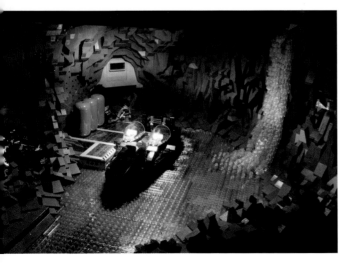

© Carlyle Livingston II

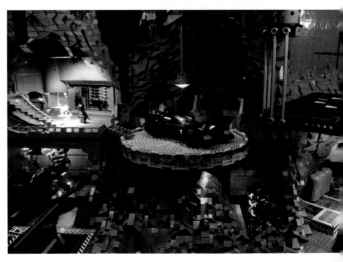

© Carlyle Livingston II

Gray LEGO parts were assembled in a random formation to recreate the natural-looking rocky appearance of the cave ceiling, while remaining structurally sound.
© Carlyle Livingston II

© Carlyle Livingston II

THE PROJECT

A model that involves motors, lighting, and is transportable, such as this one, involves a degree of forward planning, and building as a duo requires even more. "Wayne and I spent many hours discussing what we were interested in seeing in a Batcave," said Livingston. "Once we had decided on the basic elements Wayne made a small mock-up of the cave in LEGO. I started building the vehicles and we each made prototypes of different parts of the cave to work out how many pieces we would need, and in how many colors, to achieve a pleasing look to the rock surfaces of the cave." Once they had built the vehicles that would be housed inside the cave model, they were able to figure out the overall dimensions required for the structure.

Of course, building with a buddy isn't as simple as flying solo. "Fortunately, Wayne and I had the time to put into this project," said Livingston. "The real challenge was that I live forty miles from Wayne and have to take a ferry to get there. This was the type of project that had to be done in one place, and he has the much larger

KEEP BUILDING
Find Carlyle Livingston's other models and more wonderful Batcave photographs on www.Flickr.com by searching "co2pix."

135

LEGO collection to work from, so we did 95 percent of the work at his house. This project was so much fun that I didn't mind the travel!"

"Wayne's mock-up was the only design document we created besides a few crude pencil sketches. We both have enough experience building that we could dive right in and start putting parts together. We literally built from the ground up," he explained. "Once we had the width and depth decided we built the base and laid out where the major components went. Wayne started with the turntable and I began the lagoon where the Batboat would be located."

To make sure the build process went as smoothly as possible Livingston and Hussey made sure they discussed all major steps along the way. "It was especially important to stop and look at potential problems and work together on fixing them. Wayne is one of the most knowledgeable people when it comes to LEGO and what parts there are and how to best utilize them. I also have a huge amount of experience designing three-dimensionally. By combining these talents, we were able to create something better than either of us could have done on our own."

Some examples of this model's ingenuity are the rock work, the mechanisms, the way it's lit, and the roof structure. About the latter, Livingston said, "I had to try and achieve complete randomness so that it would look like naturally occurring rock formations. While considering the appearance of the rock we had to make sure that it was structurally sound while using the minimal number of pieces so that we could keep the cost down and not add too much to the weight."

The Batwing on a motorized lift ready to launch through an opening in the side of the model. © Carlyle Livingston II

Under construction—the model can be seen here in moveable sections before all the final details and roof have been added. © Carlyle Livingston II

It sounds like the experienced pair's biggest problem was being able to fit all their clever ideas into the model. "We just ran out of space," Livingston explained. "Wayne had built a rogues gallery of villains and it just didn't make it in. . . . You always want to add one more thing. And we are our own worst critics. We know where those two pieces are that don't fit together quite right or where we wanted to add some feature but ran out of time or space. In spite of all that, I think it's one of the best models I've ever been a part of. I'm very proud of what we accomplished."

SUPER STUDS

"The Batcave is very dense visually, so it has many features that we are proud of," said Livingston. "One thing that we really wanted to achieve was a sense of depth, giving the impression that there is even more to the model than meets the eye at first glance. There are tunnels leading offstage. There are hidden treats that require you to move to a different angle to see them. Behind the hangar for the Batwing is another area that we think of as leading to a runway where the Batwing could land. If you look through the doors of the hangar you can just make out a rolling stairway like you would find at an airport. All this creates a feeling that there is even more than what you can see. It makes each person's imagination fill in what might be there, and that adds to the overall enjoyment of the Batcave."

Taking on Technology

"The possibilities really are endless."
David Schilling, member of Seattle MINDSTORMS and Robotic Techies (SMART)

For many years LEGO has dominated the construction toy market, bringing out theme after theme that have inspired and delighted fans (with a few digressions that it's best not to mention). But while there were some earlier forays into programmable bricks and sensors using the LEGO Technic line, it wasn't until 1998 that the LEGO Group (TLG) took a significant leap into the domain of toy robotics. Emerging around the same time as less memorable themes—Aquazone, Adventurers, a rebranded girls' line called Scala, and a new building system called ZNAP—as well as the year TLG reported its first ever deficit, LEGO MINDSTORMS, a seemingly nerdy add-on to Technic building, has enjoyed a triumphant longevity like little else from the period.

The line was named after Seymour Papert's 1980 book *MINDSTORMS: Children, Computers, and Powerful Ideas.* In it, the author puts forth the advantages of computer-based learning for children. With all that gray and endless educative potential it would be easy to mistake MINDSTORMS as a standalone story in the LEGO canon, but not only was MINDSTORMS designed to function alongside the LEGO and Technic elements children had played with for decades, its principles of imaginative, constructive, enriching play come directly from Ole Kirk Christiansen and the birth of the LEGO brick itself.

This Ferris wheel module is part of a Great Ball Contraption built by NELUG for BrickFair NE 2013. It is actually a very large gear that transports LEGO soccer balls around in a giant loop. © Mike Ripley

The result of years of research in partnership with the Media Lab at Massachusetts Institute of Technology was RCX—a programmable brick with 32K of memory, an LCD panel, function buttons, six electrical connections, a battery space, and a microprocessor, all packaged up in a plastic casing of LEGO quality with LEGO studs. With a user-friendly programming language of its own, that users could upload to the robot using infrared technology, the RCX and its various sensory components was an exciting new territory that LEGO was bravely launching into.

Seattle-based programmer David Schilling was one of a number of adults who were intrigued by the new technology from LEGO, which appeared for the first time in the form of the RIS (Robotics Invention System). He convinced his pregnant wife to let him buy it by telling her it would be a good way to teach their unborn child about physics, programming, and mechanics. "After building the first robot based on instructions in the set, I built a juggling robot," he remembered. "After a while I actually ran out of things to build." The story could have ended there: a father-to-be dabbling in some minor LEGO robotics, only to exhaust the options and pack it in. Instead, something rather exciting happened next, which in its own way was partly responsible for the development of the MINDSTORMS line and the evolution of extreme MINDSTORMS projects.

"Right around that time I found out about a local MINDSTORMS robot competition," said Schilling. "I built a robot for each event, and did rather well. By the second or third of these events I was noticing that people bringing robots to competitions where there were prizes

weren't very open about things they'd learned. I was talking about this with Gus Jansson, who was also cleaning up at the competition, and he agreed. We formed SMART almost on the spot." SMART (Seattle MINDSTORMS and Robotic Techies) was one of the earliest clubs of its kind, encouraging both adult and kid members to improve their robotic skills by building together and sharing their knowledge and ideas.

"Each meeting is centered around a mini-challenge," Schilling explained. "We come up with a simple task that members should build a robot to accomplish. We try to use as few words to describe the task, and describe it in as open and inclusive a way, as possible. I try to make the description fit in twenty words or less. Then people have a month to build a robot, and bring it to the meeting. Any interpretation of the description is fine. We want people building robots, not picking over rules with a fine-toothed comb to look for loopholes . . . our meetings are very informal. For an hour or two we just wander around looking at each other's robots, asking questions, perhaps giving suggestions based on past experience. Then we spend a few minutes each showing and demonstrating the robots to the entire club. Finally we vote on a new mini-challenge for the next meeting."

There are relatively fewer adult LEGO clubs that focus more exclusively on MINDSTORMS in comparison with other LEGO building groups—perhaps due to the cost of MINDSTORMS kits, and the slightly more niche programming element to the building—although Schilling, who teaches robotics to middle and high school students, said that "there isn't a ton of esoteric knowledge

that you have to master. The electronics are dead simple to use. And it's very quick to build anything with LEGO." While it's more exciting to imagine a giant robot that can do all manner of tasks for you, the key to approaching MIND-STORMS for the first time is simplicity. "I always tell my students to do some-

Great Ball Contraptions like this one require a huge display space, and are therefore ideal for LEGO conventions. © Mike Ripley

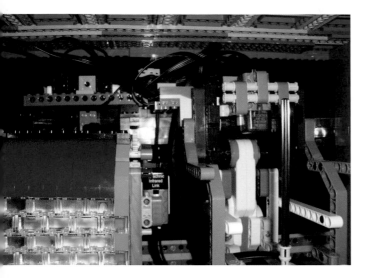

The inner workings of a MINDSTORMS model.
© Ron McRae

thing simpler. They think that won't be interesting. But it is!" said Schilling "Everyone else will be impressed with a robot that performs a task, whatever that task is, especially if it does it well. Not too many people are impressed by a robot that attempts to perform something incredibly difficult, but is unable to do it. It's the same thing with programming. I am a programmer, so I can tackle much larger projects than most of my students would be able to, but I still follow the same suggestion I give them: get a very small part of your program working first. Then slowly add on to it, testing it at each phase. As long as the robot continues to do what you expect, you're OK. If it ever doesn't do what you expected, you know where the problem probably lies."

Through groups and workshops, the LEGO MINDSTORMS community began to grow. And MINDSTORMS creations soon started appearing at LEGO events across the country, often combining their building talent with LEGO Train fans and general LEGO builders. Schilling remembered a LEGO Road Show event in 2003 that toured around the United States where Seattle's SMART, PNLTC (Pacific Northwest LEGO Train Club), and SEALUG (Seattle Area LEGO Users Group) got together to build a large display on the same set of tables. It marked the first of a series of collaborative "Crate Contraptions"—called so because they moved crates of LEGO soccer and basketballs around. Each large contraption took the group several months to design, build, and set up to make sure all the robots would work together as intended. "This required a lot of dedication on the part of the people involved," he said. "You couldn't just flake out and not show up. The entire display depended on all parts not just being there and working, but they also had to be remarkably reliable."

Steve Hassenplug, a fellow MINDSTORMS enthusiast, most recently recognized for his giant robotic chess set, took the basic elements of the Crate Contraptions and developed a group-build MINDSTORMS concept for a display at BrickFest 2005 that is still hugely popular to this day. Believing the key to simplifying the Crate Contraption template was to remove the crates completely, and have different modules simply moving balls from one module to the next, the Great Ball Contraption (GBC) was born. "There wouldn't be a huge commitment on participants, and if a module didn't work, it could just be removed, without affecting everything else," explained

The LEGO MINDSTORMS NXT "brain" features in most MINDSTORMS models, but is soon to be usurped by the new EV3 system. © Ron McRae

Schilling. The standard for building a model in this way can be found at www.greatball-contraption.com.

In 2013, Hassenplug, along with other members of NELUG (New England LEGO Users Group), beat the record for the longest GBC, as well as the largest single GBC module in Manchester, New Hampshire. Measuring in at 2,030 linear feet (which included 1,893 feet of track that carried the balls via monorail) the setup included a giant Ferris wheel that transported the balls in a huge loop, and a NXT mechanical arm. While many GBCs are built by groups such as this, some builders have earned a reputation for pushing the limits with these ball-transporting devices by themselves. One such builder is Japanese student Akiyuki, whose models provides inspiration to David Schilling and the SMART team. You can check out his videos online here—www.youtube.com/user/akiyuky.

The work of MINDSTORMS fans was beginning to garner attention, not just from the growing crowds at LEGO conventions, eager to see these robotic builds in action, but from LEGO itself, who was planning to revive the MINDSTORMS line, and was learning just who to ask for advice. "A few years after the first Crate Contraption we built, I got a very mysterious letter from someone at LEGO asking if I wanted to participate in a secret project," remembered Schilling. "I accepted and was one of the original MUPs that helped shape the course of the NXT, which LEGO was just starting to work on." "MUP" refers to MINDSTORMS Users Panel—a team devised by TLG in 2004, made up originally of four adult fans of the line, who were known for developing a strong MINDSTORMS community where they lived. Over a fourteen-month period, the MUP members met via a secure website, had phone conferences, and even met in person both in Billund and in Washington, D.C., for briefings and discussions. Their mission was to help TLG to develop the next generation of MINDSTORMS robots, rather appropriately known as NXT. Through their frank discussions and deep understanding of the product and what the fans use it for, the MUP helped to bring about the inclusion of an Ultrasonic sensor to be used as "eyes" for the robots as well as a new

LEGO Technic 90-degree angled element. The MUP has since grown dramatically, showing TLG's eagerness to harness the expertise and enthusiasm of its customers to improve the product line.

Released in 2006, the NXT Intelligent Brick eclipsed its ancestor with more memory, USB and Bluetooth connectivity, light, sound, and touch sensors, and a new icon-based programming language. The newer system was designed to enable younger builders to build simple robots, as well as providing adaptability and flexibility for more experienced programmers and builders. While the RCX kit took a child about two hours to make from opening the box to the completion of a robot, the NXT aimed to cut that time down to thirty minutes for a simple model, in an effort to compete with the instant gratification of video gaming and other hi-tech toys.

As Schilling mentioned earlier, improving your own ability in areas such as mechanics and programming is greatly increased by problem solving with others. One way that young people can do this in a fun and competitive environment is through the *FIRST* LEGO League (FLL). FLL is a robotics program formed as a partnership between *FIRST* (For Inspiration and Recognition of Science and Technology), a not-for-profit public charity that aims to help young people discover the excitement and rewards of science and technology, and TLG. Teams of up to ten children, between the ages of nine and sixteen (nine to fourteen year olds in Canada, the United States, and Mexico), work together to build their own autonomous robots capable of completing missions that usually involve problem solving and interacting with LEGO-built elements. There are currently over 20,000 school-age teams in seventy countries around the world building robots with LEGO MINDSTORMS.

LEGO conventions also challenge MINDSTORMS fans to stretch their skills with competitions such as Sumo, where two robots are pitted against one another in a small circular arena, and they must try and force the other robot out of the circle, MINDSTORMS boat racing, and build-on-the-spot competitions. One AFOL who is known for his remarkable MINDSTORMS creations is Ron McRae (check out his ATM and slot machine models on page 148). "As a kid, I was fascinated by everyday static machines such as escalators and elevators," said McRae. "If they were being worked on I would take the opportunity to study the mechanics of how they operated. . . . What I love about building with LEGO is the quickness of construction. Building things out of LEGO is much more time efficient than any other building platform I have used. For example, when I coached my FTC [*FIRST* Tech Challenge] team, I discovered that building robots out of TETRIX [a non-LEGO robotic kit by Pitsco] took much more time than building them with LEGO. I love the way pins are able to just snap into place, then add another piece, and then another—snap, snap, snap—and suddenly there's a mini model of something. Most other building platforms require screws and the hole spacing is placed in odd patterns."

This ease of building has led MINDSTORMS fans to build some of the most impressive and extreme robots seen in popular culture. See below about Rubik's Cube solver CubeStormer II for

a great example. "I believe that MINDSTORMS projects are becoming more powerful in the fact that builders can build almost anything," said McRae. "Even though it's just a toy, it has been used for multiple professional purposes, and is also used in college experiments." McRae's opinions are seconded by Schilling. "LEGO is so versatile and especially quick to build anything with," he said. "Generally when I build a robot out of LEGO, I spend less than a month on it. There are some occasions when I will spend more time getting more reliability, or speed out of something, but those are the exception. I don't need to mill my own parts, or spend hours looking at dozens of online stores to find the right electronic components. I have a limited palette, but like a good artist that not only makes do, but shines with a limitation, I thrive within the limits of what I can build. And really, those limits are pretty vast! I saw CubeStormer II in person a few weeks ago, and it is phenomenal!"

TLG's strides into providing technological elements to their traditional construction toys has also included the development of the Power Functions line, allowing LEGO builders to more easily incorporate mechanisms and sensors into their models for added aesthetic appeal. Available in

CUBESTORMER II

Since its introduction onto the toy market in 1974, and its height of popularity in the 1980s, the Rubik's Cube has continued to entertain children, but perhaps more surprisingly, push people to the limits of logic puzzle solving, with annual championships that see competitors attempt to complete it in the fastest time possible. When it comes to logic, however, it's often the case that anything humans can do, computers can do better. That's precisely the challenge Mike Dobson and David Gilday, the team behind this record-breaking build, decided to take on. Using a Rubik's Cube, a LEGO robot, and a smartphone they built CubeStormer II—a MINDSTORMS creation that uses four NXT kits and is made entirely from LEGO parts. The plan was to build a Rubik's Cube–solving robot that could take on the world record, which at the time stood at 5.66 seconds (it has since been beaten and is 5.55 seconds at the time of writing). With Dobson behind the robot and Gilday behind the software, the pair chose to use a Samsung Galaxy S II smartphone as the device's brain. A Bluetooth connection from the phone communicates with the processors inside the NXT kits instructing them which way to move the cube to complete the puzzle. The smartphone's camera analyses the image of each face of the cube as it turns and creates a 3D image simultaneously for the user, as well as timing the speed of each attempt. Unlike in normal Rubik's Cube–solving competitions where entrants are allowed to inspect the cube prior to being timed, the CubeStormer II analyzes all of the data and solves the puzzle within seconds. Literally. In 5.35 seconds. Beat that, humans.

LEGO and Technic sets since the late 2000s, Power Functions is a cross-theme system that incorporates battery boxes, motors, receivers, and remote controls in LEGO-compatible designs making it the ideal way to add light, sound, and movement to an otherwise static model. One AFOL who is known for invigorating his models in this way is Vancouver-based Paul Hetherington. For his Poseidon model (featured on page 154), he incorporated two nine-volt train transformers and four motors to animate the various undersea characters.

"The main thing to keep in mind when incorporating any kind of moving functions is to keep each motorized unit over a base plate," he offered as one of his top tips for adding animated elements to your models. "It becomes very hard to move creations when you have wires and gears that have to fit together over base plate seams. . . . Also, when you are powering multiple motors off of one power source it is important that there is not much resistance in your gearing. You don't want the motors to work too hard otherwise you can easily overload the train transformer. It is one thing to run the motor for ten minutes at home, but another to run them for eight hours at a show." Hetherington learned this lesson when the Poseidon model was displayed at a museum. "I put a lot of effort into making sure the mechanisms were bomb proof, so that I wouldn't have to drive the long distance to repair them. During the show the features were hooked up to a motion sensor, so whenever someone walked in front of his display case the lights would turn on and the motors would run for one minute. You can imagine with lots of kids running around the sensor was triggered a lot! Though I must admit that during the last week of the show Poseidon's head did stop moving. I later discovered that the ball joint had been ground down by the friction of moving back and forth constantly, so it had fallen out of its socket. I guess LEGO hadn't intended for that much wear and tear on its tow ball sockets!"

From MINDSTORMS robots to animated LEGO models, there's no denying the brick

LEGO and Technic parts make building robots with MINDSTORMS a breeze compared to other robot-building systems. © Ron McRae

has come to life—from vending machines, toilet flushers, Sudoku solvers, and LEGO faces that have been programmed to express emotions depending on the tone of your voice are just some of the more unusual (and useful) models that can be built with the latest robotics kit, NXT 2.0. With fans all over the world answering the LEGO call to build more and more exciting and innovative designs, it begs the question, what's next for NXT? And the answer is EV3. Planned for launch in fall 2013, EV3 is the third generation of intelligent brick from LEGO—the "EV" stands for Evolution. EV3 sets itself apart from its predecessor with the ability to connect to Apple devices and be controlled via apps; the robot will be capable of connecting to the Internet, and includes online building instructions for seventeen starter models. With more motor ports and more memory, combined with more powerful and intuitive sensors, this hugely exciting development for LEGO will offer builders even more opportunities to make LEGO bricks move. And as far as Ron McRae's concerned, the future of LEGO robotics looks bright. "I believe that the new EV3 will increase the capabilities of the LEGO robotics platform dramatically," he said, "and will open a huge number of new opportunities for the LEGO product to appear in places you'd never imagine."

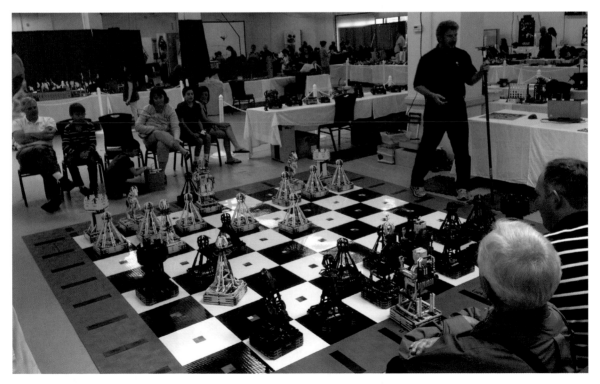

Steve Hassenplug demonstrating his giant LEGO MINDSTORMS playable chess set. © Suzanne Eaton

ATM AND SLOT MACHINE

By Ron McRae

FACTFILE

Build location: Illinois
Year completed: 2009
Time taken: Four months
LEGO elements used: 8,000 (ATM) and 10,000 (slot machine)

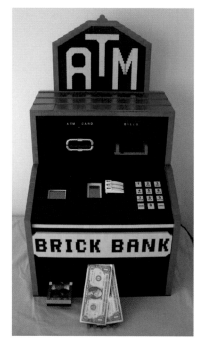

© Ron McRae

© Ron McRae

WHAT ARE THEY?

Need some extra cash? Fancy a flutter with your earnings? Prepare to be amazed by Ron McRae's LEGO ATM and slot machine creations, built almost entirely from LEGO bricks alone. Both machines are programmed in MINDSTORMS programming language Not eXactly C (NXC). The ATM incorporates two NXT Intelligent Bricks, five NXT Interactive Servo Motors, and ten different sensors. The machine can be calibrated to accept any type of banknote, including custom-printed "play" money. "The NXT interface allows a user to enter a PIN number, deposit or withdraw money from an account, and even make change," explained its creator. "An RFID sensor (Radio Frequency Identification) identifies users, who operate the machine using a LEGO RFID card to identify themselves." The ATM weighs twenty-two pounds and stands nearly two and a half feet tall.

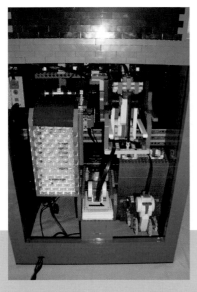

While it may share similar dimensions, McRae's Las Vegas–style slot machine is all about gambling your cash away. And to do that you'll need six Servo Motors and thirteen sensors—seven for touch and six for sound. The only thing non-LEGO about this casino creation are the reel covers, which are printed on cardstock, but "all mechanics are pure LEGO," McRae explained. "I chose to use Pachinko tokens to operate the machine. These are the same tokens used to operate real-life slot machines that are converted for home use." The machine is configurable to enable parameters to be changed to increase playability, or as McRae said, "Easy jackpots for friends, less luck for others!"

Making money—McRae's ATM is an act of technical mastery behind its shiny LEGO facade. © Ron McRae

MEET THE MAKER

Originally from Glasgow, Scotland, Ron McRae now lives in Mt. Prospect, Illinois, and is an avid member of the state's well-known MINDSTORMS community. "Our middle schools have implemented *FIRST* LEGO League programs and *FIRST* Tech Challenge programs, both of which are based on the LEGO MINDSTORMS platform," he said. "Every year, we attend Brickworld, display creations, and compete in the robotics challenges." While many AFOLs can't take their hobby to work, McRae gets to tinker with robots during the day too, working as a software engineer for a company that makes machines for printing labels. "I have been able to use my prior knowledge of writing code for my LEGO slot machine," he said, "and used it to write code for industrial machinery which is truly a novelty."

McRae prefers the LEGO themes from the company's earlier years, such as Fabuland and Modulex, and the LEGO System toys, "because I believe that they set the original theme and foundation for modern day themes and LEGO itself," he said. His first ever LEGO creation was a miniature slot machine, which ran on RCX—the first generation of LEGO MINDSTORMS—and consisted of a pull-down handle, a pay-out system, and rotating reels. A few lights even came on to indicate a win. "This creation was my first real understanding of LEGO and how to build with it," McRae said. "After many years of limited LEGO time, I was reconnected to the world of LEGO."

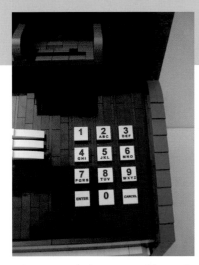

The ATM machine's raised keypad incorporated touch and light sensors and is made completely from LEGO parts! © Ron McRae

THE PROJECT

To develop these impressive fully-functioning models, McRae incorporated the feedback he received from users of previous similar models, enabling him to determine what was most popular, what subsystems functioned best, and how each feature would work. The model designs then evolved based on the space that was required to include all the working parks, as well as McRae's desired appearance for the finished product. "The planning stage took place after all of the subsystems were implemented," said McRae, "so I knew the amount of space and shape the product would have to take on. Basically, there wasn't much time spent on planning, just trial and error building."

Elements of both of McRae's models were inspired by other mechanical objects. For example, for the ATM machine, he observed standard ink jet printers, "in order to find out how printers are able to pick up only one sheet of paper from a ream so consistently without jamming." He then built a number of small prototypes, consisting of a pile of paper and a gear with rubber pieces on one side, and no rubber on the other, to try and recreate this technique with LEGO elements. For the slot machine he incorporated virtual reel technology—where each symbol on the visible reel is represented by a varying number of positions on a much larger virtual reel, thereby varying the probability of landing on each symbol by whatever amount the programmer decides—the same technique used in Las Vegas slot machines. "I was so shocked that this controversial technique is used that I felt I had to encompass it in my design and make others aware of it at every opportunity," said McRae.

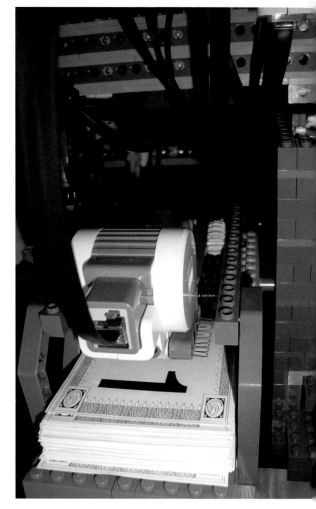

The ATM machine can be programmed to accept either real or play currency. © Ron McRae

With MINDSTORMS models, those making them not only face the same building constraints and issues confronting other AFOLs, but they are also dealing with programming challenges. For McRae, calibrating the ATM machine to successfully read deposited bills and decide whether each bill was a close enough match to be accepted was one of the hardest parts of the build. "Each bill is read

in as a series of values which can be displayed as a line graph, and each graph is compared to a control graph. The problem faced was deciding the tolerances between 'accept' and 'decline.'" The solution involved encompassing diagnostics and configurability into the program itself, enabling the values to be adjusted on the NXT machine.

McRae built a sturdy foundation to incorporate all the subsystems, and used LEGO ZNAP elements in the design along with triangulation building. "These methods helped to streamline the build process by ensuring that all the elements fitted together in a modular fashion," he said. Completed in 2009, McRae's ATM and slot machine models have been a hit at LEGO conventions and events, attracting AFOLs and public visitors in droves, keen to try out the models' mechanics. "What made it such a success was the fact that the creations were hands-on exhibits, which attracted many of the younger fans to play the machines. Eventually, we had to place signs out on the table to say, 'Only three plays per child,' or 'Please leave the tokens.'" Despite the fact he finds carting the models around to conventions a bit of chore, due to their substantial size and weight, no one could have been more pleased with the results than McRae. "When the models were completed, I felt that each was a unique construction of science and aesthetics." And money!

FANTASTIC FUNCTIONS

Here are just some of the unique functions of these two extreme robots.

ATM

- The bill scanner can be calibrated to accept any type of banknote.
- The functional numerical keypad incorporates touch and light sensors.
- The machine stores a database of customers and their PIN numbers.

- If you input the incorrect PIN three times or there is a long period of inactivity then your ATM card will be kept by the machine.

Slot Machine

- This slot machine only accepts Pachinko tokens, and rejects standard US currency.
- There is a progressive jackpot that increases with play.
- When you win the light tower flashes—it also flashes to alert the programmer to problems.

Time to hit the LEGO jackpot! These reel covers are the only non-LEGO part to this working slot machine. © Ron McRae

- There is also a bonus feature of a Blackjack card game on the screen.
- The machine plays realistic casino-esque audio files when you play, and when you win.

SUPER STUDS

"The models include some of my very first LEGO bricks, which were also used in my first slot machine, which are now over forty years old," revealed McRae. "For example, some gears used within the workings are actually the big, old-style gears with spaced teeth, which are used because they provided enough movement for the specific task. These models tell a story by bringing together all evolutions of LEGO— LEGO from the early days, and LEGO from the modern era."

KEEP BUILDING

Want to see these robots in action? Check out videos of them being used at www.youtube.com/user/ronaldmcrae. And keep your eyes peeled on MOCpages (www.mocpages.com/home.php/25102) for his latest robotic work—a Connect Four creation using MINDSTORMS balls.

EXPERT ADVICE

A few words of wisdom from a MINDSTORMS master!

- If you're planning to exhibit your model at an event, take a leaf out of McRae's book and "make the exhibit interactive for more attraction," as well as "incorporating moving parts or lights."
- Steady as she goes—McRae says the best way to build is "sturdy and modular so you don't open your box to a pile of bricks!"
- Scared that all that computer-talk might be a bit over your head, but really want to build cool LEGO robots? You can do it! "I would remind all robot builders that all of us were once beginners," said McRae. "You never know what you'll discover when trying out ideas. Remember, everything seems hard until you understand the concepts, but once you get the basics then building those concepts into an awesome robot is a bit like piecing together the LEGO bricks themselves."

POSEIDON—GUARDIAN OF ATLANTIS

By Paul Hetherington, a.k.a. Brickbaron

FACTFILE

Build location: Vancouver, Canada
Year completed: 2012
Time taken: Designed over several months; built in two months
LEGO elements used: 30,000

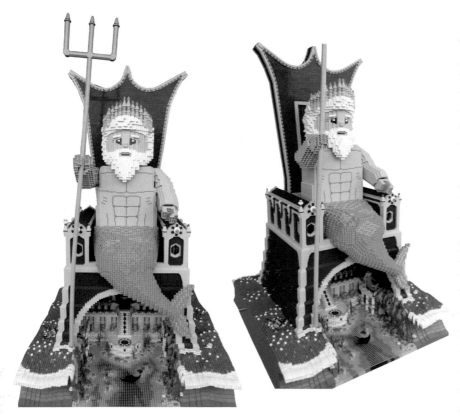

© Paul Hetherington

WHAT IS IT?

Like many creative and complex MOCs, Paul Hetherington's Poseidon model has a wonderful story behind it. "For thousands of years Poseidon has carefully guarded the secret of Atlantis," the creator narrated. "As he watches over his underwater kingdom, he always keeps Atlantis carefully hidden inside his throne. Many have tried to find the origins of Atlantis, but as long as Poseidon rules the oceans, his secrets are safe from the human race." The wonderful story of Atlantis enabled Hetherington to build a creation within a creation—something he'd wanted to do for a while.

Built for the Surrey Museum's LEGO Mythology Show, this maxifigure-scale Poseidon sits atop his throne emerging from the ocean—hidden beneath him is the city of Atlantis, complete with twenty animated minifigures, including the city's ruler—SpongeBob SquarePants—inside a clam shell and a lurking Captain Jack Sparrow. Poseidon himself is also animated, with a motor that powers his head back and forth as he keeps watch over the city, and his eyebrows for added facial expression.

The model sits on four 48 x 48 stud base plates arranged in a square, which come apart in two sections, and according to Hetherington is "very heavy" when assembled.

MEET THE MAKER

Born near to where LEGOLAND Windsor is in England, it seems Paul Hetherington's passion for LEGO bricks was written in the stars. In the 1970s his family moved to Vancouver, Canada, and he's lived there ever since. A fan of the toy throughout his childhood, "I have a picture of my mum helping me build Basic Set Number 3 from 1973," he found the toy helped pass the time as an only child. It wasn't until many years later, in 1991, that his interest in LEGO building was rekindled in the toy floor of a department store. "They had a deluxe LEGO retail setup with the entire 1991 line," he recalled. "I was really drawn to the M-Tron and Blacktron space sets, and it wasn't long before I started collecting them. I would pretend I was buying them for a nephew, because as far as I knew back then adults didn't buy LEGO for themselves, and the store clerks were always suspicious."

Inspired by the complex architectural models he saw in Henry Wiencek's book *The World of LEGO Toys*, he was instantly inspired to make his own models, especially alien-landscaped space bases, and eventually found his way into the AFOL community, attending conventions and displaying his models. Hetherington, who works at a day program for disabled adults, now has a collection

Inside the City of Atlantis! Beneath the throne lies a treasure trove of LEGO building.
© Paul Hetherington

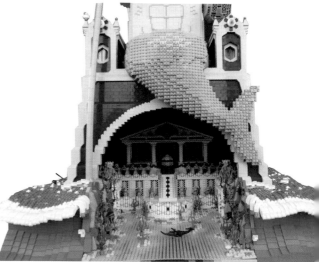

155

of some two to three million LEGO bricks at his disposal and has been on TV several times promoting his work and the hobby.

THE PROJECT

Every two years the Vancouver LEGO Club, of which Hetherington is a member, puts on a large-scale exhibit at the Surrey Museum. The "mythology" theme was selected a year in advance, and Hetherington was assigned to build an Atlantis model, although all that time actually made life more difficult for him. "Good: lots of time. Bad: no deadline, and lots of opportunity for procrastination," he said. He did a lot of research, heading to the library for inspiration, to recreate a mythological place from LEGO bricks with no real-world reference. "After looking through all the books, I still couldn't find the right kind of images. Finally, I watched Disney's animated *Atlantis* movie, and built the official LEGO set of The City of Atlantis (7985)," he said. But the real lightbulb moment came one sleepless night two months before the model needed to be completed. "I couldn't decide which version of Atlantis I wanted to build, or if I wanted to change direction completely and just build a large sculpture of Poseidon," he said. "I kept going over the

KEEP BUILDING

See more of Hetherington's models on www.Flickr.com where he goes by the handle "Brickbaron," including his BrickCon award-winning "Casa Baron" and "Mardi Gras Madness" creations, and his Bricks Cascade Best in Show model "LEGO Lady Gaga: The Built This Way Ball."

Hetherington's original sketch for the model.
© Paul Hetherington

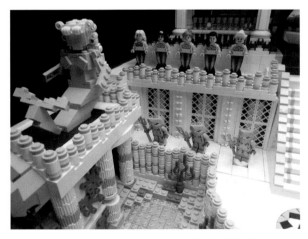

© Paul Hetherington

King SpongeBob
SquarePants on his throne.
© Paul Hetherington

ideas, and finally around 3 a.m. a vision popped into my head of Poseidon sitting on a throne, coming up out of the ocean with Atlantis tucked safely inside his throne. Instantly, I knew this was the idea, so I turned on all the lights and started to do a very rough sketch of what I thought it would look like." Hetherington envisaged the model, with the moving head, eyebrows, and mermaids, before going to sleep knowing he had a lot of work ahead of him.

"I decided to go with a classic version of Atlantis," said Hetherington of the ancient feel that the model took on, "to try and tie it in with the other exhibits that my friends were doing based on Ancient Greece and Rome. I also thought that if I went with the futuristic version of Atlantis it wouldn't be as instantly recognizable." It was Series Six of TLG's own collectible minifigures, which included a Poseidon (albeit much smaller than the one Hetherington was planning), that inspired the look of the sea god himself.

"The color palate was chosen to make use of colors and parts that I already had in my collection," said Hetherington. "That is always a huge consideration when I am planning my MOCs." While the scale of this model was determined by the museum's display case that it was destined for. So with one sketch to guide him, Hetherington began the build from the bottom up. Starting

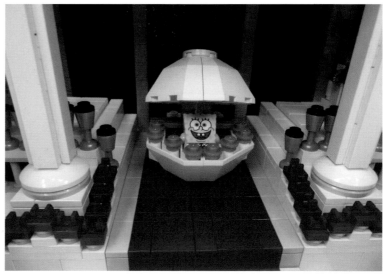

with the seabed, and the waves, he then built the foundations of Atlantis, the details of the city, the base of the throne, and the rest of Atlantis. "Next was the top of the throne seat, the IKEA lights, the armrests and Poseidon's scaly fish half," he said. "Then the back of the throne was built, and finally Poseidon's torso, and, running out of time, his head. A last minute addition was his trident."

Hetherington's mosaic using the "cheese wedge" LEGO piece—a building style made popular by Katie Walker. © Paul Hetherington

Hetherington used trial and error to design the correct mechanisms to bring his model to life. "I tend to envision what motion I want the minifigs to do," he said, "then I try and reverse engineer the gearing and motors to achieve the look that I want. It just takes time and patience. I can say that the more you do it, the better you get." He was particularly proud that all his motorized features survived the museum's three-month-long exhibit, running for six hours a day.

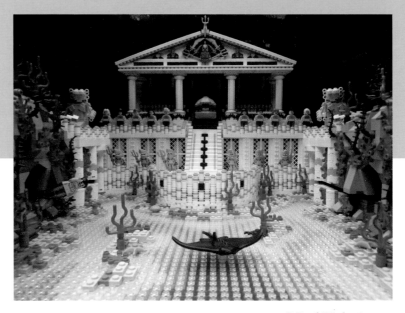

© Paul Hetherington

"I am still very proud of this creation," he said of the result. "I think it is my best so far. I like that it combines different scales and styles of building and brings them together to tell a story." He plans to keep the model, now back in his home, for many years to come. There's a good way of telling that other AFOLs are impressed by a model, and Hetherington witnessed it with this one.

One of Hetherington's motorized mermaids attached to the mechanism that makes her move. © Paul Hetherington

"Lots of people would watch it for several minutes and just shake their heads." Just like Poseidon himself. . . .

SUPER STUDS

This is a model where you don't quite know where to look first. "The seabed is what catches people's eyes right away," Hetherington pointed out. "It uses a fairly rare 48 x 48 clear base plate, with a tile mosaic underneath to simulate shadows on the ocean floor." This is a technique that he admits to borrowing from fellow builder Soren Hixenbaugh. "Next is the Katie Walker–style cheese wedge mosaic," he says of a tricky mosaic-modeling method that AFOL Katie Walker is known for, which employs the sole use of the 1 x 1 slope element. "It took about two days to come up with a mosaic design I was happy with, but it was worth it as it adds a nice focal point at the base of the staircase."

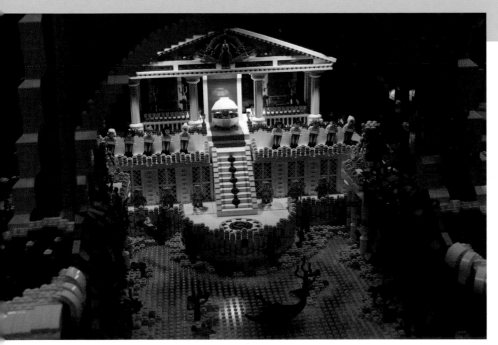

Hetherington's model on display at BrickCon 2012 with the interior lights showing off the City of Atlantis. © J. J. Williams (DmChylde on Flickr)

BALLMAGEDDON

By SMART (Seattle MINDSTORMS and Robotic Techies):
(Adults) David Schilling, Gus Jansson, Dan Tebbs, and Craig Zupke;
(kids) Kyle K, Sean K, Andrew W, and Alex N

FACTFILE

Build location: Various locations—final display at BrickCon 2011, Seattle, Washington
Year completed: 2011
Time taken: Designed and built between March and October 2011
LEGO elements used: Eleven NXTs, 800 DUPLO balls, and approximately 20–25,000 LEGO elements

WHAT IS IT?

BallMageddon is a collaborative display built by Seattle-based robotics club SMART. Using the principles of Steve Hassenplug's GBC method (please see page 142 for more on this)—whereby DUPLO balls are moved around a large MINDSTORMS design, comprised of smaller modules built by individual builders—the club created a scrolling marquee sign capable of displaying either a text message or a simple picture design. While over 20,000 LEGO elements sounds like a lot to your average builder, SMART member David Schilling doesn't think so. "This is a fairly small number of pieces for such a large LEGO display," he said, "but it's very airy. The focus is on the motion the device produces, not the objects built."

MEET THE MAKER

"Programming and logical thinking have been a strong part of why I like MINDSTORM robotics," said David Schilling, the mastermind behind BallMageddon. "I bought my first MINDSTORMS set a week or so after it came out, but at two hundred dollars it was a lot to spend. Since my wife was pregnant, I came home and told her about it, telling her how good it would be for our future child to learn about physics, mechanics, and programming. She said I

160

could go ahead. I suspect she's regretted that decision ever since because it ended my LEGO dark age for good. . . . Once I could build robots, my imagination was unleashed!" With a degree in mathematics, Schilling has been programming from the age of eight, and was one of the four charter MUP members, involved in the development of NXT. He was responsible, alongside Gus Jansson, for starting SMART—"We wanted a forum which would encourage people to build, and more importantly to share what they'd learned. We've been going strong ever since."

THE PROJECT

"I'd been thinking for a long time that it would be neat to have a scrolling sign with the balls as 'pixel elements,'" said Schilling of the incarnation of BallMageddon. "But the tiny LEGO soccer and basketballs were rather limiting. First, they were only widely available in two colors, and second, they were really small. The robotic part of a display would totally dwarf the actual display part." When LEGO released the original MINDSTORMS NXT set with two large DUPLO balls, Schilling realized they would make the perfect

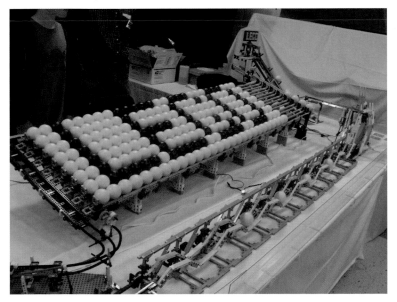

BallMageddon spells out every LEGO fan's favorite word!
© David Schilling

display element for his scrolling sign. "The problem was coming up with enough of them. A quick calculation showed that a single character at six by eight bits would take forty-eight balls, and you really need at least four characters, preferably eight or more to have a scrolling sign that was readable. So we would need to find 200–400 balls at a minimum."

Even when work had begun on the display the team still didn't know if they would be able to come up with enough balls to make it work. "But it had

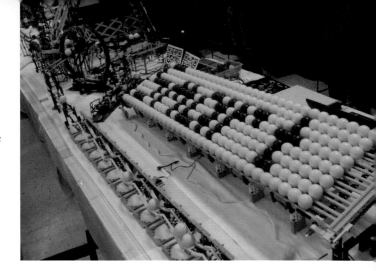

been a couple of years since we did our last Crate Contraption, and SMART was ready to build another collaborative display of some sort," said Schilling, "so we started designing it, hoping that somehow we could come up with the balls."

While BallMageddon had been on Schilling's mind for many years, he said the actual design only took a couple of hours to materialize. "One evening I got together in March [2011] with the two other leaders for SMART and we discussed possible ideas for a new collaborative display. I suggested we try the scrolling marquee sign. We did some back-of-the-envelope calculations for the size, number of balls required, and speed required, and while it seemed iffy, we were excited enough about it that we decided to tentatively use it as our display for the next BrickCon in October."

To the left of this photograph you can make out just some of the ball moving modules the team built for the display. © David Schilling

The team's original plan was to have multiple paths of balls leading to the sign and was designed by Schilling, Gus Jansson, and Mark Kenworth. "Unlike Crate Contraptions where everything was planned out in advance, BallMageddon would be much more like the GBC where everyone could build modules, and we would fit them in as needed," said Schilling. "There were three main components we knew we needed, but each of the ball elevators would be up to the individual to design." The three elements were the display generator, a ball sorter or storage device to hold unused balls and supply them to the generator, and the display itself. The paths between these components could consist of any number of ball-passing devices. Schilling built a display generator that allowed three different colors of balls to be generated for either four or eight paths leading to the display.

Schilling built the display generator, and a number of the ball devices in the display, and built most of the 'glue' that connected various devices, while Gus Jansson built the interesting mechanical parts of the display: the counter/queuing device, and the release mechanism. "As we met for our SMART meeting to discuss the idea, other

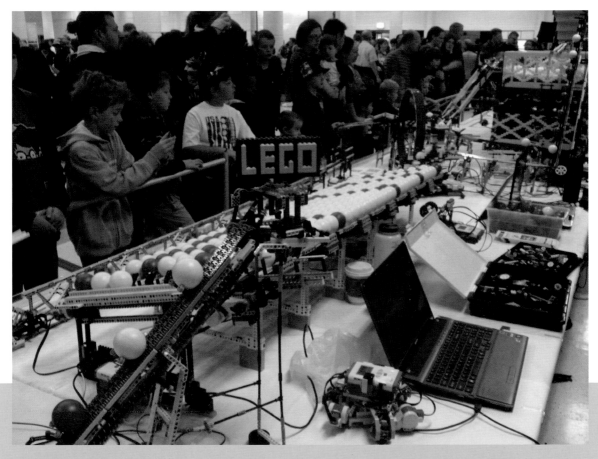

The crowds look on to see a word spelled out by a LEGO robot! © David Schilling

people volunteered what they wanted to build. Dan Tebbs had just started coming to our meetings, but volunteered to build the hoppers, Craig Zupke built a couple of ball lifting devices over the summer, ending up with a very eye-pleasing wheel that lifted balls. There were also a number of kids in our club who built various portions."

As with any logical building project, there were a number of interesting problems and challenges faced by the team. Firstly, the display generator needed to be incredibly reliable, because if a single ball was missed or of the wrong color, then the whole message would be out. Using a HiTechnic color sensor, certified by TLG, which checked the balls as they rolled by to be queued up, Schilling was able to maintain a high level of accuracy by making the sensor

reject everything by default, only letting a ball through if it determined that it was the correct one.

The ball hoppers were also cause for concern. "The first problem was that the balls would inevitably be sitting in the hopper, and try as it might to pull one up the conveyor to the ramp, no ball would make it onto the conveyor," said Schilling. "This problem was expected. We'd dealt with many ball devices over the years with our Crate Contraption, and it has become abundantly clear to us that individually a ball is just a ball. But as soon as you put a couple of them together, they begin having some odd form of intelligence whose only purpose is to frustrate what you want the balls to do. . . . Dozens of designs all ended up with the balls piled around the lifting conveyor belt, laughing at their ingenuity at figuring out yet another way of not having to go up the conveyor." To thwart these stubborn balls, one of the group's younger members built an agitator that was put inside the hoppers, to stir up the balls whenever the ramp was empty.

"There were a lot of other last minute headaches that we had to solve, including building a couple of new ball devices that we needed to get just a bit of extra height," said Schilling, "and unfortunately a couple of the devices built were either not reliable enough or didn't fit in properly, and so they were left out altogether. Then there was a lot of little 'glue' between pieces that had to be built, areas that had to be reinforced, and some modules that had to be modified to work better when everything was going."

Even though Schilling managed to secure the required number of yellow, blue, and red balls from a donor, the number of ball devices built by SMART members was significantly less than he had hoped for. "As time was getting closer to BrickCon, we realized for sure that we wouldn't have enough for four paths, and might not even have enough for two paths," said Schilling. "This was somewhat discouraging, but by that point we at least knew the idea would work!"

Some last minute changes, and the sheer size and complexity of the project meant that there were some inevitable technical difficulties during BrickCon. "I think the display was finally reliable enough to be considered 'ready' to be displayed just as BrickCon was over, and it was time to tear everything down," said Schilling.

BRICK BIT
There was skepticism among some SMART members, as to whether the project would be a success. "Hence the name Ball-Mageddon," said Schilling. "Everyone was convinced it would end in one of two ways: total catastrophe for us, and we would have nothing to show—the end of the world with a whimper—or a fantastic display that would be something that would be hard to top—the end of the world with a bang! The consensus was it would be a whimper. I was certain it would be bang! I'm happy that I was proven correct."

KEEP BUILDING

To find out more about SMART visit the group's page at www.lugnet.com/org/us/smart.

And while he admits he would have preferred more ball devices to increase the speed of the display, he was thrilled with the final result and so were the BrickCon crowds. "It was hugely popular!" he said. "The entire weekend we had crowds six and seven deep trying to get a look at it. People would keep coming back to see what it was displaying now. Whenever a new message started, they would try to figure out what it was going to say. . . . I was exhausted by that point, but super happy that everything worked out, especially since there had been much reservation by other people in the club that we would be able to pull it off. It was a difficult task, but we all did a great job to get it to work!"

FANTASTIC FUNCTIONS

"Something that most people wouldn't know or realize is that the display generator constantly saves the state of the message that it's sent so far, down to which column of which character it's on," said Schilling. "This way, if you have to shut it down for any reason, when you start it up again, it will resume where it left off. This ended up being useful on a number of occasions."

Also, check out the large spinning wheel with prongs, built by Craig Zupke. Rather surprisingly, the wheel was built with standard LEGO 1 x 2 bricks. "If you start off building a long, straight wall, since there is enough slop in such a large wall to allow some bending, if you make it long enough, you can actually wrap it around to build a wheel," said Schilling. "Lots of people wondered how this was accomplished."

SUPER STUDS

Due to the smaller number of ball devices included in the final build, it actually took over three minutes for one character (comprised of six columns of eight balls each) to be displayed on the scrolling sign. "This was considerably longer than we wanted it to be," said Schilling, "but was at our lower limit of what was acceptable. To display a message would take much longer." In fact, it took thirty-nine minutes to display the message "BrickCon 2011."

165

Big Builds for Bucks

"I can only hope that after a child sees my models, they go home inspired, and play with their own LEGO bricks to create their own unique works of art."

Sean Kenney, LEGO Certified Professional

For hundreds of thousands of children who spend their playtime building towering castles, armored spacecrafts, and carnivorous dinosaurs from a box of LEGO bricks, this is the ultimate dream—the dream that keeps them building long past bedtime; the dream that lulls them to sleep when frazzled parents finally lift them off the floor and tuck them in: to build with LEGO for a living. Of course, what do we know of such things at an age when cash is something we save for candy, video games, and the latest LEGO set? We know that more money equals more LEGO bricks, and if that money can come from building with LEGO itself, then the universe has surely caused a cyclical miracle of unimaginable proportions.

On learning that he had been accepted into the LEGO Group's (TLG) designer internship program, eighteen-year-old Jordan Schwartz remarked, "It was quite a thrill; one that I remember vividly." He told the Brothers Brick blog in a 2010 interview that "I've always wanted to do this work—in fact, my mother dug up some old papers from grade school, and when prompted to write what I wanted to be when I grow up I always answered, 'I want to work for the LEGO company.'"

Schwartz attended a group interview and workshop in Billund alongside other AFOLs (Adult Fans of LEGO) from all over the world. He then returned home to Boston to begin college, unaware

TFOL turned LEGO employee—Jordan Schwartz who spent a year working at LEGO headquarters in Billund and contributed to the design of this Creator Expert set Palace Cinema.
© Jordan Schwartz

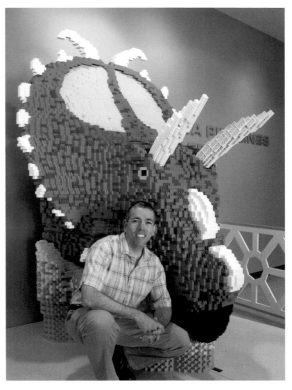

Canadian LEGO Certified Professional Robin Sather with his "Albertaceratops" model built for the Lost Worlds exhibition at the Telus World of Science in Edmonton, Alberta. © Robin Sather

of the opportunity that awaited him. "During the few weeks I was living in Boston, I was a nervous wreck waiting for my phone to ring or that email to come," he said. And when it did, LEGO's offer of an "internship" was more than your typical summer stint filing and copying—he had a salary and would be accommodated in Billund as part of the deal. "I was treated as a full-time resource, meaning I worked the same hours as everyone else, and designed just as many products. . . . Obviously I accepted the offer and moved to Denmark, to the middle of nowhere."

For Schwartz, fulfilling his dream meant a year spent in Billund helping to design some of the actual toys those very children would be crossing their fingers they'd find in their stockings, including the LEGO Creator Expert set Palace Cinema (10232). This set in itself—part of TLG's Modular Building Series—is a prime example of how to work for the LEGO company: you have

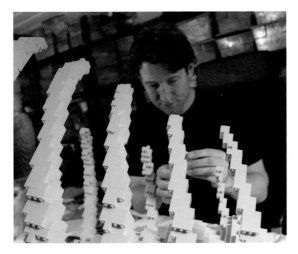

LCP Nathan Sawaya sculpts the bones of a LEGO Tyrannosaurus rex © Nathan Sawaya

to love LEGO toys far more than your average amateur builder. Only an experienced AFOL, although still technically a teenager (or TFOL) at the time, who exists literally and virtually among the community (Schwartz is known as Sir Nadroj online), could have conceived such a whimsical, inspired, and artistic creation using 2,194 LEGO elements, which not only has children gladly offering up their younger siblings in exchange for, but that adult fans are sticking at the top of their Christmas wish list too.

Jordan no longer works at TLG and has since returned from his yearlong placement in Billund, Denmark to continue his studies in Boston, but has fond memories of the experience. "Although the culture shock was quite the kick in the teeth," he said, "earning the job so early [in my career] was a humbling and once-in-a-lifetime opportunity I'll carry with me for a long time." Not only that, but he has the Palace Cinema—a tangible reminder of his LEGO designing career. "I'm so excited to have had the opportunity to work on 10232 Palace Cinema with designer Astrid G," he said. "I designed all the initial ideations of

the model, coming up with the overall aesthetic for it, what should go where, and even coming up with some of the playful movie posters that decorate the side of the building. Astrid then took my design and engineered it to better fit within the budget."

Although nowhere near as extreme as all the models featured in this book, Schwartz recognizes the important role official LEGO sets play in inspiring children to build new things, and the impact they have on the wider AFOL community. "Because LEGO sets are subject to so many restrictions, no set is ever the most definitive version of

Nathan Sawaya's finished twenty-foot-long T-rex model on display at the ArtScience Museum in Singapore. © Nathan Sawaya

its designer's dreams," he explained. "That means there are a million more impressive models out there online. AFOLs who regularly view these other models and fail to take in the context of LEGO sets (that is, the restrictions that are imposed on them), may be less than inspired when looking at them. . . . But it's imperative to understand the restrictions the product designers face in order to fully appreciate the artistic merits of a set and thus be inspired by it."

For now Schwartz is back building his own models—many of which can be seen on his website www.jrschwartz.com—a little wiser, and a little more appreciative of his personal collections. "I'm not sure that my experience working on the Creator team changed my way of building," he said. "It's made me a bit guiltier about using so many illegal techniques in my own models, because obviously official sets can't contain a lot of the really dynamic techniques I have a tendency to use. But I've been able to separate my knowledge of LEGO set design from the knowledge I went into the company knowing. That's a good thing. Very few people get the full 'LEGO set design training' experience, so that information will hopefully serve me again one day."

Of course, working for TLG, in the bowels of that great ABS-molding machine, is not the only way to work *with* LEGO bricks, as a number of dedicated (and lucky) AFOLs have discovered. With a growing interest in large LEGO sculptures from companies, events, brands, and individuals—the likes of which TLG's own model-making team could never fulfill, there seemed to be an emerging market for other builders to start taking commissions for their work. This has become the norm for many popular

Inside an LCP workshop—here is a model in progress at the Bright Bricks studio in England. © Bright Bricks

LCPs have access to huge supplies of LEGO bricks which they purchase directly from TLG and store in giant shelving units like this one, so they can always find the pieces they need. © Bright Bricks

modelers and artists who use LEGO parts and minifigures as the basis for functional objects (e.g., photo frames, pencil pots, and jewelery) as well as artworks and commercial items to sell, but there are a select group, known as LEGO Certified Professionals (LCPs), who have the unique stamp of approval from TLG to do just that.

In the early 2000s it became apparent that TLG were fully aware of the adults who weren't on their payroll but who were making either a part-time or full-time living from their product. LEGO Certified Professional Sean Kenney said, "It turned out that everyone at the LEGO Group—from the call center to the CEO—had their eye on what I'd been doing. And we realized that with their support, I could reach out to even more people. Somewhere along the line, we realized that if TLG could somehow officially recognize and support people like me, I could reach even more people and spread the word about LEGO-coolness even further."

LCP Sean Kenney poses next to his four-foot-tall interpretation of the Empire State Building, which is made from 13,000 LEGO bricks. © Sean Kenney

In 2004, Robin Sather came up with the idea of two programs to help meet the growing demand for representation and communication between adult fans and TLG, as well as a way for skilled builders to provide services in association with the LEGO name. "I was the person that came up with the idea of the 'LEGO Ambassador' and 'LEGO Certified Professional' programs," he said. "I pitched them to the LEGO Company, and both programs were adopted and have grown since then." Sather is now himself an LCP, running his own company Brickville Design Works out of Vancouver, Canada (www.brickville.ca). "I am one of thirteen people worldwide who are independent LEGO Certified Professionals. That means my 'regular life' consists of building cool LEGO stuff, and creating fun LEGO events, for a living! We call ourselves 'LCPs' and we are all independent LEGO artists and artisans, working with LEGO bricks to create cool sculptures, events, custom building sets, building workshops and more."

Sather's fellow LCPs live and work around the globe, from Nathan Sawaya in New York City (pages 202 and 227), and Ryan McNaught in Melbourne, Australia (page 194), to Nicholas Foo in Singapore (page 192) and Duncan Titmarsh in the United Kingdom (page 84). The work of almost all the thirteen creators can be found in the pages of this book, and theirs is some of the most jaw-

dropping around. "I'm so impressed with all the extreme stuff that my fellow LCPs create!"said Sather, whose own replica of the Giant Sphinx of Giza can be seen on page 208. "We are privileged to have access to a larger number of bricks than most builders, and it's so cool to see what these guys come up with!" Those feelings of camaraderie are shared by New York–based Sean Kenney who said being an LCP was the LEGO equivalent of winning an Oscar or a Pulitzer. "We all know each other very well, keep on top of each other's work, do projects together, and learn from each other by sharing our experiences."

Many LCPs have come directly from the AFOL community (or what existed of it in the past) turning their hobby into a business. LCP Dan Parker who now makes a living building LEGO models and running LEGO workshops (see box-out) started building in 1990 when he was 29, before AFOL fever was widespread and in the popular sphere, and found much of his inspiration in other forms of sculpture and model-making.

Motivated by a desire to find a hands-on hobby, he said, "I was also considering furniture building, gunsmithing, and motorcycle building . . . LEGO just won the day. Also, at some point in 1992 I was struck by the notion that I'd be working as some sort of specialized LEGO artist making public shows. I suppose I hung on to that thought!"

Although what they build can be wide-reaching and different, one thing most of the LCPs are called upon to do is build sculptures quickly, on location, often with little planning and a live audi-

Sean Kenney working on a model of a polar bear for an exhibition at the Philadelphia Zoo. The model took 1,100 hours to construct with a team of five. © Sean Kenney

ence. According to Robin Sather it's essential to have great building instincts rather than a concrete plan that can be adapted to the bricks available and the environment. "When I plan a sculpture, I put more trust in my on-site building instincts and skill, and do much less pre-planning and design," he said. "It's very easy to over-plan, over-design, and over-engineer a sculpture, and nine times out of ten the plan will change once you actually start building, so it's really a waste of time to try and create a brick-by-brick design plan for a sculpture ahead of time."

Sean Kenney's finished polar bear sculpture—made from 95,000 LEGO bricks—on display at the Philadelphia Zoo. © Sean Kenney

Other builds can take weeks or months of preparation and research, such as Nathan Sawaya's *In Pieces* collection of builds (as shown on page 202), and his other large life-size human sculptures. "Patience is important," Sawaya said. "It takes weeks to complete a life size human form. Full days every day with the bricks. For me, the long hours of creating a new piece bring me immense satisfaction. When I am working on a project I enjoy, I completely submerge myself into the project, going into a trance-like state."

Some LCPs such as Belgium-based Dirk Denoyelle (page 180) incorporate LEGO into their lives in a different way. The comedian began his professional LEGO journey by building LEGO sculptures of famous comedians as part of his act. "I made a comedy sketch about a famous Flemish artist unveiling a (3D) self-portrait. That was a big success, and since then I have been building 2D and 3D portraits for clients all over the world." Now he divides his time equally between his two passions—LEGO and comedy.

If you feel that this might be the job for you, then don't despair, LEGO is always on the lookout for new builders who want to spread the LEGO philosophy through their work. "They're always keeping their eyes peeled for who might be a good fit," said Sean Kenney. "The LEGO Group selects people who are doing great things with LEGO products as a full-time or part-time business, whom they think best exemplify the fundamentals of building proficiency, enthusiasm, and professionalism." But if you want to build big like him—on of his largest models was a 95,000-piece polar bear—then you will need to stock up on bricks, because these models don't build themselves. "I usually keep several million LEGO elements in my workshop, in assorted colors, sizes, and shapes," said Kenney. "On every project, I always need to purchase more bricks than I need, just in case, so I end up spending more than a project might seem to require. During a normal year, I could easily go through a quarter million elements, which alone is twenty-thousand dollars worth of LEGO bricks!"

DAN PARKER, LEGO CERTIFIED PROFESSIONAL

Working as a LEGO Certified Professional (LCP) really is as awesome as it sounds. Dan Parker, based out of Tacoma, Washington, runs TbP Group providing a diverse range of custom LEGO artwork, events, and education and youth services all based around LEGO. "One day I'm down on the floor working alongside a pre-schooler, the next I'm flying across country to an industrial tradeshow, while over a weekend I might be helping a family with a birthday party while my crew is putting the finishing touches on a museum exhibit. . . . I'm not sure if there is such a thing as a typical day!" he exclaimed.

TbP operates between two sites—one a closed-door workshop for builders only, the other a center for visitors, which includes community outreach programs, a play area for guests, and a variety of the company's older works on display. The site also allows visitors to talk to one of TbP's artists, and all this for free!

While TbP is not part of TLG, and is not owned or operated by it, Parker says that they have a positive relationship with the company. "While we have done so, and much to their satisfaction, we rarely work on projects in conjunction with TLG. Our work is generally quite direct and obtained without a reference from TLG. Nonetheless, our relationship with TLG is a positive one in that we can ideally 'co-leverage' our respective strengths for the benefit of both parties." Some of those advantages as an LCP include procuring materials, and help coordinating the debut of special models.

As an LCP, Parker has agreed to work within certain branding guidelines set out by TLG that help to maintain the integrity of the LEGO brand, the only real restriction on the firm's building output. "The commercial artists including the LCPs, as in other artistic fields, are either working with clients along defined pathways or, when given freedom, will often explore works in hopes to inspire thought or move LEGO art into new circles and audiences," Parker said.

Sharing some common ground with the company's own Master Model Builders (see below)—namely their involvement in public and special events—Parker's company also handles a number of other types of events including private functions, as well as working with a multitude of group organizations, schools, and community centers to provide LEGO-based activities, camps, and workshops.

Fancy taking some time out from your office job to work with Dan Parker and his team? Or maybe you're still in school and looking ahead to your career? Well look no further than the boss's top criteria when hiring a new model maker for his shop. "I look for four things in a prospective builder: one, technical craft (how well they can build), two, practical craft (the

supporting tools and activities to produce and deliver the LEGO work), three, people skills (including working with youth), and four, work ethic."

With over three thousand LEGO projects under his belt in twenty-three years, each with a unique story, Parker said he keeps learning new things. "I've enjoyed beating the odds, whether the challenge was working with other people, the time available in which to build a project, how and why we designed a project just so, sometimes impossible logistics to overcome, and some of the venues and clients we've worked in and with." And of course, like every model builder, the reaction is always worth the work. "I love showing off models and, specifically, sharing some of the intricacies and techniques of the project that onlookers can take home and try," said Parker of his dream job. "I try to convey that they can have just as much fun as I'm having, and that what I've done they might be able to accomplish themselves."

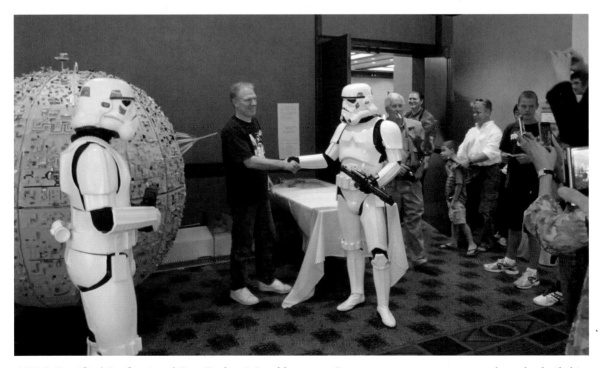

LEGO Certified Professional Dan Parker joined by some Stormtroopers at an event where he built his giant LEGO Death Star. © Dan Parker

175

While the LCPs enjoy the freedom of artistic autonomy and being able to work the hours they choose, there are another group of accomplished and prolific builders who also make a living piecing together LEGO bricks, with arguably a little less freedom but a lot more bricks. Master Model Builders (MMBs) are the creators of almost all the LEGO models you see in LEGOLAND Parks, LEGO Stores, and at official LEGO events. They are the authorized building pros of the LEGO Group. "I am in complete respect and awe of the LEGO model shop builders," said LCP Dan Parker.

Drawn largely from the AFOL community through a rigorous selection process, Master Model Builders (MMBs) work in a number of model shops across the world—some produce models largely for LEGOLAND Parks, while others build display models for events, LEGO Stores, and other promotional outlets. MMB Gary McIntire works in the LEGOLAND California Model Shop and describes his job as "the best job in the world" (can't argue with that). He came to work for LEGOLAND after a stint being employed by LCP Dan Parker, and sees his work as a progression of his building hobby. There is a fine line between the artistic merit of what he creates for work and what he builds for himself. "I consider the projects I do for myself to be my art, but the work that I do professionally, while it is artistic, I don't really have full ownership over it," he said. "Sometimes someone will say, 'Build a toolbox,' and I will put some artistic license into that, but I'm not making a statement with it. I'm creating a toolbox because someone wanted a toolbox. But every now and then I do get to do projects that I have a little more creative license with and the more creative I get to be, the more I feel like my art is coming through in it. I think your art is something you own yourself and you don't do it for anybody else but you."

Most MMBs retain their connections and associations with the fan community and continue to build for fun. "It's definitely two different worlds," said McIntire, of the professional and fan domains. "When I first started working professionally I had to establish, for my employer's sake, a line between doing this for a living whilst still maintaining it as a hobby, and having that social aspect of the LEGO world outside of work. And I think as I've proven myself over the years it's more appreciated now that I am involved in [the fan world]. . . . I love doing LEGO for a living—It's really awesome to be able to do something you're really passionate about every day and get paid for it; it's great. But it's no substitute for being part of the fan community."

It's hard to imagine a life where you get up, eat your breakfast, head into the office and sit down to start playing with toys. It's hard to imagine that this wouldn't be the best job in the world, every single day.

THE *MYTHBUSTERS* LEGO BALL

Of course not every day is your average day fixing some tiny LEGO sightseers in Miniland, or repairing sun-faded pieces from a tired looking LEGO Yoda. For Gary McIntire, 2009 saw him taking on an extreme LEGO challenge of a different sort for the Discovery Channel's *MythBusters* TV show.

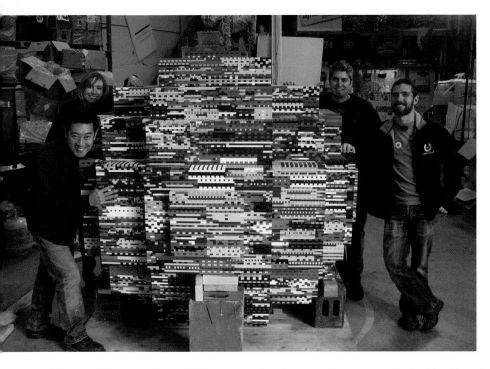

Master Model Builder Gary McIntire (far right) poses with the *MythBusters* team and the giant LEGO ball they built. © Gary McIntire

After working at the park for a couple of years, he was contacted by the show who wanted to see if they could debunk a YouTube video where a "seven-foot-tall LEGO ball made from five million LEGO bricks" was pushed down a steep San Francisco street, rolling into a car without damaging it. McIntire's friend and LCP Dan Parker had advised the video's makers on the project, so he was in on the secret—"They didn't actually build it all out of LEGO," McIntire said. "They built a Styrofoam core and then covered it in base plates, and glued them on the outside of it." But the *MythBusters* show wanted to see if it could actually be done, and McIntire was convinced to help them out.

McIntire went to San Francisco and worked on the model for seven days straight for fourteen hours a day. "It had to be the same shape as the one in the video of the myth we were trying to bust," he said, "and I had to find a way for it to be worked on by twenty or thirty people at the same time. The best way to build quickly with a large number of people is to scale up a smaller model. The original prototype was small and it was made primarily out of two by four bricks, so for every little two by four brick on that model, we had to build one giant brick. We had all thirty volunteers come in and they would just build bricks. I knew how many we needed so we were keeping track of them as we went. As they started building giant bricks I would start assembling the whole thing."

Once they had assembled this giant ball, without gluing it, because they deemed this as cheating, it weighed a staggering three thousand pounds, and consisted of about a million bricks. Then it had to be transported to the test hill. "The forklift that they have in their workshop was not strong enough to pick it up," said McIntire. "So we had to rent a bigger forklift to move it onto the truck."

Only when it was in position on the test hill did McIntire realize how dangerously large this LEGO ball was. "There was a point on our test day where it was sitting at the top of the hill. We had some blocks in front of it so it wouldn't go anywhere accidentally. And I went around the front of it to pull the blocks out and at that moment I was literally, mortally afraid of LEGO. It was completely stable, but if for some crazy reason if it had started to roll it would have crushed me and killed me."

Then it was time to push. . . . "I helped them push it, and as it started rolling the sound was amazing," McIntire recalled. "You could actually feel it impacting the ground under your feet. We were running after it and it veered off to one side and bounced off the barrier, and instead of going end over end it went on its side, and it hit a bump, and once it was on its side it just blew up everywhere." The video shows the shocked and mortified reaction of the team. "If you look at the video you'll see the [presenters] are up in front and I'm in back, and there's this sad moment where they're cheering, very conscious of the camera, and in the background there's me and I'm looking at it and sighing."

McIntire maintains that if the road surface had been more even and if the ball hadn't rolled onto its side, and had instead rolled straight down, end to end, it would've made it all the way down

Below: **A special forklift had to be hired to move the ball on and off the truck to the test site.** *Right:* **Ready to roll—the giant ball is poised at the top of the test hill.** © Gary McIntire

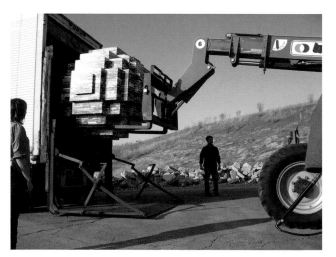

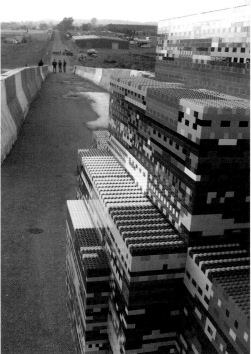

The result of all McIntire's hard work—a big old pile of LEGO bricks! © Gary McIntire

to the bottom, but there was something special about seeing a million LEGO bricks shatter apart before your eyes. "When it explodes and you see little pieces flying up in the air, it was amazing. And the sound of it breaking was unlike anything. . . . It was the sound of a million LEGO pieces being dumped out at the same time. It was really awesome." Ah, yes. Just another day at the office for a Master Model Builder.

RUBENS PAINTING

By Dirk Denoyelle

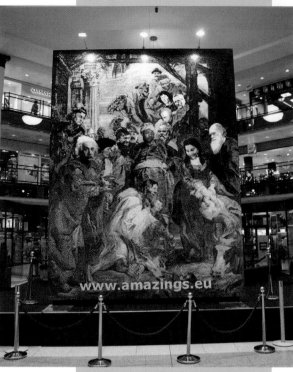

© Dirk Denoyelle

FACTFILE

Build location: Hoboken, Antwerp, Belgium
Year completed: 2010
Time taken: 500 hours
LEGO elements used: Approximately 250,000

WHAT IS IT?

As mosaics go, LEGO Certified Professional Dirk Denoyelle's parody of *The Adoration of the Magi* is spectacular, quirky, and impressive. It measures 15.75 by 11.8 feet (4.8 by 3.6 meters) and while it has been called the largest LEGO mosaic built by an individual, its creator insists he was aided by fifteen friends. The 1 x 1 studded tiles sit on 108 individual 48 x 48 base plates glued onto nine aluminum surfaces.

Peter Paul Rubens painted this scene from the Bible in 1624, but for his interpretation, Denoyelle thought he would have a bit of fun. "I have been a professional comedian for over twenty years. My strong point has always been my ability to imitate voices and do accents in different languages, so parody is in my genes. Putting all of this together, given the title of the original art piece and this background, it was a very natural decision to 'mess with the heads.' As in Dutch the 'Magi' is translated as 'de Wijzen' (the wise people), I replaced the faces in the existing painting with those of people that we may still recognize as wise today," he said. "I did not change Joseph nor the baby Christ. But all other characters have been changed. I prefer not to name them all—it is part of the mystery around this parody that people should try and find them, and what they represent. Of course it is easy to recognize Einstein, Gandhi, and Martin Luther King Jr. Confucius and Erasmus may

be a little harder. But who is Teilhard de Chardin? Shri Mataji Nirmala Devi? I also took the liberty to add a good friend of mine, Danny Braem, and my wife. But where are they?"

The Belgium-born artist and comedian was inspired by his hometown Flanders and its history of famous painters. "I wanted to step in their footsteps, and set up a series of LEGO versions of their work. Rubens is regarded as our greatest and best, just like the Dutch probably swear by Rembrandt and the Italians would go for Michelangelo. So it was obvious to start with Rubens."

Dirk Denoyelle with his mammoth sculpture. © Dirk Denoyelle

MEET THE MAKER

Denoyelle remembers the start of his LEGO journey very clearly. "I started playing—that was playing—when I was about six," he said. "I still remember my granddad giving me the set. The little shop where he got it is still in place, with the same lady as a shopkeeper. I still have the set: it is number 346." His collection grew until he put the hobby aside to attend university. It was only in 1998 when his oldest daughter received her first set of LEGO bricks that he returned to the fold.

"After building towns for a year, as a hobby, I decided to incorporate LEGO into my comedy shows: I made a sketch about a famous Flemish artist unveiling a 3D self-portrait. That was a big success, and since then I have been building 2D and 3D portraits for clients all over the world. And other stuff as well, of course." He is now well-known for his LEGO heads, particularly his portraits of Laurel and Hardy, which he said are constantly touring.

He no longer collects LEGO sets, with the exception of the odd Modular House and some LEGO Architecture sets. "They look nice in our small library," he said. "But I'm more into building art, really. Thinking about new odd creations and then finding ways to realize and commercialize them."

THE PROJECT

Unlike for some builders, who have a clear idea of an entire build before beginning it, Denoyelle's decision to create this comical sculp-

BRICK BIT

There's not much that Denoyelle would change about the mosaic, but there's something his wife would. "I should mention the presence of my very wise wife in the painting. She is hidden pretty well, and I had not told her anything about it. When she first saw the finished project, I had to show her where she was. She would never have guessed. And then she said, 'you could have used a better picture of me!' And she is right. So if I ever have to make a copy, I'll use a better picture of her!"

ture appeared the way most of his works do. "This kind of project typically starts somewhere in the back of your head," he said. "You wake up; have a shower, and the idea of a series of parodies on famous paintings pops to your mind. You walk around with the idea for a few weeks, until something else triggers actual action. . . . Then you start Googling for images of the real painting. You see that one of the characters looks an awful lot like one of our first Belgian kings. But rather than putting his face there, you go for Socrates . . . and then you make a list of other wise people. And you start playing around."

Denoyelle admits to using various mosaic-generating software, commonly used by some mosaic builders to generate the color palette they will require for building MOCs of this size, but finds his own method, "which involves a lot of Photoshopping," the most effective. He said he spent approximately twenty-four hours over a series of days planning for the build. Initially he was in no real hurry to complete the project, and began building one plate at a time. "After a while it was obvious it would take ages to complete, and I do have other LEGO building jobs and comedy shows to do." He then made prints of the design, one print per each base plate, and distributed them together with parts to friends and relatives to help him with the build, although the result wasn't always the most efficient—"Halfway through the process I discovered one plate had been built twice and another was missing."

The finished model has been exhibited twice so far—at LE-GOWORLD in Zwolle, in 2011 and in a shopping mall in Belgium. The reason being it's a costly affair to erect the model given the manpower and the model's need for trusses to support it. But the final effect is well worth the effort. "It is one of the pieces that still stuns me when I see it. Because of its size, for sure, but also because of its colors, brightness, grandeur. . . . People are amazed. But the funniest reaction was from the Museum of Fine Arts in Antwerp, where the original is being kept. They had seen a picture of my LEGO version in a Dutch newspaper, and then tracked me down, only to find

KEEP BUILDING
To find out what Dirk is up, and to check out his comedian LEGO heads, other mosaics, and stunning LEGO architecture creations head to www.amazings.eu.

© Dirk Denoyelle

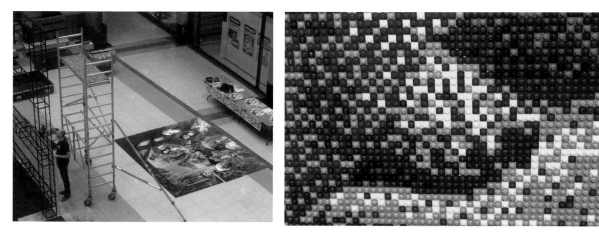

The mosaic is fixed onto a aluminum back and then attached to a truss system. © Dirk Denoyelle

This close-up reveals the detail of required using 1 x 1 tiles to create the final image. © Dirk Denoyelle

out that I live just a few kilometers away. In fact, the director's secretary lives just round the corner and her kids have been friends with mine for years."

SUPER STUDS

As a LEGO Certified Professional, Denoyelle orders his bricks directly from the company. But even Certified status can't help against halts in production. "One major problem was the fact that between the time of designing the mosaic, and the actual building, one LEGO element had become unavailable. Sometimes an element is taken out of production, usually because there is no more need for it in sets. That happened to the lime green 1 x 1 plate, of which I needed about seven thousand or so. I could have searched the Internet for them, via online shops like Bricklink, but in this case, I preferred to redo the design. My sky has a lot more blue in it than the original painting!"

EXPERT ADVICE

Some words from the wonderfully wise Dirk Denoyelle when taking on a large-scale mosaic. . . .

- "Instead of using a paper copy of the building plan, put the file into an iPad and zoom in if in doubt of the exact color to use."
- "Bricks are expensive, but if you want this thing to be transportable, triple your budget! Painful detail: the mounting system was more expensive then the LEGO part."
- "Don't put it on a wooden back: it will come off because of temperature variations."

183

HUMMINGBIRD

By Sean Kenney

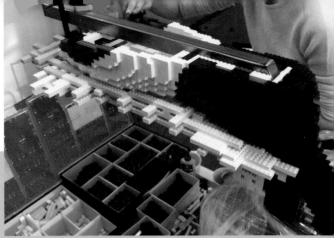

FACTFILE

Build location: Built in New York City; currently on tour throughout the United States visiting botanical gardens.
Year completed: 2011
Time taken: 150 hours to design; 500 hours to build
LEGO elements used: 31,565

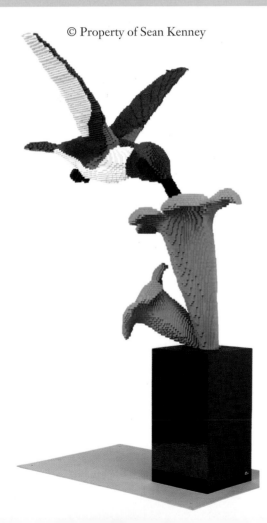

WHAT IS IT?

This gravity-defying model of an eight-foot-high Ruby-throated Hummingbird, with its beak nestling into the petals of giant flowers, is part of LEGO Certified Professional Sean Kenney's touring exhibit *Nature Connects*, which is currently touring botanical gardens across the United States. "Much as LEGO pieces connect, everything in nature is connected in an intricate balance," said Kenney on the show's theme. Developed in conjunction with Iowa State University's Reiman Gardens in 2011, *Nature Connects* has been on tour since early 2012, and includes twenty-seven different creations. "Some sculptures indicate the relationship between elements of nature, like a fox hunting a rabbit, or a lotus, koi, frog, and water platter sharing space in a pond," he said. "Others showcase the beauty of nature, like a giant seven-foot-tall rose, and a five-foot-wide butterfly. There's also a life-size lawn mower that visitors often mistake for the real thing, which is just good for a laugh!"

184

Kenney said the idea for the hummingbird model just popped into his head when someone mentioned the bird's name. "I immediately had this vision of something that you could actually walk under, suspended as if by magic," he recalled. "Creating a spindly little nose and paper-thin wings built out of chunky LEGO pieces seemed like a wonderful challenge and, if done right, something that would look amazing."

MEET THE MAKER

Based out of his studio in New York City, Sean Kenney was one of the first to be given LEGO Certified Professional status, making his living from sculptures, artworks, personalized gifts, and commissions. His impressive backlist of clients includes Google, Nintendo, and Samsung, and his work has been celebrated by the media in the *New York Times*, the *Wall Street Journal*, and on *Good Morning America*. "Before I became a LEGO professional, I spent ten years designing web site interfaces and web user experiences, and I wore a suit every day to work," he said. "But the whole time, my 'inner child' was itching to get out and play! Every night after work I would go home and play with my LEGO toys . . . sometimes while I was still in my suit! One day I was sitting at my desk but I wasn't working; I was daydreaming about beautiful architecture and bright LEGO colors and thinking about what I would build with LEGO bricks when I got home. It was about then that I realized that was exactly what I needed to do . . . I should follow my dreams. So I stood up, took off my tie, and walked straight out—just like that, in the middle of the day. And I never looked back."

THE PROJECT

With a quick Google image search, and four weeks of designing and planning, Kenney and his team dedicated five weeks to build this elegant sculpture. Although he is quick to tell kids that the model is "tied to a satellite" to explain how the bird stays up, in reality, the whole model is steel reinforced. "There's a long metal

KEEP BUILDING

To find out where you can catch the *Nature Connects* exhibition and to see more of Sean Kenney's impressive LEGO portfolio, visit his website www. seankenney.com.

185

rod that extends upwards from a rolled steel base," he said. "It travels through one of the trumpet flowers, up the beak, and along the length of the body. We've also got a little bit of steel in each wing, mainly because they are so thin." The bird hovers eight feet high meaning the team had to build on ladders to complete it and rested a trolley under the bird's belly while they were building (for support, and to keep all their LEGO pieces handy). But it's comforting to know that even the pros with expert planning precision can make small oversights: "We were six weeks in and seven feet up, working diligently on the upper portion of the hummingbird's body when we suddenly realized that it was going to be too tall to fit out the door of my studio!" said Kenney. "We stopped everything and had to redesign the wings to be removable—they now slot into channels in the bird's body and for extra strength are tied to each other with piano wire."

The hummingbird forms a stunning centerpiece for the exhibit—eye-catching and mysterious as nature often is. "I love the way it came out," said Kenney. "It's really exactly how I imagined it. Seeing it installed at the botanical gardens, set outdoors and in a bed of tulips really made the sculpture shine. It's nice to see a piece like this be given proper presentation."

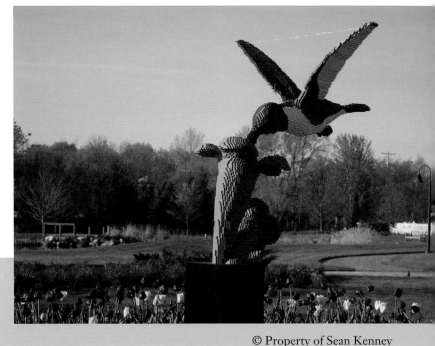

© Property of Sean Kenney

Despite not being seen by the general public in the exhibition, Kenney makes sure the model looks detailed and accurate from all angles.
© Property of Sean Kenney

SOLAR SYSTEM CEILING

By Gary McIntire

FACTFILE

Build location: American Fork, Utah
Year completed: 2006
Time taken: 140 hours
LEGO elements used: Approximately 15,000–30,000

WHAT IS IT?

"When I was a kid I had those glow-in-the-dark stars on the ceiling in my bedroom, so I thought what would be better than putting LEGO stars on the ceiling in a LEGO room? But better than that, why not do the entire solar system? So that's what I did," said Gary McIntire about this stellar creation, which he designed and constructed as part of a model-home housing project in Utah. "It's the perspective of the solar system from the moon, loosely. The planets

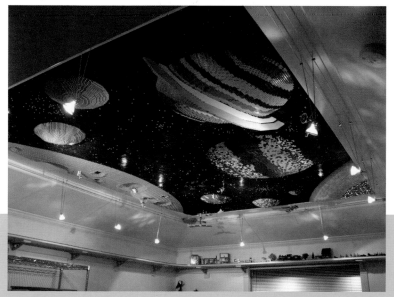

© Gary McIntire

are all in relative size to each other, but they're not all in scale otherwise the sun and Jupiter would take up the whole thing. The sun is in one corner, and Mercury's next to that and they continue all the way up to Pluto."

McIntire was working for the model-home company, who brought together custom home contractors to showcase their work to the public in million-dollar homes. "They saw what I was doing with LEGO and realized it's pretty cool and

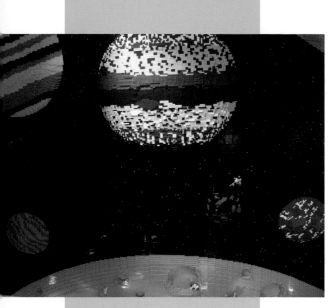

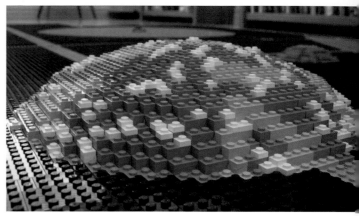

McIntire was able to give the smaller planets more relief, while the larger planets had slightly less so as not to protrude too much into the room. © Gary McIntire

asked if I wanted to do something for the house." He was charged with designing the interior of the ultimate LEGO studio—complete with workbench, desk, cork floor, light fixtures, and a LEGO train that circles the top of the room.

MEET THE MAKER

Gary McIntire is a Master Model Builder at LEGOLAND California, and lives in San Diego. Outside of work he is active in the fan community, building for pleasure. When asked what it's like to be an inspiration for the thousands of children who see his installations at LEGOLAND each year, he said he found such a notion flattering. "It's a strange thing to get that attention and to be idolized and recognized in that way," he said. "For me I'm just a normal guy who's gotten to do some cool stuff. I don't feel like I'm anybody special. I like the thought of thinking that I'm an inspiration to people but I wouldn't be very humble to even recognize that."

McIntire joined the LEGOLAND team in 2007 and has been part of some truly awesome builds both inside and outside

Marking out where all the planets were going to go and their relative sizes using LEGO bricks.
© Gary McIntire

the park. Most famously he appeared on Discovery Channel's *MythBusters* helping the presenting team to build a three three-thousand-pound LEGO ball. But the model that's most impressed McIntire is one he didn't build himself. "Number one, most amazing model is The Walker," he said of Jørn Rønnau's gray LEGO sculpture that formed part of a 1989 exhibition in Denmark, and now resides in Billund (see page 24). "There was a picture of it in a book I had as a kid and I always thought it was such an amazing model so to see it in person was incredible."

THE PROJECT

To prepare for the build, McIntire referred to another book from his childhood called *Our Universe*. "I used that really as most of my source material, looking at sizes and deciding what colors I wanted to use for each planet. I did a color-study first where I built teeny versions of each planet to see how the colors would go together." He then went about ordering the correct quantities of bricks—especially black plates, of which he needed a considerable amount, and specialty colors for the planets.

"I cleared out my dining room and laid out all the base plates on the floor and then I literally took handfuls of 1 x 1 plates and laid them out in circles to decide how big I wanted the planets to be and where they were, and would slide them around and roughly create the shapes I was looking for and get an idea of the full layout." He then had to decide how much relief to incorporate into each planet. "I didn't want to go too tall because it was going to be on the ceiling, so I had to keep it within a certain amount.

189

The smaller planets are a little bit more spherical because I had more room and the bigger ones slope up around the edges and then flatten off a bit in the middle," he said.

Knowing the clutch power of LEGO, he didn't have too many concerns about the ceiling holding, despite being upside down above paying visitors. "I was a little bit nervous about the rings on Saturn because they really hung out a lot and were only connected by eight studs each, but it worked. I did do a test in the room where I stuck a base plate to the ceiling and built a bunch of LEGO on to that just to make sure that the tape would hold." Rather astonishingly, no glue or screws were used to hold the model in place—just a whole lot of double-sided tape. "I was definitely nervous," he said of whether it would hold. "I had a little sag at one point where the tape released a little bit and I was able to put a new piece under there to stick back up. I think mostly that was due to the heat. But I never really lost anything, it all stayed up pretty well.

The build was finished on-site, in front of visitors, so they could see the room in action—many visitors returned more than once to see the build completed. "I put a lot into the whole room and it was really cool to see how it all tied together. Probably one of the most awesome things was at night I would dim down the lights real low, and also the sun lit up in the corner and that was on a dimmer too, so I'd dim down the sun. I had to build all of that in place because it was all wired into the ceiling. That was probably the most time-consuming part of it, because I was building above my head the whole time."

Completing the black ceiling, and marking out the color palette of each planet with a handful of bricks.
© Gary McIntire

KEEP BUILDING

To see Gary McIntire working in the model shop, head down to LEGO-LAND California. Otherwise, check out his Flickr stream—www.Flickr.com/garymc.

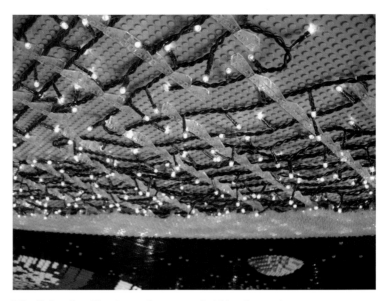

The lights that illuminate the sun are held in place using transparent LEGO elements. © Gary McIntire

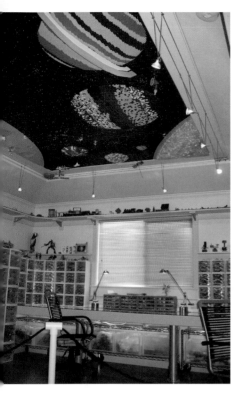

A LEGO room fit for a Master Model Builder! © Gary McIntire

Unfortunately, the ceiling no longer exists. "It's kind of sad," McIntire said, "but it's a testament to the impermanence of art." And despite working on huge LEGO sculptures for a day job he still remembers the experience fondly, and with pride. "It was really amazing because I put a lot into it. I think one of the best parts about being an artist is having a vision and seeing it come to life and so that definitely happened with this. I dreamed pretty big on that project and it actually came together better than I could have imagined. It was an amazing thing."

SUPER STUDS

"I used 1 x 1 transparent round plates as stars on the ceiling and I put in constellations too. It wasn't the entire night sky but I did representations of the Big Dipper and Orion. I didn't have glow-in-the-dark bricks on that project, unfortunately, but I think the transparent ones worked probably better because you could see them sparkle a little bit but they didn't really stand out; I think it would've detracted from the planets."

BUS STOP MURALS

By Nicholas Foo

FACTFILE

Build location: Singapore
Year completed: 2011
Time taken: Fifty-two hours
LEGO elements used: 97,000

KEEP BUILDING

To see more of Nicholas Foo's work, or to commission him yourself, visit www.blackbulbcreations.blogspot.com.

WHAT IS IT?

Commissioned by advertising agency Oglivy and Mather in 2011, these remarkable murals by LEGO Certified Professional Nicholas Foo make the most of the bricks' colorful creativity. Built as part of the LEGO Imagine campaign, Foo described the mosaics as "windows into another world." The striking images of a whale, a caterpillar, and an alien monster were designed to blend into their surroundings at bus stops across Singapore—transforming what the viewer can see into a LEGO brick universe, and in turn firing up our imaginations. Each mural measures four by six feet (1.2 by 1.8 meters), and over thirty thousand LEGO elements were used to create each highly detailed illusion.

MEET THE MAKER

Nicholas Foo is one of only thirteen LEGO Certified Professionals in the world, and the only one based in Singapore. His work largely focuses on gift items made from LEGO materials, but he is also known for some larger creations including a 16,000-element minifigure-scale city. Born and raised in Singapore, where he said there is a "small and interesting AFOL community," Foo has been

building on and off with LEGO bricks ever since he was eight years old, until he made LEGO his career. "The timing was right," he said of the transition from the design and media industries, where his last role was as a creative director. "The stage was set, opportunities presented themselves. I laid out my plans, seized the moment, and pursued it." And it seems he's never looked back now that he's working every day with a medium he loves. "I have the same feeling as anyone would who's passionate about life and in what they do. Mostly, I'm thankful and appreciative for everything and everyone that's in my life."

Foo's creative, functional, and fun models often arise from commissions, although even he is surprised occasionally by the things people want made from LEGO bricks. "The weirdest would have to be an inquiry for lingerie," he said. "The commission never materialized though." Probably for the best; it would hardly have been comfortable.

THE PROJECT

Working with the creative team from Oglivy and Mather, Foo determined the technical requirements of the three murals, before he could set about drawing and inking the designs on a computer. "It was fairly easy once the concept was worked out," Foo said. "The rest is simply acquiring the materials and creating it." Easy for a pro, but to make the murals happen in the required timeframe, Foo required the help of four other builders to finish the project in just one day. The murals were enjoyed by passersby on the streets of Sinapore for a week, and received considerable press attention, and all three pieces picked up a Silver Lion at the Cannes Lion International Festival of Creativity in 2011. "I think the final result and the ten awards these murals bagged speak volumes," said Foo. "I'm happy they turned out the way they were intended."

All images in this profile
© Nicholas Foo

ELVIS HELICOPTER

By Ryan McNaught

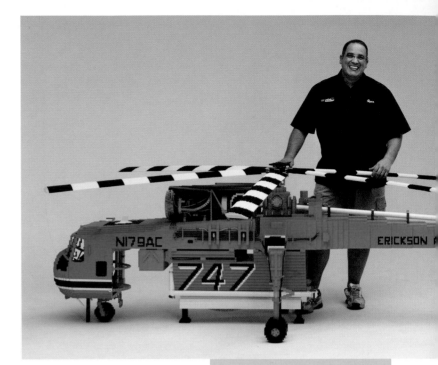

FACTFILE

Build location: Melbourne, Australia
Year completed: 2013
Time taken: One month
LEGO elements used: Approximately 100,000

WHAT IS IT?

LEGO Certified Professional Ryan McNaught spends eleven months each year building commissioned models for a living. But he allocates his month off to something from his bucket-list of models—things he has always wanted to build. "I have an amazingly long list of stuff I would like to do, and 'Elvis' was on top," he said of the bright orange Erickson Air Crane S-64F firefighting helicopter, known colloquially as Elvis in Australia. "Each year we have a huge issue with bush fires, and every day on the news it is a headline story, with 'Elvis' and his family of helicopters playing a key part in saving lives every day. 'Elvis' is almost synonymous with summer in Australia."

While most novice builders would be overwhelmed by such a challenge, McNaught has the calm confidence of a professional saying, "Nothing is impossible to recreate in LEGO, so there were quite a few technical challenges (doing round things with rectangular bricks is always a challenge) but it didn't pose anything that wasn't overcome." Measuring in at an impressive thirteen feet (four meters) long and more than three feet (one meter) tall, he estimates that the model weighs 110–165 pounds (50–75 kilograms), and with very little ground contact posed a welcome challenge for the builder. It features more orange bricks than McNaught had bargained

Ryan McNaught with his 100,000-LEGO piece Elvis helicopter. © Ryan McNaught

for—"I'm a little over orange bricks now"—and a six-blade rotor configuration, which he intended to motorize but ran out of time at the end of the project. "Perhaps I'll revisit it one day," he said.

MEET THE MAKER

Before being issued Certified Professional status from the LEGO company and turning his hobby into a career, McNaught worked in IT and was the Chief Information Officer for a media company. "I look back to when I was a small child, and how much I loved LEGO," he said. "It was my dream to one day work with LEGO bricks for a living, of course life moves on and the dream is just that, but it's funny how sometimes the world turns and you end up doing things you always wanted to do."

McNaught is known across Australia and around the world for some of his larger creations—most notably his 5.7-meter-high (nearly nineteen-foot) Saturn V rocket, and a minifigure-scale version of the *Pacific Princess*—a cruise ship from the eighties TV series, *The Love Boat*. He sees building on such an impressive scale, beyond the limits of a child's bedroom, as a way to reach out to the community and inspire others. "I think it's about pushing the boundaries of LEGO; it's about showing people the possibilities of what it can do and where it can go. . . . It doesn't have to be big and extreme; it's all about challenging LEGO to be used in new and interesting ways and methods."

THE PROJECT

"The Internet is my friend!" said McNaught of the researching process for the Elvis helicopter. "Thanks to the diligent aviation photographers and plane spotters around the world, there was a stack of pictures available." The wealth of photographs made research for this project a breeze as far as he was concerned, and meant more time could be spent on planning the build—normally 5 to 10 percent of his total project time. Believing an object "of this shape and complexity" wouldn't benefit from computer programs

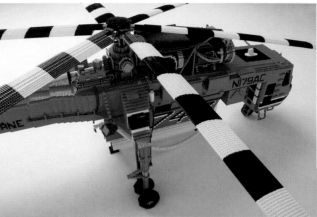

designed for modeling, McNaught preferred a more traditional method. "I always do some sketches and drawings first," he said, "to work out scale, dimensions, weights, center of gravity, and to also work out the rough pieces needed."

With ample experience undertaking large-scale projects, and the materials to match, McNaught's approach is methodical and pragmatic. "It's about planning and tackling the model in the right way, doing the stuff which is relied upon first, that helps you with other sections later on." Still, even a pro can face challenges, especially with a build of this scale, most notably with the rotor blade. "They are long and LEGO is not a rigid construction material. I made many prototypes of the blades first before I settled upon the final design. What the pictures don't show is that the model is actually designed and built to be hung from above as if it were actually flying. . . . There are a lot of engineering principles around center of gravity and hook access points built into the model."

Like any builder, it's hard, even for McNaught, to know when a creation is complete. "I would always make improvements on my models," he said, "but you do have to have an end date on a model at some point. When it was finished, I had a real nervousness about if the model was any good, and if it would inspire children to create too." There's no doubt about that. Elvis made his debut at

KEEP BUILDING

As the Southern Hemisphere's only LEGO Certified Professional, Ryan McNaught is always working on something new. To find out where you can see Ryan McNaught's "next models" head to www.thebrickman.com.

The helicopter model under construction in McNaught's workshop.
© Ryan McNaught

Australia's premier LEGO fan convention—Brickvention 2013, and has been on a bit of a tour around Australia. McNaught is pretty sure it will end up overseas, so keep your eyes peeled at a LEGO event near you. With all that orange, it's a hard one to miss! "While this model isn't the biggest, and doesn't use the most parts of those that I have built, it's one of my favorites. After all who doesn't love a giant helicopter made out of LEGO?"

SUPER STUDS

McNaught's favorite parts of his Elvis model are the helicopter's engines. "Many years ago I made a LEGO Airbus A380, at a totally different scale, for minifigures," he said, "and the turbine blade system which I created for that plane was re-used almost identically here in something that is twenty times the scale!"

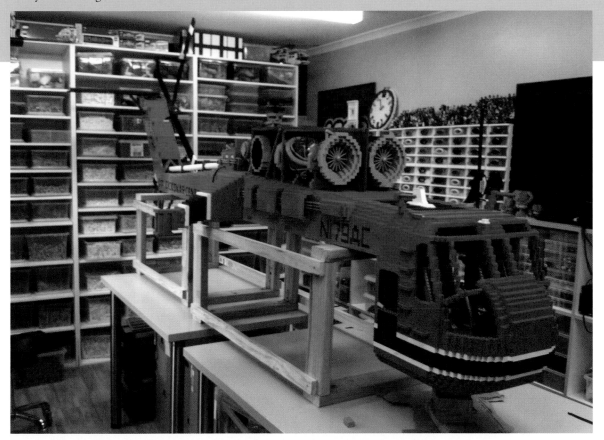

STAR WARS DEATH STAR

By Dan Parker

FACTFILE

Build location: Tacoma, Washington
Year completed: 2012
Time taken: Five weeks
LEGO elements used: 24,000

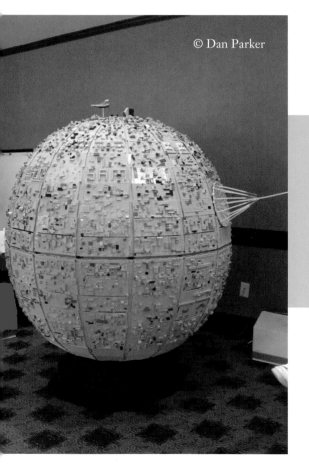

© Dan Parker

WHAT IS IT?

Not long ago, in a galaxy far, far away (otherwise known as Tacoma, Washington), LEGO Certified Professional Dan Parker built this sixty-six-inch diameter Death Star from the *Star Wars* saga that Darth Sidious would be proud of. The model is replete with superlaser cannon and has been designed to enable guests at an event to cover the surface panels, which populate the model. "This gives guests a great sense of involvement and excitement in the growing attraction," Parker said.

"Clearly we drew inspiration from the *Star Wars* saga," he said. "We wanted to create something that others said couldn't be done, particularly with a round shape *and* something we could move to shows repeatedly. More-over—and this was key—something in which crowds could participate." The model hits the spot on all three factors— it can even be broken down into four pieces of airport luggage for convenient shipping.

Thinking about recreating this beauty for your *Star Wars* model collection? Make sure you've got some giant, robust shelving—the completed Death Star weighs about 250 pounds, and according to Parker is fifty times the volume of TLG's most recent Death Star set.

MEET THE MAKER

Dan Parker's first flourish with LEGO occurred typically in childhood, between four and ten years old, "although I also enjoyed several other construction-oriented toys and *any* other construction/creative media my parents or grandparents allowed me to use." In his teen years, this morphed into a more specialized interest in carpentry and furniture building, as well as an interest in both architecture and engineering. "After time in several relevant fields and the military, heading back to university and working for a research and development company helped me rekindle an interest in LEGO at age twenty-nine," he said. "After enjoying this as a hobby for a few years I began to understand some of the potential commercial applications of the LEGO medium."

A closer look at the model's customizable surface panels.
© Dan Parker

He now runs TbP Group, and is a LEGO Certified Professional. His company specializes in building LEGO models and participating in LEGO events, as well as running educational programs. "We've built a nine-foot Statue of Liberty, actual coffin, four-foot Borg Cube from *Star Trek*, six-foot Ferris wheel, large castle that can be re-configured, 120-square foot minifigure castle scene with 2,300 minifigures, and are currently producing two major museum displays that will go on tour. The first focuses on skyscrapers while the other is a multipart exhibit covering American culture from the point of view of a LEGO brick." For more on Dan Parker's TbP Group see page 174.

Parker is keen to further explore the educational and inspirational aspects of LEGO building, which is how he'd use an unlimited amount of LEGO bricks. "I'd set up a living exhibit and center where I could invite people to drop in and help me create a reflection of our world using a variety of formats, from miniatures to mechanics and sculptures to mosaics," he said.

THE PROJECT

"My design philosophy for large models is to 'design as one would eat an elephant: one bite at a time,'" said Parker. "My team and I break complicated problems into smaller components which lead to quicker solutions. This is

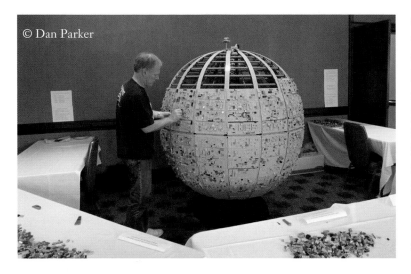
© Dan Parker

critical for our large models, which are often complex, hybrid designs of art *and* engineering. Our creations are where the aesthetic view meets the physical forces." And from the sound of it, this 'elephant-eating' design process is not always instantaneous. "For the Death Star, I considered design solutions in my head while driving around in my car for about a month."

Next step, for a group project such as this, was to get his team together for a design and build brief, with a simple sketch by Parker as the main reference point. "I shared a few small design solutions of key parts. Two builders were assigned to the project while I supervised assembly and handled some of the support/build-up tasks. Key to capturing the curved shape of the surface was creating bowed assemblies. We built these using short Technic beams and pins which, when assembled, give just enough flex to produce curved assemblies installed vertically (as a longitudinal member) on a central pillar. We also used ball-joint assemblies to run latitudinal (horizontal) bars between the vertical bows. Surface panels were simple, built-up trapezoids of plate."

He does admit to one unfortunate omission, however. "The equatorial trench encircling the Death Star is modeled, however, due to constraints caused by the resolution (size) of LEGO elements, we are precluded from modeling any unprotected/uncovered 2M exhaust ports."

The build has been designed for continuous use, and as a result is open to constant reform and improvement. "For a large, complex project, the build was fairly straightforward. It travels well and pre-staging at events goes as expected, though could be streamlined. The curve could be improved," he said. But the fans aren't

BRICK BIT

"In procuring material for the model, we momentarily cleaned out Bricklink of some materials," said Parker. Well, Bricklink users, hold onto your light sabers, because Parker isn't finished with the Death Star just yet. Oh no, he's going ever bigger. "I am now considering increasing the size of the sphere by nine inches which would result in a Death Star one hundred times the size of the current LEGO kit!"

complaining. The model made its debut appearance at BrickMagic 2012 in North Carolina, and received a suitably stunned reception. "AFOLs were blown away," said Parker. "One of the more knowledgeable and proficient AFOL-builders stated he believed our custom Death Star creation to be one of the top five creations ever made. The model is a popular attraction at software industry shows and is safely stored in our warehouse."

SUPER STUDS

Even serious Death Star models can involve a bit of wit and whimsy, especially where LEGO is involved. "We always show a mini kit of an Imperial Star Destroyer—about four inches long—on top of the model," said Parker. "It gives people a sense of scale. We've also built a few small, humorous vignettes to accompany the model such as the Emperor using a tanning bed while a Stormtrooper gets him a juice, or Anakin fighting Darth Vader (himself!) while slipping on a banana peel."

EXPERT ADVICE

Dan Parker has more big-building experience than most, so it's probably a good idea to listening to what he has to say:

- "Build and learn from your mistakes."
- "Build with other mediums and apply techniques from those creations."
- "Building large LEGO models is often relevant to building the hull of a ship: the same stresses and strains will manifest themselves so you need to solve for this."

KEEP BUILDING

To find out what Dan Parker and his studio are up to next, check out www. facebook.com/cityblocks and if you're in Washington be sure visit the world's only public demo LEGO art studio in Tacoma, run by Parker.

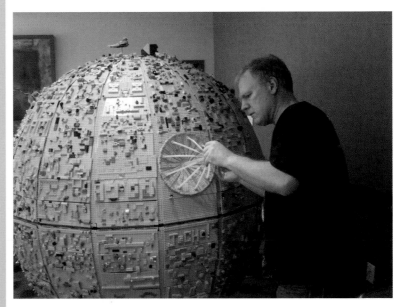

LCP Dan Parker puts the finishing touches to his Death Star model.
© Dan Parker

RED DRESS
By Nathan Sawaya

FACTFILE

Build location: Los Angeles, California. The Red Dress model is currently on tour as part of the *In Pieces* gallery exhibition.
Year completed: 2012
Time taken: Six weeks
LEGO elements used: 63,400

WHAT IS IT?

Renowned artist and LEGO Certified Professional Nathan Sawaya teamed up with Australian photographer Dean West, to create a stunning collection of photographs called *In Pieces* featuring Sawaya's sculptured LEGO objects. "I quickly saw how exciting the collaboration could be," he said. "My sculptures are built in layers and Dean's photos are layered images, so it seemed like a natural fit."

The result pays homage to unnerving, inspiring, and quirky Americana landscapes and characters. This model of a dramatic red gown stars in arguably the collection's stand-out image of a glamorous woman shivering in front of an art deco movie theater—the LEGO 'fabric' of the dress seemingly blowing in the wind.

"By using Dean's modern photography methods we were able to capture emotion, depth, and an eerie feeling of emptiness," Sawaya said of the finished result. "The integration of my brick sculptures acts almost as a pixilated portion of each image."

MEET THE MAKER

LEGO Certified Professional Nathan Sawaya switched his briefcase for a box of bricks after realizing his relaxing hobby might just be the career he was meant for. The New York City–based former lawyer ditched the suit-and-tie and went pro in

The dress model on display at the *In Pieces* exhibition. © Nathan Sawaya (Brickartist.com)

A model wears a fabric red dress so Sawaya has a point of reference for his model. © Nathan Sawaya (Brickartist.com)

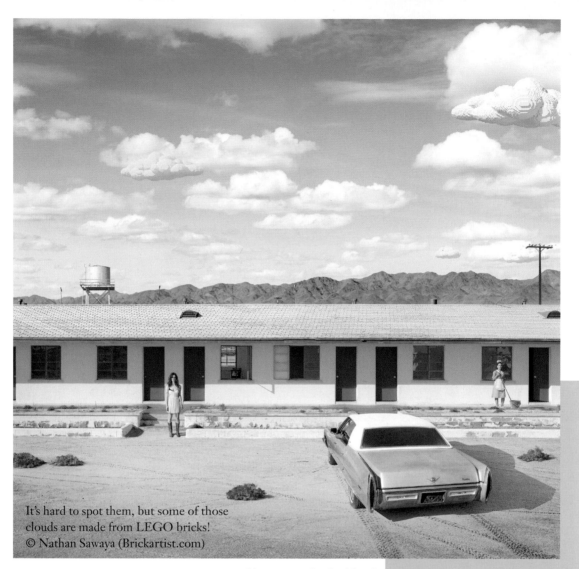

It's hard to spot them, but some of those clouds are made from LEGO bricks! © Nathan Sawaya (Brickartist.com)

One of the cloud models. © Nathan Sawaya (Brickartist.com)

2002, and he's never looked back. "As you may know, New York corporate attorneys work over eighty hours a week," he said. "These days I'm working more hours, but having more fun."

Sawaya grew up on LEGO Town sets, like many of his generation, but he's a big fan of the licensed *Star Wars* products, saying, "It's still fun to sit down and build a Death Star or two." And as a freelance LEGO artist, he gets to have more fun than most building his unusual large-scale sculptures of anything from a giant pencil to a Tyrannosaurus-Rex skeleton. His works have been featured on TV, music album covers, and in a number of books, and a lot of

them can be seen in his popular touring exhibition *The Art of the Brick*. But ask him to pick his stand-out model, and he's as stumped as his fans: "I love all of my pieces," he explained. "If asked to pick a favorite, I say 'the next one!'"

THE PROJECT

Fashion photographer West contacted Sawaya in 2010 and proposed the idea of blending his highly stylized photography with the artist's LEGO sculptures. They spent time together discussing the themes of the exhibition and sketching concepts before hitting the road to find suitable locations to capture their joint vision. They also cast models to appear in the photos before Sawaya began crafting his sculptures.

The Brick Artist himself appeared in this photo in the collection. Watch out for those LEGO tracks! © Nathan Sawaya (Brickartist.com)

The project was a complete fusion of the two artists' ideas, as he explained. "If one of us vetoed an idea, or an actor, or even a potential piece of wardrobe—it was out. We only moved forward when we were in total agreement. Each image and each sculpture represent a true collaboration, a true joint and unified vision."

But the LEGO building was all up to Sawaya, who drew on years of experience to create the floating fabric of *that* red dress. The planning and design phase, which took over two weeks, saw him experimenting with various designs—some of which could actually be worn, albeit painfully. A non-wearable design was settled on to avoid serious injury and the added bulkiness that would be

KEEP BUILDING

"I'm really excited about some upcoming projects," said Sawaya, "but I can't talk about them yet. Just keep checking my website for my latest creations!" To see more of Nathan Sawaya's LEGO sculptures look out for his book *The Art of Nathan Sawaya* and visit www.brickartist.com.

205

required to fit the bricks around a real figure. It would later be layered onto the girl's portrait using photographic wizardry. A photo-shoot in Toronto, using a model and yards of red silk fabric rigged to wire, captured the illusion of movement and created the basis for the life-size brick model. "It was important to me that the dress looked realistic," he said. "The challenge and the magic were making sure the red dress didn't look cartoonish or out-of-place." Structural supports built from LEGO were hidden within the dress making it possible to hang it at the exhibition. Wires are also used to incorporate the floating bricks that make up the dress's train.

The build was not without its challenges though, even for an expert like Sawaya, such as the fact the sculpture was going to be part of an exhibition and therefore all sides would be seen. The artist struggled particularly with making the waves of cloth appear lifelike from so many angles. "When I am building a three-dimensional object, the interior of the sculpture does not show, so it can be as messy as I want," he said. "But with the dress, the cloth could be seen from both sides, so it had to be both thin, but also accurate on either side. This proved quite challenging. I would glue whole sections in place, and then have to chisel them apart when it wasn't looking right. I think I threw away as much chiseled bricks as I used in the actual sculpture."

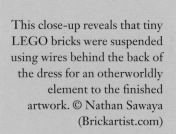

This close-up reveals that tiny LEGO bricks were suspended using wires behind the back of the dress for an otherworldly element to the finished artwork. © Nathan Sawaya (Brickartist.com)

Problems overcome, the dress has since been displayed as part of the *In Pieces* collection at various museums and galleries including the Columbus Museum of Art and the William J. Clinton Presidential Library, where it received a presidential seal of approval from Bill Clinton himself. "Overall the reaction [to the exhibition] has been fantastic. People especially like the Red Dress and the many little red bricks breaking off of it in the wind."

SUPER STUDS

While the Red Dress is undoubtedly the icon of the collection, Sawaya's favorite build was for a different photograph featuring a hotel and some rather inconspicuous LEGO clouds. "A lot of viewers struggle to see that some of the clouds in the image are actually made from LEGO bricks," he said. "Creating those sculptures was a real challenge for me given that clouds are soft, round, puffy objects, while LEGO bricks are nothing but hard, sharp, right angles." At the exhibition he took pleasure from seeing people's reactions to the clouds hanging above their heads.

EXPERT ADVICE

Is your wardrobe missing that certain *je ne sais quoi*? Here are Sawaya's top tips for building a dress from LEGO bricks. (And watch out for those sharp angles!)

- Want to get that floaty fabric look? Sawaya says, "Plate elements can appear like fabric when layered properly. . . . The thinness of the plate elements became critical in capturing the look of the fabric of the dress."
- Think in the round to avoid a dimension disaster. "Remember to look at your creation from all sides, because even if you don't someone else will."
- And above all, "Have patience. You can't finish something like this in a day."

GREAT SPHINX

By Robin Sather

© Robin Sather

FACTFILE

Build location: Built from the ground up on six different occasions (and then taken apart, brick by brick), in six different Canadian cities.
Year completed: 2006–2011
Time taken: Takes two builders three days to construct.
LEGO elements used: 25,000 LEGO and DUPLO bricks

BRICK BIT

Due to its extreme nature, Sather built the head and headdress of the Great Sphinx model on the floor beside the main body rather than directly onto it. "When it was completed, it weighed almost ninety kilograms [two hundred pounds]!" he said. "It took four or five strong people to carefully lift it up, and place it on top of the shoulders of the sphinx to complete the sculpture."

WHAT IS IT?

As part of the LEGO Secrets of the Pharaohs traveling exhibit, which toured across six different cities in Canada between 2006 and 2011, Canada's only LEGO Certified Professional, Robin Sather, built this giant Sphinx model. The design was based on what the original Great Sphinx of Giza in Egypt may have looked like thousands of years ago. "Flecks of paint have been found on the actual Great Sphinx that indicate it may once have been red in color, with yellow and blue highlights like the Nemes headdress, and the facial makeup," said Sather. Of course, while this model measures over eight feet (2.5 meters) tall, wide (at the paws), and deep, it is tiny in comparison with the one it's replicating. "Overall the real Sphinx is almost nine times the size of my sculpture," he said. "It's about as tall as the height of the paws on the real Sphinx." Sather also took some liberties with the shape, choosing to make it in "a more pleasing shape, and I gave him back his nose!" The completed model weighs hundreds of pounds!

MEET THE MAKER

"I was always a 'LEGO kid,'" said Sather of his childhood where the bricks were his number one toy. "Like many adult LEGO fans, I slowed down a bit in my teen years, and in college, but I eventually came back to it, and eventually found a way to turn LEGO building into my career." Now, as the only LCP residing in Canada, Sather's job involves building wonderful creations such as this one, a far cry from his previous profession working in IT, developing and programming database applications. Although he does find some use for his well-practiced analyst skills. "An analytical approach to LEGO building is helpful, especially for large builds," he said, "but working with LEGO is vastly more creative than computer programming!" Sather lives on the West Coast in Vancouver, where he was one of the Vancouver LEGO Club's founding members, and is committed to attending fan events in the area—he's been to every BrickCon in Seattle, Washington, apart from one!

THE PROJECT

Designing and building the Great Sphinx was one of the first large-scale projects Robin Sather had attempted. "I had a few days to create a design, but in the end, the design plans really only served as a guideline for the build, and the end result was quite different from the initial design," he said of the experience. To prepare, he studied dozens of images of the Great Sphinx and referred to websites about it for reference and factual information. He then devised some rough sketches of how the sculpture might be interpreted in LEGO bricks. "Eventually, I settled on a basic overall shape for the sculpture, and mapped out some rough dimensions," he said.

"I generally do simple sketches by hand, or just grab some bricks and build some key components or shapes that will make up the sculpture (like the paws, or the face in this case)." Sather then scanned the images into a computer and used a program to measure aspects of the piece, which then translate into LEGO brick dimensions. "For the Sphinx, I used another 3D modeling program to help sculpt and colorize the face," he explained. "Usually I just grab bricks

KEEP BUILDING

Robin Sather is always building bigger and more impressive LEGO creations to wow the folks in Canada. Let him wow you a little bit more at www.brickville.ca.

© Robin Sather

Sather used a smaller half-model and a mirror (in the background) to help him build the larger-scale version in full. © Robin Sather

© Robin Sather

and sculpt until I'm happy with the result, but this time, using software was quicker than doing it with bricks. . . . Then, I simply started building!" Because he had to build the model for the first time on-site for the exhibition, he took dozens of photos, and then rebuilt a half-scale model of the big sculpture which he could keep constructed, using it as a blueprint for the further five exhibition rebuilds that were required.

With only three days to complete the 25,000-brick build, each time, Sather relied on the help of a second builder to make sure he would meet his deadline. "Thankfully, the sculpture is symmetrical, so often I would build on one side of the sculpture, and a helper builder would mirror my bricks on the other side." Another method he employed to ensure the build moved along at the required speed was DUPLO bricks. "Almost everything other than the head of the Sphinx is built with DUPLO bricks," he revealed. "But, to get better detail and sharper features for the face and head, I used smaller LEGO bricks, combined with the DUPLO bricks. Most people don't realize that the two sizes of bricks can be used together."

With a limited selection of basic bricks available to him for the build, Sather faced a number of challenges. Unable to rely on plates, slopes, and other special parts, he had to make do with what he had and use a bit of simple math. "For the spots where I needed a one by two DUPLO brick, for example, I 'made' one from two, two by four LEGO bricks!"

Now that the exhibition is over, the model's bricks have since been recycled to build lots of Sather's other extreme creations including a dinosaur, a double-decker bus, a Japanese Torii gate, and a giant parrot. Although he still remembers his time in LEGO Egypt fondly. "The giant LEGO Sphinx is still one of my favorite builds," he said, "and honestly, I wouldn't change a thing about it. Instead, I prefer to move on and build something new!"

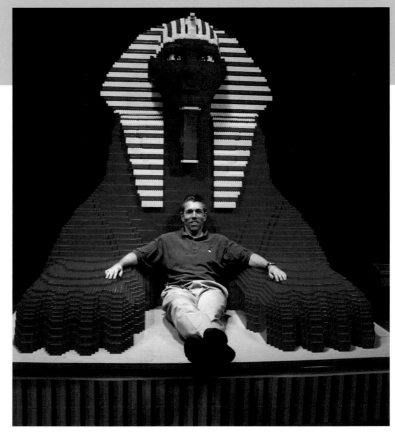

Robin Sather with the finished Sphinx model.
© Robin Sather

SUPER STUDS

"After I built the Great Sphinx the first time, in full size, I created a half-scale model of the sculpture to use as a blueprint to re-build the giant Sphinx in each new location," said Sather. "Because the sculpture is symmetrical, I only needed to build half of it (one paw, one side of the face and headdress, etc.) When I displayed the half-scale model, I placed it up against a mirror, and presto! It looked like a full model! People were always surprised when they looked closer and realized that only half of the model was actually built, and the other half existed only in the mirror's reflection. It was a very cool optical illusion! I was able to 'copy' the model, and use it to rebuild the full-size version."

A computer-generated image of the Sphinx's head allows Sather to calculate quantities and colors of bricks. © Robin Sather

CHAPTER SEVEN

Be Extreme

"If you don't start you will never know what you are capable of."

Paul Hetherington, Adult Fan of LEGO

O nce you've picked your jaw up off the floor after looking at the models in this book, you'll probably feel a little sorry for yourself: A) you don't have a collection of twenty million LEGO elements like Dan Brown at his Toy and Plastic Brick Museum, B) if you played with LEGO at *your* job or school, it would probably involve you getting into some kind of trouble, and C) even if you did have that many bricks, and your job required you to build with them, you're pretty sure you'd never be able to construct a life-size LEGO self-portrait, a giant ship that doesn't fit in your house, or even something that would impress your friends.

Remember, this is a children's toy—we can all pick up any number of LEGO elements and stick them together, or build a tower to touch our living room ceiling out of DUPLO bricks, but it's how you do it that separates an average model from a great one! Sometimes building big is not enough to stand out from the crowd and it can take practice, patience, and a full piggy bank to make an extreme model that gets people talking.

But it's good to know that even the professionals, with their walls of parts stored neatly in perfectly labeled containers, can't always make LEGO bricks do whatever they want. "Every creative medium has its own set of unique constraints," said LCP Dan Parker. "The trade-off in reaching the occasional impasse is wonderfully eclipsed by the breakthrough to follow."

Bjørn Richter, who spent two years working on the Sitting Bull sculpture at LEGOLAND Billund in the 1970s, was fairly brief when asked what advice he would offer to younger builders interested in taking on larger-scale projects like his, saying all they needed was "glue, a barn, patience, and a rich dad." If the items on that list are out of your reach, never fear (although patience is pretty

much a prerequisite). In the process of finding out just how all of the other extreme builders make their models big and beautiful, your esteemed author also made sure to ask for their top tips for big-build novices, or those looking to take their building to the next level. And if you need any more inspiration or advice, head over to www.Flickr.com, www.MOCpages.com, or one of the great LEGO blogs out there, such as www.brothers-brick.com, for more inspirational models. So, whether you want to build the ultimate Harry Potter playhouse for your kids like Alice Finch, cover your ceiling in a LEGO solar system like Gary McIntire, build a detailed superhero hideout like Carlyle Livingston II and Wayne Hussey, or just make people say "That can't be made out of LEGO!" then read on, and happy building!

WAYNE HUSSEY—Seattle Space Needle (page 112)

- "When building large, remember that gravity is your friend *and* your nemesis. Use it but don't let it get the better of you."
- "Don't build big just to be building big. Make it something you are passionate about."
- "Whenever I build a large project, I keep in mind that if I want to show it to others, I need to be able to transport and assemble it. So I make it in sections. I make the sections strong and light-weight enough to carry by one individual (no more than thirty-five pounds). I make the sections small enough to fit through an average doorway. I make the section joints mate easily and firmly."

ALICE FINCH—Hogwarts (page 36)

- "When you know what color scheme you are going to use, look through the parts available in those colors. You can do this on www.Bricklink.com by going to 'catalog,' then the 'color' tab, then choose the color you want, then choose 'thumbnails.' For Hogwarts I used an awful lot of tan, but I didn't want it to all be tan, so I looked through the parts available in dark tan, brown, dark gray, and even sand green and dark green to see what kind of interesting pieces were available that might add visual interest or detail."
- "I found it incredibly freeing to order a few of a part that I thought might be useful, but didn't really have any idea how. For example, I got a whole bunch of the tan spindles used as the center of spiral staircases. I knew they had an interesting texture and I thought I'd find a place for them eventually. I used a couple dozen of them as the pillars in the Quidditch courtyard directly below the hospital wing."
- "Have someone you trust to do show-and-tell to as you build. It is so important to pause and reflect and describe what you are trying to achieve with a particular brick or idea. Sometimes it works and sometimes it doesn't and it is good to have someone give honest feedback and suggestions on what might make it work better."

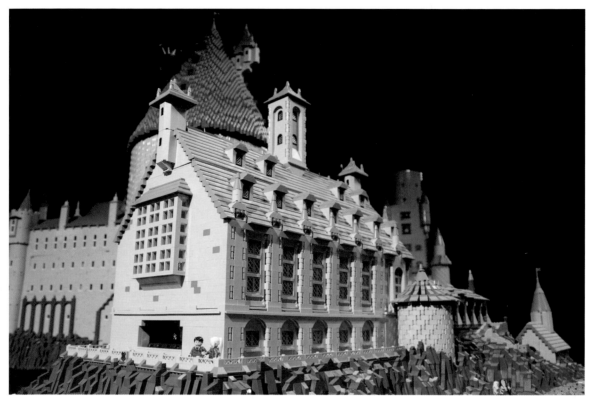

Just some of Alice Finch's remarkable Harry Potter Hogwarts model. © Alice Finch

GARY MCINTIRE (Master Model Builder)—Solar System Ceiling (page 187)

Unlike many of the other builders included here, McIntire wouldn't recommend taking on an extreme build like his. But if you feel the urge to build on your ceiling, he said, "It's a major project to cover a ceiling of a room, so I don't know if I would recommend a little kid do it. The hardest part is getting it to fit in the corners because LEGO is perfectly square, and no building is. Any kind of construction, whether the house is old or new, the walls will never be perfectly square or straight." To account for this, he built a framework around the perimeter of the ceiling, so the LEGO wasn't built out all the way to the walls.

He said the trick to building something above you is to build it on the ground first and then put those built sections up onto the ceiling. "Don't build the whole thing on the ceiling," he warned.

Gary McIntire hammering the foundations of his solar system ceiling into place for extra security.
© Gary McIntire

"I had to build some of it up there but there's no way I could've built the whole thing upside down like that."

He also explained the difficulty in sticking up base plates for a big mosaic build like this onto a wall. "You can't put them right up against each other, because if you put a plate on top of it, it actually overhangs the base plate a bit, so you actually have to put LEGO on the edges of the base plate before you butt them up to each other, otherwise you'll never get pieces to connect across them, or get pieces to even sit next to each other properly." The only way to make sure the plates are all lined up perfectly is to take your time when affixing them to the wall or ceiling. "I'll start in one corner and make sure it's absolutely straight," he said, "because it's a lot like doing tile work except you don't have grout lines in between, so once you lay that first piece down everything will follow in line with it. So if it's crooked your entire wall will turn out crooked. And the longer length that you have the more it will be out of square by the end of it. It involves measuring really carefully and crossing your fingers when you stick that first piece up."

And if you want to know how best to affix your LEGO base plates to the walls or ceiling, don't waste your energy with screws and glue—McIntire would bet on some good indoor/outdoor construction adhesive tape, although you're going to need to save up for it. "I think 3M™ makes it," he said. "I should've got them to sponsor me. I spent eighty dollars on tape or something like that. You wouldn't ever think of spending that much on a box of tape." But it's worth it if you don't want your creation to collapse on top of you.

RYAN MCNAUGHT (LEGO Certified Professional)— Elvis Helicopter (page 194)

- ❖ "You cannot plan enough, research is the key and makes for better end results."
- ❖ "Do not only build things you are interested in, challenge yourself by building things you normally wouldn't."
- ❖ "Sometimes the logistics around your model are just as important as the model itself—how do you move it around? How do you install it easily?"

ANTHONY HOETE FROM WHAT_ARCHITECTURE— Cowley St Laurence Primary School Mosaic (page 88)

- ❖ "Believe. We hope that Cowley St Laurence Primary School can be used as an exemplar model for other schools or public buildings. In this sense if anyone (government official, building controls officer) says it cannot be done, i.e., built with LEGO, show them it already has."
- ❖ "WHAT_architecture was asked by the Department of Education how the process could be replicated, and so we have produced some design information including details (patent pending) and logistical programming which will allow anyone anywhere in the world to build their own school. Call us! Or contact us at: info@whatarchitecture.com."
- ❖ "Put the 'fun back into functionality.' Working together in a team is so much better than working alone. Socially one has more fun in the company of others so use a building project to open up ambitions and dream a little."

Who said LEGO bricks were only for indoor play? Bring LEGO fun to the outside of a building like the team from WHAT_architecture.
© WHAT_architecture

DIRK VAN HAESBROECK—
Mario (page 96)

- ✦ "Build a small model first and register the required bricks and building time. My rule of thumb in extreme building: doubling the size of a model typically means approximately eight times the amount of bricks and time. Stay realistic and within budget—when deciding to do an extreme build, it is more important to finish your build than risking having to give up halfway."

- ✦ "Ensure at least four studs thickness for the outer surfaces. Provide sufficient structural reinforcements inside the hollow model by determining the optimal dimensions of the inner skyscraper allowing frequent branches to the outer shell. Stack two or three 2 x 2 bricks and alternate with one row of 2 x 4 bricks."

- ✦ "When building a slender model taller than eighty centimeters [three inches] go for a modular build. Include a layer of tiles, separating the model into parts to facilitate moving or transport."

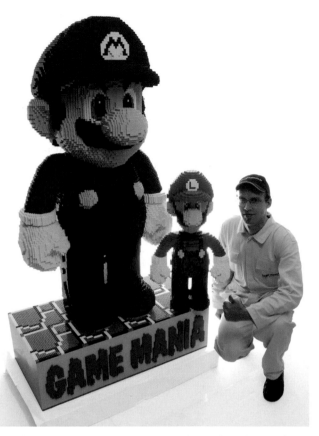

Dirk Van Haesbroeck built a small model of Luigi first to help him calculate bricks and time required for the larger Mario model. © Dirk Van Haesbroeck

DAVID SCHILLING—BallMageddon (page 160)

Schilling teaches robotics to sixth- to twelfth-graders, so he's an expert when it comes to guiding those new to the wonderful world of MINDSTORMS. Yes, working with robotics might seem a little scary compared to simply snapping LEGO bricks together, but Schilling believes the best place to start is the simplest. "There's nothing like getting your feet wet!" he said. "Build a few simple robots first. You'll have some fun, and learn a lot. Then build slightly more complicated things. If you lack ideas, there are thousands of other robots people have built. Search the web, especially

YouTube for ideas. There is absolutely nothing wrong with copying an idea. But don't just copy the robot directly if you can help it. Try to build your own version of the idea." Below are some of Schilling's top tips for working on a Great Ball Contraption similar to the one he built with robotics club SMART.

- "Find a source of balls before you start. This was much more difficult than it would seem. We looked into all sorts of alternative types of balls because we weren't sure we could get that many—everything from ping-pong balls to the balls you see in child ball pits. But we really wanted to be 'pure' in our LEGO display, and had our hearts set on LEGO balls. If you're going to build a similar device, you might consider not being LEGO pure in the type of ball you use."

- "You really need a lot of different ball mechanisms that are different and interesting to look at. The more you have, the more interesting the display will be. In my opinion, we ended up with just the bare minimum number needed."

- "Reliability! There is no such thing as a device which is too reliable. If you have one failure in every thousand balls in one device that seems like it's very reliable. Multiply that out by ten or twenty devices, though, and if you are handling ten to twenty balls per minute, you will have a failure every couple of minutes. I told the group, but especially the younger builders, to loop

Taking inspiration from the real world—just some of the everyday items Sawaya made from LEGO for a photographic collaboration with Dean West. © Nathan Sawaya (Brickartist.com)

219

the balls around on their own device at home, and have it run all day, just to see how it would work. Many problems were discovered this way that fortunately we didn't have to deal with at the show."

🎁 "Balls have an uncanny ability to jam in so many ways that you would never expect. The best thing is to keep them totally isolated from each other at all times. Rarely is this ever possible. But even two balls can figure out ways to jam so that your device won't work anymore. It takes a lot of time to discover these situations, and find how to work around them."

🎁 "One really useful tip for ball contraptions is that there should always be a drop in elevation whenever there is a change in the direction the ball is traveling. Corners are one place balls slow down or stop moving for a moment. So that's one place they will start jamming. Even a small drop at that point, though, will get them moving so that can't happen."

🎁 "Variety. You need many different types of ball devices for a GBC to be interesting to look at. If everyone builds a ball counter, which is a strong desire (same with sorters), even though each counter might be different, it's not as interesting as if there is only one ball counter, and twenty or thirty other devices that each do something else interesting and clever."

NATHAN SAWAYA (LEGO Certified Professional)—Red Dress and Gray (pages 202 and 227)

🎁 "Look at the real world for inspiration. I researched tearing to get the wall's opening accurately portrayed in Gray."

🎁 "Building on different levels gives a lot of depth to your sculpture. For example, the figure's body in Gray, being behind the tear of the wall, really creates a sense of emerging from the box."

🎁 "Have patience. You can't finish something like this in a day."

PAUL HETHERINGTON—Poseidon (page 154)

🎁 "Be true to your vision; don't give up. I think the reason that I'm successful is that I never give up if I feel I have a good idea. I may not know exactly what my projects will turn out like, but I stay focused and refuse to compromise on the build until it's finished and I'm satisfied."

🎁 "Don't be afraid to fail. Every time you build you learn something, or gain some kind of experience with the bricks. Some people can be intimidated by what they see online and at conventions. If you don't start you will never know what you are capable of."

🎁 "Build a strong base for your creation if you are going to be moving it, or showing it off. It takes more bricks to brace your creations, but it is so much easier to transport them if the base plates are well built."

CARLYLE LIVINGSTON II—Batcave (page 132)

- ❖ "I find it best to plan ahead on a big model. If you can do it in your head like I can, great! If not, use whatever works best for you, whether it is computer graphics, building a smaller study model, or just drawing on paper. There is no wrong way. The right way is what works for you!"

- ❖ "Practice, practice, practice! Or in other words—build, build, build! The best way to learn for me is by doing. Learn from your mistakes and move on."

- ❖ "The next best way to learn for me is to see what others are doing. I go to my local Lego User Group (LUG) meeting and see what other people are building. I talk to them and we discuss how we found a great new technique. It's also been very inspirational to go to LEGO conventions. BrickCon is close to me but there are conventions you can attend all over the world."

- ❖ "Look online at what people are doing. Join discussion groups and chat about new ideas. There are so many LEGO forums and websites that have a strong sense of community."

- ❖ Probably the most annoying thing for any LEGO builder is when you build up a certain amount and realize you forgot something, or made a mistake, or see a better way to build it and then you have to take apart the last hour of construction and do it all over again. This can really get your blood boiling. We just take a deep breath, fix it, and keep going."

The NELUG team worked together and relied on their joint strengths and building experience to make their Millyard creation as accurate and impressive as possible. © Mike Ripley

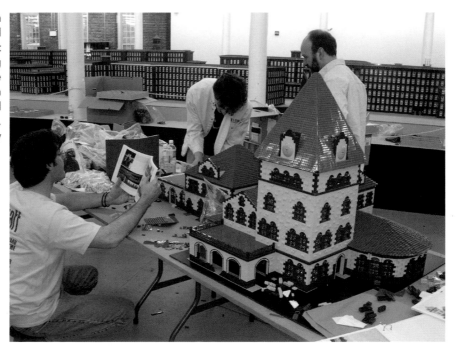

MIKE RIPLEY FROM New England LEGO Users Group (NELUG)— Millyard (page 78)

- 🧊 "Start with the windows first. Even with the new and improved LEGO window sizes and colors, this will limit your options. And if you want to build your own windows, start there first as well. The size of the windows will determine the size of your overall MOC [My Own Creation]."
- 🧊 "Sort and build the way you think and approach building. Some people are color oriented, some are size, some are shape. Use a system that matches best with how you build."
- 🧊 "Ask for help. Few of us are expert builders in all areas, so don't be shy about reaching out to people who do certain things much better than you."

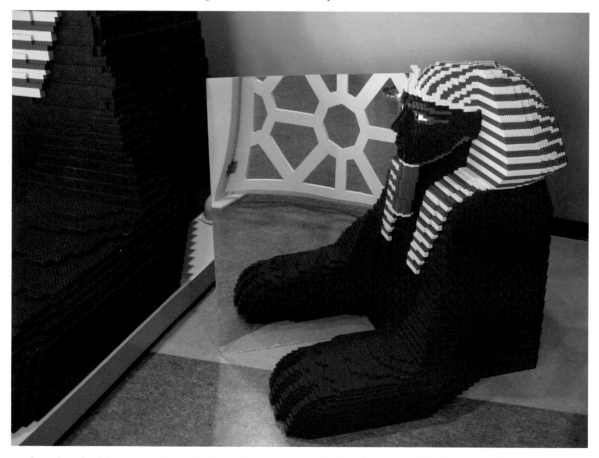

Rather than building a giant model blind from scratch, Robin Sather build half of a smaller version and positioned it beside a mirror so he could see an entire miniature version to guide him. © Robin Sather

ROBIN SATHER (LEGO Certified Professional)—Great Sphinx (page 208)

- "When building big, try to build from the bottom up. That seems like an obvious tip, but often as you build, you make changes to your design, and if you have already built a section from 'higher up' on your model, it may no longer fit or work with the change you made, so you have to dismantle it and rebuild it anyway."

- "Don't over-engineer! When building big, you will often have to span large gaps, and create internal support structures for different parts of your model. It's very easy to go overboard on these sections and over-build them. This adds unnecessary weight, uses up more precious bricks, and takes up more time. It's crucial to build your model structurally sound, but try to be as efficient as possible when doing so."

- "Remember that DUPLO bricks and regular LEGO bricks work together very nicely. The only catch is that any LEGO bricks you attach on top of DUPLO bricks must be even-numbered bricks, like 2 x 2, 2 x 4, 2 x 6, 2 x 8 bricks, etc. 1 x 2 bricks and 2 x 3 bricks, for example, will not work."

- "For LEGO models that I build, I have a 10–3–1 rule. I want the model to be big and impressive in some way from ten meters [thirty feet] away. Then, as you approach the model, I want to include details that become more apparent from about three meters [ten feet] away. Finally, I try to add little details that you can really only see if you are right up close, one meter [three feet] from the model. Fun!"

STEGOSAURUS

By Henry Lim

FACTFILE

Build location: Redondo Beach, California

Year completed: 2000

Time taken: Seven months

LEGO elements used: Approximately 150,000

© Todd Lehman

WHAT IS IT?

Before he set about building a playable LEGO harpsichord to take pride of place in his apartment (see page 56), Henry Lim spent seven months fulfilling another LEGO-building ambition. "I've always wanted to build a life-size dinosaur out of LEGO," he said. "My favorite's the stegosaurus. And so I did." Of course the dimensions of his living room only served to fit a juvenile stegosaurus sculpture, rather than an adult. This yellow, green, white, and gray

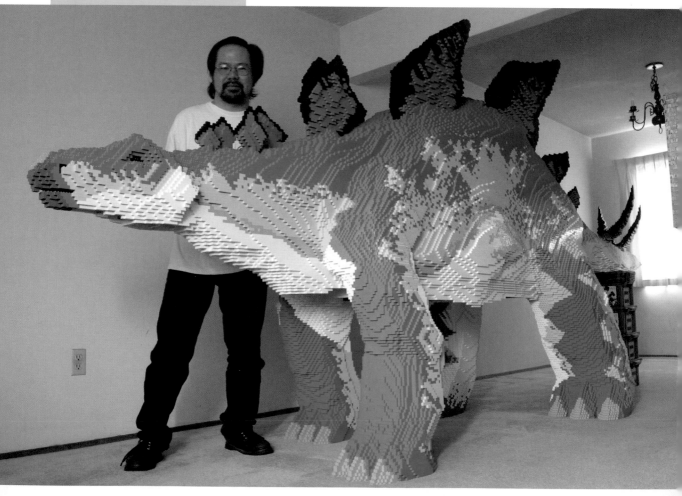

© Todd Lehman

Ever wanted to see inside the belly of a LEGOsaurus? © Todd Lehman

KEEP BUILDING

To read more about Henry Lim and his models, turn to page 56 or visit his website www.henrylim.org.

plastic-bricked creature from the land that time forgot is hard to miss, and over thirteen years later, it's still standing, although the tail now needs some additional support from a few empty tubs. Rather shockingly, no glue was used on this model, thanks to its impressive internal structure.

MEET THE MAKER

Henry Lim works at the UCLA Music Library, and used to be an active member of LUGOLA, and attend a number of LEGO events and conventions, although the scale of his more recent models have prohibited him from sharing them in person. He's known for his large mosaics of the Beatles, Michelle Pfeiffer Catwoman, and Audrey Hepburn, as well as a three-foot-tall bust of Beethoven.

THE PROJECT

Lim refers to this model as the largest LEGO sculpture he's ever made. And it's not hard to see why. This stegosaurus, which is

225

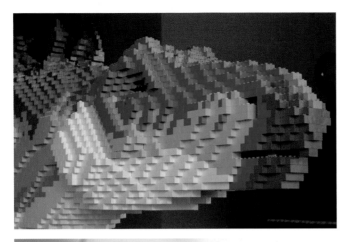

largely hollow on the inside, measures fourteen feet long from the tip of its beak to the end of its tail. Its back plates measure six feet tall at the highest point, and its body is three feet wide in places. To complete this model, Lim used over one hundred tubs of 1,200 pieces (using mainly the larger bricks included), two hundred service packs of green bricks, several more green bricks that he accrued from auctions and trades, as well as 2,500 2 x 4 green bricks that he bulk ordered especially. The internal structure of the body is very hollow, due to its huge size, while the legs are nearly solid, to support the weight of the body and the tension on the bricks caused by the neck and the tail. "I spent seven months slowly watching it grow into my living room," Lim said. "If I had more space, I would've made a fully grown life-size stegosaurus."

All images in this profile
© Todd Lehman

GRAY

By Nathan Sawaya

FACTFILE

Build location: New York City
Year completed: 2007
Time taken: Three months
LEGO elements used: 48,090

© Nathan Sawaya
(Brickartist.com)

WHAT IS IT?

While some of Nathan Sawaya's pieces are recognizable objects created in LEGO: a pencil, a cookie with a glass of milk, or a cat, this work, known as Gray, is a work of art through and through. "It's the embodiment of my emotions during the time in my life when I was going through a lot of transitions," Sawaya said. "I had recently made the decision to leave my legal practice to become a full-time artist a few years prior, and with that came a lot of changes in my life—some good, some bad. I was also coming out of a very dark place, so the sculpture has some very strong overtones of breaking free from the depression that engulfed me at the time."

Sawaya said that despite its inspiration, the figure is not a self-portrait, rather a universal figure, with the hope that the viewer can empathize with the sculpture. And with the reaction he's received, it clearly works. "I have had many people tell me that this sculpture gives them hope. Hope of changing their life; hope of getting out of a bad situation; hope to move on. It has been so special to talk with folks at an exhibition and hear their strong reactions to Gray. It has inspired so many people. I have had people come up and tell me that they know exactly how that figure is feeling, and this sculpture has given them hope to break free."

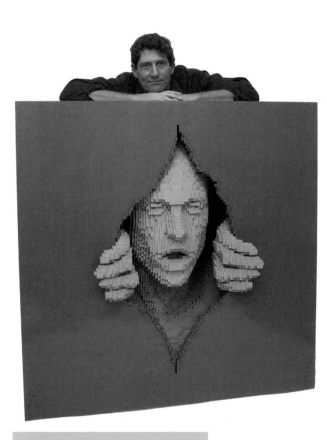

© Nathan Sawaya (Brickartist.com)

MEET THE MAKER

Nathan Sawaya is a LEGO Certified Professional from New York City. For more about Nathan take a look at another of his works featured in this book on page 202. "My hope with the sculpture was simply to captivate the viewer for as long as I could hold their attention," said Sawaya, of this eye-catching gray creation. "LEGO is such a fantastic child's toy and I want to use it to entertain folks. In this particular case, I was using it to entertain, but also to ask the viewer to think."

THE PROJECT

Sawaya chose to express the emotions he was dealing with through the medium of LEGO bricks, and the color palette played a big part in that. "Two tones of gray are used to suggest universality. But also the gray suggests the dark depression that I was struggling with personally."

Since making Gray the artist has produced even larger sculptures and more complex builds, but at the time it was the largest human form he'd created, and it was important to him that the figure emerging from the box truly was larger than life. "I really wanted to capture the detail and anguish of the figure's face," he said. "I created a smaller version to experiment with the overall look of the sculpture."

Sawaya spent over two months of planning and experimenting on how to best capture this idea of breaking free. That included sketches of how the sculpture might look, and various tests involving ripped boxes, cardboard, and other materials to decide on how the LEGO elements needed to be utilized for the desired effect. "It was important that the tearing looked like a natural result of someone using two hands to tear out of a confined space," he said.

One of the most interesting things about this model, that you wouldn't necessarily notice, is that the figure's face and hands are supported by a partial torso—a neck and chest than extend to the bottom of the box. "This was critical to me when I was building it," said Sawaya, "that the figure had accurate arms, but in the end, they are almost impossible to see."

Although the use of monotone gray bricks was an effective creative decision, it made parts of the build more than tedious. "My most clever trick was to not go into a coma while building the repetitive gray wall that encompasses the sculpture on all sides," said Sawaya. He also glued the bricks as he went, so any changes meant getting out the chisel and prizing them apart.

The result, however, is something that still resonates with the artist and the public many years later. "I believe the sculpture is more about inspiration for me than it was at the time of creation," Sawaya said. "When I was building it, it was a healing process for me, and a reaction to the metamorphosis of my personal life. Now I look at the sculpture as inspiration to break free. It is the embodiment of me breaking out of my everyday doldrums to follow my dream."

KEEP BUILDING
For more models from Nathan Sawaya head to page 202 or his website www.brickartist.com.

© Nathan Sawaya
(Brickartist.com)

229

GRAND PALACE OF THAILAND

By Vincent Cheung Sin Luen, a.k.a. Fvin

FACTFILE

Build location: Hong Kong
Year completed: 2010
Time taken: About three hundred hours over six weeks
LEGO elements used: 25,000

WHAT IS IT?

This stunning work of LEGO architecture is a minifigure-scale replica of Thailand's Grand Palace. The real palace, built in 1782, is situated in central Bangkok, and was home to the country's kings until 1925. The LEGO version was built by Hong Kong AFOL (Adult Fan of LEGO) Vincent Cheung Sin Luen and weighs almost

© Vincent Cheung

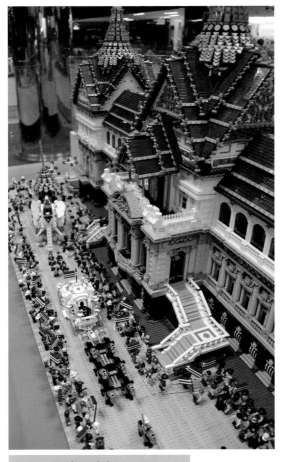

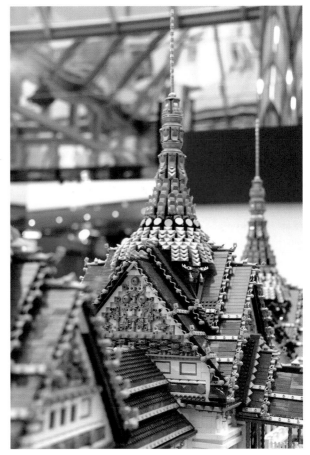

© Vincent Cheung

On-site at the exhibition, Cheung built a grand procession of LEGO minifigures outside the palace.
© Vincent Cheung

two hundred pounds. The model measures three meters long by one and a half meters wide and one and a half meters tall (approximately ten by five by five feet). It was first exhibited at a LEGO exhibition in Hong Kong in 2010 that centered on famous scenes from around the world. For ease of transportation the model can be divided into three parts and then pieced back together in the exhibition space. "It certainly was a big challenge for me to realize the Grand Palace with LEGO bricks," said Cheung. "The special geometry of the roof as well as the special patterns on the walls were the most challenging."

Cats love LEGO too! One of Cheung's cats tests out the model's strength. © Vincent Cheung

KEEP BUILDING

To see more of Vincent Cheung's creations, you can visit fvin&yan on www. Flickr.com

MEET THE MAKER

It was being a father that got Vincent Cheung back into LEGO building as an adult in 2006. "I played with LEGO in my childhood, but like many people, I stopped playing as a teenager. It wasn't until I had a son who was three years old, and I played with him, that my interest in LEGO was lit up again." Cheung is based in Hong Kong, working as a design manager for a semiconductor company, and is an active member of the local AFOL community. "There are hundreds of AFOLs in HK that like building with LEGO for different things," he said. "We hold AFOLs' activities, competitions, and gatherings." He is also one of the founding members of the Hong Kong LEGO User Group (HKLUG). Cheung described completing this model as one of the milestones of his LEGO-building life. "It is just simply a wonderful experience to build in such a scale," he said. "It gives me confidence to tackle other buildings on an extreme scale. I developed some new building techniques during the building of this model, which could be very useful for the future."

THE PROJECT

Cheung spent a few days planning out the model, collating images of the Grand Palace from the Internet and travel magazines. He made sure he knew how the model was going to be transported and assembled at the exhibition site—dividing it into three sections—before he started on the design. He then checked his brick inventory, and built the design in an economical way, making use of his existing collection as much as possible to reduce the budget of the project and to save time ordering parts.

Rather than building immediately from the ground up, Cheung tackled some of the building's key features first to test out any potential issues that may arise. When he felt confident in the design and its key components he began building. He utilized a well-practiced circular building method for the various cone shapes required on the build, which meant he was fairly confident he could handle the project before he started. "Having said that, the reality

still gave me a lot of challenges and surprises," he said. The 25,000-brick build was a solo venture, supported by his wife's cooking, his children working on simple elements of the build, and his cats who like to test out his models (see photo).

"The complete model was not integrated together at my home," said Cheung. "All of the modules were only roughly tested to see if it was possible to put them together." Cheung only saw the completed model at the exhibition where there was enough space to assemble it, which took four hours. Cheung was very happy with result, believing the model to be as detailed and accurate as he had planned it. "This is the biggest LEGO model I have built so far; I love this project very much," he said.

Cheung's children check out one giant section of the model in the family's kitchen.
© Vincent Cheung

"LEGO" BRIDGE

By Martin Heuwold, a.k.a. MEGX

FACTFILE

Location: Schwesterstraße, Wuppertal, Germany
Year completed: 2011
Time taken: Five weeks (two weeks of design; three weeks of painting)
LEGO elements used: none

WHAT IS IT?

Yes, your eyes are deceiving you. This bridge in Wuppertal, Germany is not built from one of the products of your dreams—giant LEGO bricks. It is actually the work of graffiti artist Martin Heuwold, who goes by the street art name MEGX. The concrete bridge renovation was funded by Wuppertal Bewegung e.V.—a community organization that works on projects that benefit the city and its residents. "Dr. Carsten Gerhardt, managing director of the Wuppertal Bewegung e.V., asked me for a design for this bridge, to improve the cycle path that runs over it," said Heuwold. The concept title for the 250-square-meter (2,691-square-foot) design was "playing allowed," and when he asked his wife if she had any bright ideas for painting something big across the street, she said, "try it with LEGO," so he built a LEGO model, and used that as the basis for his colorful painting.

MEET THE MAKER

Martin Heuwold, a.k.a. MEGX, has been a graffiti artist since 1989 when he started "spraying a lot of walls and trains in the night," but it wasn't until 2002 that he became a professional freelance artist, commissioned by companies and individuals to create works of art. While this creation is not built from LEGO bricks, its artist is a fan—"When I was young I had it like all the kids around me, and later I played LEGO with my daughters."

© Lukas Sprenger

The bridge prior to MEGX working his LEGO graffiti magic.
© Martin Heuwold

© Rolf Dellenbusch

Heuwold is as extreme an artist as they come, and said "Bigger is better for me, I like to work on this scale. I´m not one of those artists that prefers to paint canvases." So if you fancy a LEGO bridge popping up in your town, he's definitely the man for the job. Would he do it again? "Maybe," he said. "Ask me if you want one!"

THE PROJECT

Before he got his paint-splotched hands on it, Heuwold described the bridge as "really unappealing," so with his computer, his phone, and some good food, the artist set about brightening it up with a touch of LEGO magic. "I took a picture of real LEGO bricks and then I projected it with my computer onto a photo of the bridge," he said. Design in place, he required a team of four people to lead traffic around where he was working, and help him run a boom lift that enabled him to paint those hard-to-reach places.

"The first three days I had to stop working if there was a truck coming along the road," he said, "Because the bridge was only seven meters [twenty-three feet] high. That was really cruel and I began to think that I would never finish this job, but with good

Martin Heuwold, otherwise known as MEGX, working on the "LEGO" bridge. © Lukas Sprenger

235

© Martin Heuwold

communication we got a solution for this." Heuwold was able to complete the project, using facade color and spray cans, in about three weeks.

After it was complete there was an official opening ceremony, attended by all the people involved, the bridge's sponsors, local press, and the city's mayor. "I was really proud of this project," he said. "Before, I couldn't imagine that it would look so cool. . . . I'm really grateful to all the people who helped to make the project happen." It was almost a year later that word of the bridge started to spread outside of the city, and Heuwold received emails and phone calls about the bridge from everywhere in the world. "I never thought that it would be so popular, but now this city will never be without this piece of street art."

KEEP BUILDING
To see more of MEGX's wonderful street art works, head to www.megx.de.

236

Index